BANG BANG

MY LIFE IN INK

DEY ST.

AN IMPRINT OF WILLIAM MORROW PUBLISHERS

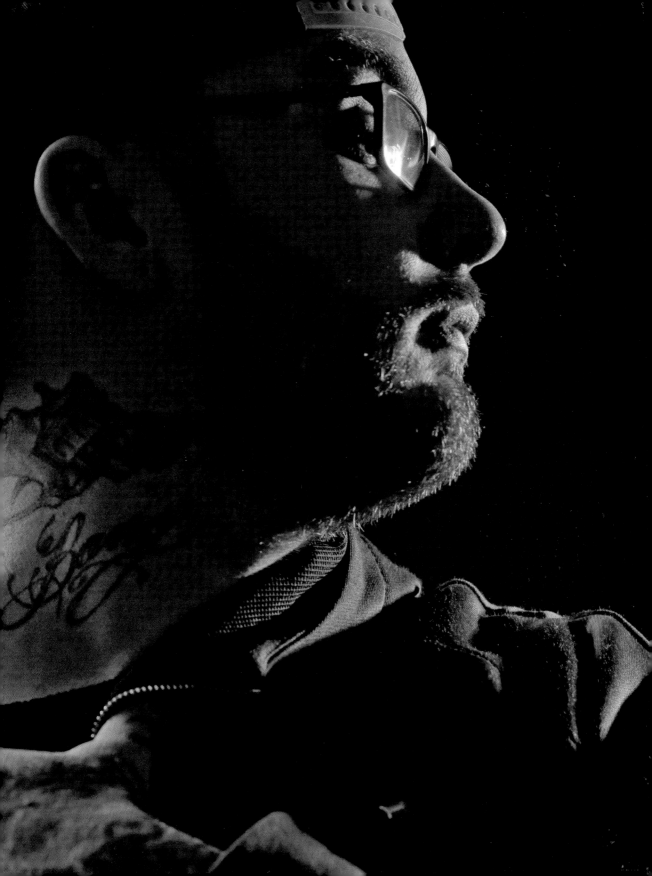

This is a work of nonfiction. The events and experiences detailed herein are true and have been faithfully rendered as remembered by the author, to the best of his abilities. Some names and identifying characteristics have been changed to protect the privacy and anonymity of the individuals involved.

DEY ST.

HarperCollins books may be purchased for educational, business, or sales promotional use. For information please e-mail the Special Markets Department at SPsales@harpercollins.com.

FIRST EDITION

Designed by Suet Yee Chong and Jesse McGowan

Library of Congress Cataloging-in-Publication Data has been applied for.

ISBN 978-0-06-238222-1

15 16 17 18 19 OV/RRD 10 9 8 7 6 5 4 3 2 1

CONTENTS

PART III: LIVING THE HIGH LIFE

PART IV: NOW EVERYTHING I SEE WAS ONCE AN IDEA

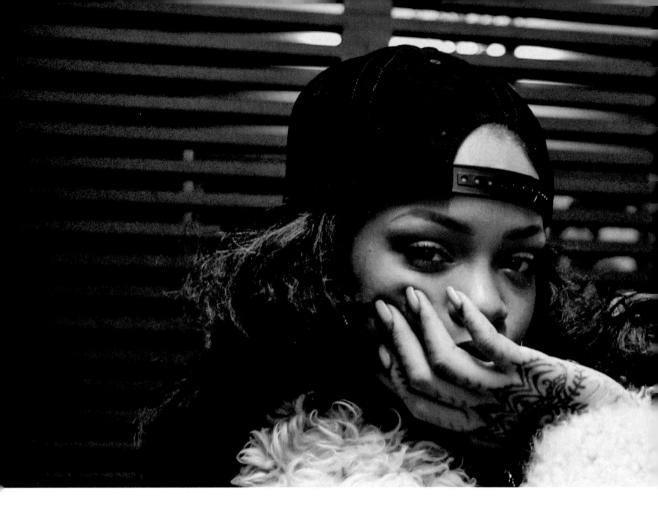

FOREWORD
BY RIHANNA

I met Bang Bang because about ten years ago I used to hang out downtown, by the tattoo shop where he worked. I would usually just roam around the streets, but one night I went into the shop and started looking around at nipple rings, and asking all kinds of questions about tattoos.

Tupac was playing loud, and Bang Bang was just sitting there, looking at me—with this face on—thinking, this girl isn't going to buy shit. I could tell! He was like, this girl would never get a piercing . . . she would *never* get a tattoo.

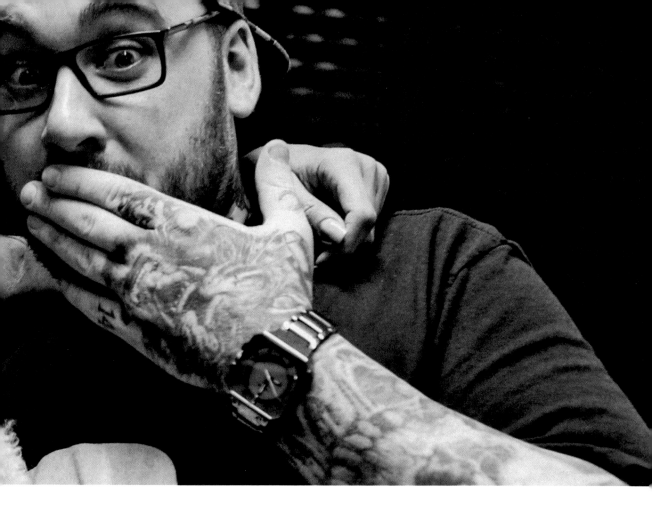

I remember thinking, this guy is gangsta as fuck. He doesn't give a fuck about me—he doesn't know who I am and that is brilliant. So that's why I wanted him to do my tattoo. I knew he wasn't going to try any funny shit or act crazy; he was just going to do my tattoo.

When he showed me the Freddy Krueger tattoo he did on his boss at the time, it was all over.

And that's the day I got my first Bang Bang tattoo!

I love tattoos because I think they're another way of expressing myself artistically. They're another outlet for art, and I love art. Each one of my tattoos means something to me, and they're not going anywhere—they're here for life. I love that.

When I first got a tattoo I was seventeen years old and I was in Japan. They needed consent from a guardian, so I called my mom and she was surprisingly into it. That one was

just behind my ear. I went to Australia from there, and got two music notes on my ankle, which Bang Bang later covered with my falcon. And then I came to New York. . . .

My favorite tattoo is still the first one Bang did—the Sanskrit on my hip.

Eventually, I want to be covered. I'm going to keep my skin pretty as long as possible, but the minute that starts to go south—Bang Bang can just knock me out and I'll wake up a week later, covered in tattoos. Maybe when I'm fifty.

Tattoos aren't something I want to be patient about. When I want one, I want it that moment. If you're lucky enough to find a really great artist, you're going to get it. Most of my work has been done in New York, by Bang Bang. But if not in NYC, in a hotel room, or my house, or wherever I am.

I was surprised when he wouldn't put my first tattoo where I wanted it to go—up the back of my leg—but I was so shocked that I was actually open to his idea of moving it, and I'm glad I did. I was still early on in my tattoo game, so I trusted him as an expert more than I trusted myself because I didn't know.

When you're well known, it can be hard knowing who to trust, but I trusted Bang Bang from the first time he tattooed me. I'm a very observant person, even when it might not seem like it. I may not say much, but I'm definitely taking it all in. When I figure out enough about who you are, that determines how close I'll allow you to get to me.

The thing I value most about Bang Bang is his honesty. He will never tattoo a bad idea—like EVER. That is the best thing about him—he has shut down so many of my crazy ideas. Or he'll correct them, tweak them, and turn them into something great. Like my gun tattoo—I was sure I wanted two of them on my collarbones, but he talked me out of it and I'm so glad. Bang is invested in his art—it's not about the money. That's really rare and very special.

I love you, Bang Bang!

INTRODUCTION

+

When I was eighteen years old, I ordered a tattoo kit online. The moment it arrived, I sat down at the kitchen table and got to work. I sat for hours on end, day after day, delivering permanent mistakes to my cousins, friends, and anywhere my right hand could reach on my own body.

Twelve years later, and I've tattooed Rihanna poolside in the Dominican Republic, worked on Justin Bieber at forty thousand feet in the air on board a private plane, inked Katy Perry after the halftime show at Super Bowl XLIX, and etched a globally iconic lion tattoo on Cara Delevingne's index finger while hanging out in Rihanna's hotel room in the middle of the night.

I've been told my life is the American dream. I didn't grow up with much, and against all odds I made it. It didn't come easy, and I worked my fingers to the bone to get here, but not a day goes by when I don't take a minute to appreciate how amazing my life is and how lucky I am to live it.

My name is Bang Bang.

I hope you enjoy my story.

P.S. DuPont
Elementary School
Student Keith McCurdy
Address 912 Parksode R
DOB_____ Grade 4
SS#_____
Emergency#_____
1994 - 1995

KID LAWARE

Pottstown Memorial Medical Center

POTTSTOWN, PENNSYLVANIA

This Certifies that _Keith Scott McCurdy_

was born to _Susan McCurdy_

in this Hospital at _9:57_ o'clock, A.M. on _Thursday_

the _twenty-eighth_ day of _November_ 19 8

In Witness Whereof the said Hospital has caused this Certificate to

be signed by its duly authorized officer, and its Official Seal to be

hereunto affixed

Albert P. Pollick
PRESIDENT

Lee S. Zeller MD
ATTENDING PHYSICIAN

JDS LithoGraving® HOLLISTER INCORPORATED 211 E. CHICAGO AVE., CHICAGO, ILL. 60611

ONE

+

BABY BANG

I was conceived on top of a weight bench in my grandmother's attic on Valentine's Day, 1985, and was born nine months later on Thanksgiving.

Most people don't know the specifics of their conception, and believe me, I wish I didn't know mine. For one thing, Valentine's Day will always feel oddly compromised.

My mother, Susan, was a seventeen-year-old high school dropout, who was working at Domino's Pizza when I came into the world. My dad was able to stay in high school—and later went on to college—but the two of them were never an official couple after that magical night on the weight bench, so he wasn't around much when I was very young.

For the first couple years of my life, my mom and I lived in Pennsylvania with my great-grandmother Edith, about an hour outside of Philadelphia in a town called Pottstown, where I was born. Nobody talked about it at the time, but I think Edith was a lesbian in a town and era where being gay was frowned upon. Though she lived with her partner, we never witnessed any sign of affection between the two of them. Until a lightbulb went off sometime in my late teens, I figured they were just friends and roommates. Edith was a toymaker who made porcelain dolls. When my mom was pregnant, she made a doll in my presumed likeness, and it's one of the only artifacts left from that time in my life.

When I was three or four we moved into our own place, in a public housing sprawl

called Brookview, in Claymont, Delaware. One thing I need to clarify is that public housing in Delaware isn't anything like the high-rises you see in New York and other big cities. Brookview was by no means a place where anyone would aspire to live, but these were more like crappy town houses than apartments, so we had a two-bedroom duplex and I had my own room. When you're young, you can't really tell that you're poor, but that's what we were, and I never minded.

Besides, I was a kid, and like every other kid, I thought my experience was universal. I didn't know what "poor" was, and most of my friends lived in households headed by single moms, too, so it all seemed pretty normal. Eventually I realized my mother had a hard time affording the stuff we needed to live, and that's when I started to mind being poor. She quit Domino's and started dancing nude for money. Because it was all I knew, this didn't seem unusual to me, and I didn't understand until I was much older how far from normal my life actually was.

Living in Brookview was fun because the neighborhood was filled with kids my age, and frankly, I didn't really know any better. The complex was made up of several big circles centered around a court. There was grass everywhere and all the kids were always running around getting dirty. They usually stayed dirty, because I realize in retrospect that most of their parents were junkies.

All the kids in Brookview were wild. We were always stealing stuff and would've been getting into trouble if anyone had stopped us. There was this one old woman called Ms. Jazz. She was afraid to leave her house, so she would stand at her front door and yell at passersby, asking them to go buy her food. She'd give them money and often nobody would return. You couldn't even breathe the air by her front door because it smelled so intensely of piss. That poor woman.

My best friend was a little girl named Kristi. More on her later, but Kristi and I were inseparable. We'd turn her bunk beds into a fort, play outside in the dirt, goof off,

and watch endless hours of cartoons to-gether.

One day when we must've been about four, Kristi and I were running around a nearby field and found some mushrooms. Naturally, we set about eating them. Almost immediately the stomach cramps set in and the two of us were rushed to the hospital, where we had liquid charcoal pumped down our throats.

Every day I'd go knock on Kristi's door to see if she could come out and play, until one day nobody answered. They'd moved without warning. I was bereft, and for years I wondered where my best friend had gone. But like I said, more on her later.

I was a big kid and always had a lot of friends so I was surprised when I started getting bullied at Brookview. This kid named Jimmy was always on me about something. I never had any problem

standing up for myself, but something about Jimmy just made me feel bad for him. He lived with his big fat disgusting dad in a filthy apartment. I never felt like I wanted to do anything back to him, because I understood why Jimmy was sad. We didn't have a lot, but at least we had *some* money. His house was dirty and dark and just awful. He was the only person I ever let bully me. I'm sure he'd probably still be in Brookview if it hadn't been torn down.

Brookview was also where my dad's mom—my mum-mum—lived, and with her around, I got a lot of parenting. I always loved that. My mum-mum had long ago divorced my grandfather and was married to Leo, who I called Pop-Pop. Leo was the best grandfather I could ask for—hell, he was the best *dad* I had. He was super strict and picky, but I learned a lot from him. Those few years with my mum-mum next door were really good for me. I was

so happy to have the attention, but we only stayed there a short time.

I know my parents—well, my mom at least—loved me, but I didn't realize until having children of my own how much I missed. Later in life my father confessed that he'd never liked children—a shocking thing to hear from one of your own parents. But after growing up witnessing his constant outbursts, fits of rage, and inability to connect with people, I firmly believe it wasn't *me* he didn't love; it was *himself*.

Thinking back on how poor we were, I doubt my pops ever gave my mom much child support when I was young. If that was the case, it was understandable, because he was only sixteen when I was born, and when he finally did start coming around, he was poor too. When I was about eleven, he started making money. Meanwhile, my mom was still shaking her tits for money and would sweat every tank of gas, even though gas was only ninety cents a gallon back then. This made the idea of money very stressful for me.

Money was always an issue for us. Even though my mom was dancing nearly every night, we were still hurting. My mom was beautiful, and still is—she looks a lot like Gwyneth Paltrow. More than anything, I hated seeing her cry. The first time I remember seeing my mom cry was after a good friend of hers had been shot—it's my oldest memory. She says I was only two. After that, though, whenever I saw her crying, it was usually about money. Even as a little kid, I realized what kind of power money can have over you, and I vowed that I would never be poor once I grew up.

Since my mom worked nights and usually slept till three in the afternoon, I would often have to get myself to school in the morning (you can guess how well that worked out), make my own meals, and decide whether to do my homework or go out and play with my friends until they got called home for dinner. We were more like two little kid roommates than mother and son. Even now, I'm more of a parent to her than she is to me. It's OK, though—I'll love her forever.

Because I was in charge of making breakfast myself, I grew up never eating anything before school. But one year—on the first day of fourth grade—my mom surprised us

both by actually getting up to make me breakfast. It was a new school, and I was really nervous. I told her I was too queasy to eat, but since she rarely made me breakfast, she forced me to eat it. By the time we got to school, my stomach was making louder noises than it ever did when I was hungry. As we walked through the doors on my first day at my new school, I threw up all over myself. Way to make a good impression.

Obviously, along with the bad, there were some extremely cool things about growing up fast and having a mom who had questionable parenting strategies, to say the least. Like when I was five and she bought me a kid-sized motorcycle—I loved that thing right up until one of her junkie friends stole it. The downside to moves like that was that I wound up getting hurt. A lot.

Eventually we moved to Valley Run, which wasn't nearly as awful as Brookview had been. It was the same setup—attached town houses, lots of crazy kids, very little supervision. But here not *everyone's* parent was a complete fuck-up. For the first time, I was exposed to nice kids from good families. Even my mom was happier.

When I was about nine, my grandmom Kate, my mom's mom, decided to move to Arizona, and sold her house to my mom. While I loved the house, my grandparents were the only stable people in my life and I really resented what I saw as their abandonment. They still live there, and I still miss them twenty years later. But having our own house was amazing. It had a big yard and a basketball hoop in the driveway, and it wasn't attached to other

houses. For the first time I was living somewhere that felt like *ours*. The only drawback was that the neighbors hated us because my mom was a crazy young stripper and I was wild. But fuck 'em—we were happy.

Years after I moved out to tattoo in New York, my mom was foreclosed on and lost the house, which broke both our hearts. Not one of our family members would loan me the money to help her hold on to it, and while I could understand them not trusting her to pay them back, I was a bit surprised that they didn't seem to trust me either. I'd been working my ass off. There was just no way I would blow off a loan, but they all refused. They better never come to me looking for money.

I used to think that I'd buy the house back as soon

as I could afford to, and just bulldoze the whole thing and build some horrifying hobbit hole in its space. But now that I can actually afford it, I don't want it. Fuck that house. It reminds me of being poor.

My mom must've had some money—or, more likely, credit cards—when we moved in there because she made my room really cool. I had Chicago Bulls *everything*—wallpaper, sheets, the works. I even had a six-foot-tall cutout of Michael Jordan in that room! He was my hero, my role model, my idol.

When I was a teen, if my mom wasn't sleeping or dancing, she was baking in one of her tanning beds. There were several, most likely bought with credit cards since we were always in debt. We didn't really know about how harmful tanning beds were back then, but I doubt it would've made much of a difference.

There was always music playing in our house and my mom was the one who introduced me to hip-hop. I remember being real young and listening to MC Hammer, Snoop, Vanilla Ice, and Sir Mix-A-Lot. My mom loved that I loved "Baby Got Back." When I'd hear a good song, I remember thinking, Oh, Mom, you can dance to this! Now I realize that picking out music to accompany your mom when she takes off her clothes in front of strangers is kind of weird, but so is a toddler napping in the kitchen of a strip club. Most kids didn't fall asleep, sucking their thumb, holding onto their silky pillow, watching naked ladies through the service window. But it wasn't odd to me, because my mom was always walking around naked. This was my reality.

Most of what I learned from my parents was via negative example, so I put my fucking pajamas on around my kids. Ever since I first became a parent, I've done the opposite of most things my parents did with me, from the food I feed my kids to when they're allowed to eat it; from their activities to the amount of supervision they get. But most of all, I teach; I don't punish. I *love* them and I would never abandon them.

When my first daughter, Kumiko, was born a couple of years after I moved to New York, her mom, Etsuko, and I were so incredibly in love. We were also dirt poor. Ets couldn't work because she had really bad morning sickness, and I wasn't making enough money tattooing to support a family. It was rough, but we moved in together, and shit got real, real fucking quick. When we got married, Ets got a seventy-dollar wedding ring because we couldn't afford anything better, and I didn't even get a ring. We didn't even have a wedding—we just went to City Hall.

Still, we were so happy with each other that when Kumiko was born . . . man, we just

loved this kid. Even though we didn't have shit, it was like being wrapped up in this cloud of love. Everything was about Kumi. We'd eat, breathe, and sleep this kid. She was our whole world.

Then things started to unravel, and we separated. Over the next couple of years, we went back and forth, and during the time we were back together, Ets got pregnant again. We stayed together for a couple of months, and then we started fighting and separated again.

We split up right after Yukari was born, and it took a while for things to get better. But throughout anything between Ets and me, we love each other no matter what—we are family. We will always be family. I quickly fell deeply in love with Yukari. This little baby loves her dad so much and her dad loves *her* so much. She, like her sister, is perfect.

Before Yukari was born I couldn't even imagine that it was possible to love another child as much as I love Kumiko. But I feel the same love for Yukari as I do for my oldest. I always wanted a daughter, and now I have two. Twice the blessing.

Given how I was raised, parenting has been a wild ride, but the only things I love more than tattooing are my kids. I'm committed to giving them the best life I possibly can. Already their lives are the polar opposite of mine at their ages, and I know it's only going to get better. I work *all the time*. If it was just me, I'd tattoo just enough to get by, and then go on vacation or play video games. Everything I do, I do for those girls, and I wouldn't have it any other way. Ets, Kumi, Kari, you are everything to me.

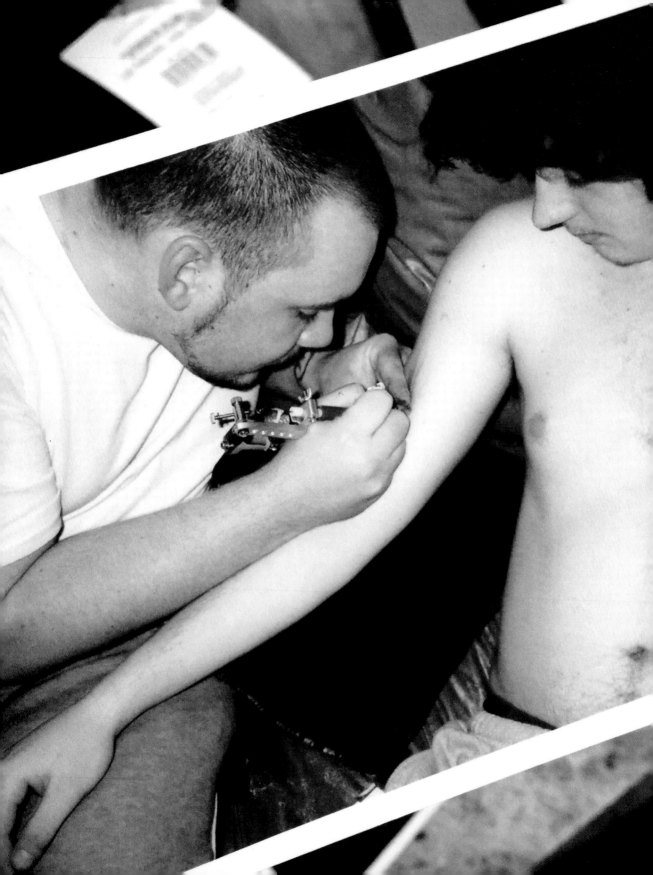

TWO

+

LEAVING HOME

By the time I was twelve, I was six feet tall, so everyone thought I was a lot older. I was always sneaking girls in and out of the house, doing drugs, drinking, and messing around with girls. We'd steal my cousin Edward's mom's car—I always drove—and drive to Chester, Pennsylvania, to buy weed, coke, dust, whatever.

My cousins Edward and Chris were like big brothers to me. Their mom was also a stripper; she even danced at the same club as my mom—Lou Turk's—so we had that in common. They were two and four years older than me, and were protective in their own, sometimes weird, way. Like I could drive to the gas station but I had to stay in the car while one distracted the attendant as the other one robbed the store. True story.

One time Ed and I were smoking angel dust in this van that we'd "borrowed" from his mom and we were so fucked up, Ed couldn't tell me how to get to where we were going. I remember when we finally found the spot—it was this Chinese restaurant in Chester, but there were no Chinese people to be found. Instead, you walked in and someone grabbed you and walked you back out to your car. Then the guy would walk over to the field beside the place, and he'd pick up the package and toss it onto your lap in the car. But some days you'd get there and these dudes would be competing for business—everyone would

COURSE TITLE	COURSE NUMBER	TEACHER	1st MARKING PERIOD			2nd MARKING PERIOD			SEM. EXAM	3rd MARKING PERIOD		
			GRADE	REMARKS	CLASS ABS.	GRADE	REMARKS	CLASS ABS.		GRADE	REMARKS	CLASS ABS.
PHYS ED	7012	NEFF										
HEALTH 7	7013	NEFF										
LANG ARTS 7	7113	CHAMBERLAIN	F	18 28	20	F	28 17	8				
GEOGRAPHY	7123	GROSSMAN	F	24		F	20 14					
MATH 7	7133	DOOLEY	F	15 28		F	28 15					
LIFE SCIENCE	7143	HARASIKA	F	17 24	17	FD	27 28	21				
TECH ED	7270	BROWN	I	18	16	F	15	18				
HOME EC 7	7370	SLOVEY										
INTRO WRLD LA	7470	DEGREGORIIS				F	15 17	15				
CHORUS	7671	MARCOZZI	D	21 24		DC	15 27					
KEYBOARDING	7878	LYNCH	F	37	17							

be yelling at each other, trying to get your money. We never got busted or hurt, but we came close a bunch of times. Not that that ever stopped us. We were dumb.

Though I had been having fun, a *lot* of fun, by about age thirteen I started to worry about my future. So I convinced my parents to send me to boarding school in Connecticut. It seems like a weird decision for some-one who had spent so much time running around like a maniac and avoiding school, but I think I actually got tired of getting in trouble. It was exhausting, and **it seemed pretty clear where I was headed if I didn't make a big change.**

Things were getting out of hand, and I think both my parents knew it. School was my dad's thing, and while my mom didn't do a lot of punishing, whenever my dad was around he was always giving me shit about homework—not that he was there much to help me do it. Even though he hated to spend money on us, he actually bought me a fax machine—just what every teen wants—so I could fax him daily progress reports from school. He loved school as much as I hated it (maybe that's why I've always disliked it so much). Because he valued school more than most things, my dad actually agreed to pay for boarding school.

The school was called South Kent, and it was in South Kent, Connecticut, near New Milford. It was a small, all-boys school, and at the time it was maybe a hundred kids total. Some of my classes only had four people in them. Since I'd run wild for thirteen years, the structure and attention I found there was just what I needed. You're either born with a good head or you're not, and I had a good head but no boundaries or discipline. As much as I hated rules, I'm glad I was smart enough to realize that going there would be a good move.

For one thing, South Kent wasn't your typical boarding school—it wasn't a rich-white-kid school by any stretch. Sure, there were a few of those, but there were also Puerto Ricans, Dominicans, black kids from Harlem, and a lot of students from Korea and Russia. There were maybe twenty countries represented. It wasn't the kind of place where you'd see douche bags like "Tristan" or "Chase" out on the lawn playing croquet. (Sorry, Tristan; sorry, Chase.)

Instead, we played serious sports. Athletics were a big part of the school's culture and we were competing with schools that had a thousand students, so South Kent actively recruited athletes. Basketball star Dorell Wright was drafted to the pros right out of South Kent. He and I didn't go to school together, but we keep in touch because we're probably South Kent's most well-known recent alumni. Anthony Rice—Ray Rice's cousin—was my running back in high school. Anthony was better than Ray, though his career didn't go as well. I'll forever be an Anthony Rice fan.

Unlike in public school, I learned a lot at South Kent because they found interesting ways to teach us. I quickly figured out that I wasn't going to be the kind of kid who got straight As. That kid was a drone. The cool thing about South Kent was that they realized there wasn't one archetypal student. We memorized Chaucer, but didn't do spelling tests. Instead, we read books like *October Sky* and built rockets. Like most prep schools, ours had a dress code, but within the blazer, khaki pants, tie, and button-down shirt parameters, we could rock it. They encouraged our individuality in a way that I'd never experienced in a school before. They let me be me as much as they could. It was a hell of an educational experience.

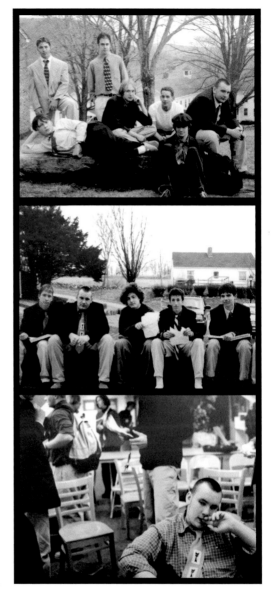

But even though I was happy there, I did manage to get kicked out *twice*. SMH. The first time I was expelled, it was for huffing Glade (don't ask) and stealing a radio from the gym. This was one of the few times my father went to bat for me. He came up to Connecticut and yelled at the headmaster, pointing out that the radio had only moved from one part of campus to another, so it wasn't technically theft. I don't think he had much of a defense for the air freshener, but his argument convinced the school to give me another chance.

As a condition of my return, they made me attend this thing called SUWS (pronounced like Dr. Seuss) of the Carolinas. The website describes it as "a supportive outdoor environment free from the stresses and distractions of everyday life," but I felt like it was more of a way to torture kids into behaving, breaking them mentally as well as physically. In the woods. With very little food.

Even though I was in OK shape, hiking through the woods anywhere from ten to as many as twenty-four miles a day sucked, and then at night they'd take away our boots and pants so we couldn't make a run for it. Not that anyone had the energy for escape. The food was disgusting—all rice, lentils, or noodles with beef bouillon, everything cooked over your own handmade fire. Oh, and peanut butter for days. We'd eat as much as we could stand because we were hiking with eight full canteens of water every day.

Because I wanted to go back to South Kent, I went to SUWS grudgingly, but willingly. A lot of the other kids there, though, had either been tricked into going by their parents, or basically kidnapped by hired goons from "teen escort firms." The truly fucked part was that it was either a twenty-eight-day program or a sixty-day program, and they didn't tell you which one you were doing, so you never knew when you'd be able to leave. But I played their game, manipulated it as hard as I could, and got out in twenty-eight days.

For a while afterward, I did great at school. I knew it was time to shape up, because I didn't want to be a bum. And even though they weren't around to supervise—not that they supervised when they were actually around—my parents did want me to do well in school, so I worked out a bargain with them: **if I made the honor roll, they'd let me get a tattoo.**

I'd wanted a tattoo since I was twelve—ever since I saw my cousin Ed get tattooed by Shane O'Neill—but even the grungiest shop isn't going to tattoo a teenager without parental permission, so I put it out of my head until this bargaining chip turned up.

When, much to all our surprise, I kept my end of the bargain, they did, too. I was fifteen when my mom drove me to Tattoos by RC, in Folsom, Pennsylvania. We went there because they had tattooed the devil that lived on my mother's hip and she vaguely trusted them. She signed what amounted to a permission slip and I got the cheesiest version of the Superman logo you have ever seen. The tattoo artist did a fine job; my dad and I had just done a horrible job "personalizing" the design. I still remember that it cost $180, and I thought I was cool as shit when I went back to South Kent with that thing on my arm.

Now, when I'm reminded of it, I die a little inside. It's so bad. Just so, so bad . . . I don't even want to look at it long enough to cover it up.

When tenth grade rolled around, I started hanging out with a kid named Josh (my roommate), who turned me on to a lot of rap music. Like me, Josh was a troublemaker, only his troubles were bigger than huffing air freshener or "borrowing" a radio.

Josh intercepted a kilo of hash that had been mailed to another kid. Somehow the cops got wind of this, and throughout the investigation, Josh maintained that the hash was stolen from him right after he swiped it. Then the DEA came knocking. They never found the drugs or any evidence that Josh, me, or the other kid had anything to do with it, so they eventually dropped it. The bad news for me was that I was already on the school's radar for drug use—and not just for the Glade thing. The year before we'd had an assignment to write about the craziest thing we'd ever done. I wrote about all the drugs I'd taken, the petty crimes I'd committed, and girls I'd had sex with when I was twelve and thirteen years old. I don't know what they were expecting us to write about, but after I turned that in, the headmaster asked me to come see him for a talk. He'd read the essay and was worried that I might be a drug addict.

As a result of that talk, I spent tenth grade attending mandatory weekly AA meetings. It was so stupid, because I wasn't an addict. But every week I went off to my meeting, where I could smoke cigarettes, drink coffee, eat cookies, and listen to *real* fuck-ups talk about their problems—not to say that everyone there was a fuck-up. When the DEA came a year later, needless to say, I was suspect number one.

By eleventh grade, I was gearing up for college, doing applications and getting my portfolio together because I had decided I was going to go to art school. I had always loved cartoons and Disney art—typical kid—so I decided to learn how to be a graphic designer because that was the only paying art job I'd ever heard of. When I told my counselor that that was the plan, the administration let me cut some of my academic classes and just work in the art room, which was so cool of them. But despite having such a sweet deal, I got complacent and cheated on a Spanish test. Not only that, but I was blatant about it.

This was what finally got me kicked me out of South Kent for good. So many kids did worse things and were barely punished, but I was expelled. At first I was angry that they made me leave, but now I'm able to recognize that just being there for a couple years was really good for me. If I'd stayed in Delaware that whole time, I wouldn't have had the

discipline to make honor roll. I probably would've started selling drugs and wound up in prison or dead.

Even though I didn't graduate, South Kent recently offered me an honorary diploma. Now, I know it's partly because they want my money (they've been sending me alumni donation requests for years, and I finally reminded them I wasn't a graduate), but I do feel vindicated in getting my diploma without ever finishing school. Revisiting the campus to get my diploma was such a fun day.

I showed up and recognized a lot of the teachers and administrators from my time. The headmaster was the same one who expelled me—I always liked that guy, despite the whole expulsion thing (both of them). I got a tour of the grounds, and that night they asked me to speak to the entire student body.

I feel like I'm probably more relatable than a lot of the alumni they bring in to talk to the kids, and with me, they're able to see a relatively quick, nontraditional timeline of success. I'm not a fifty-year-old finance guy in a suit; I could be their older brother, *and* I'm friends with all their heroes.

I tried to encourage them in a way I wish I'd been encouraged when I was young. I explained how important it is to grab opportunities that you're offered. Instead of being insulted when someone asks you to clean a floor, look at it as an opportunity. Seriously, a traditional sushi chef in training could clean floors for years before he's allowed to cook the rice. Then he'll cook rice for years before he's allowed to cut fish. The only way people will give you more opportunities is if you excel at the one they tasked you with first. You have to earn your place in the world, so do it.

Hearing the kids say that I'd inspired them was really special. And after all these years, I finally got my diploma. It was the first time they'd ever given a diploma to someone they'd expelled. Class of 2004, dated April 2015.

I started twelfth grade back in Mount Pleasant, Delaware, which everyone called Mount Pregnant . . . It was such a joke. Suddenly I'm stuck doing vocabulary tests and prepping for the SAT, when I hadn't done a spelling test in years. Here's this eighty-year-old teacher reading out of a twenty-year-old book and nobody's listening to a word she's saying anyway because they're all bored out of their skulls. Unlike South Kent, where they viewed every kid as an individual, at Mount Pleasant we were all just cogs in a dysfunctional machine.

But while I was academically a bust, socially I did great. I was always the popular kid in school and concentrated on smoking weed, writing rhymes, recording music, and making

This is to certify that

Keith Scott McCurdy

having satisfactorily completed the
course of study is now a graduate of

South Kent School

Keith, your life thus far is one of the great illustrations of the Hero's Journey. You were never content to follow in the footsteps of others, but, instead, fought to find your own path--one that made more sense to your higher self. As a young boy, this trait made fitting into conventional structures, with conventional expectations, extremely difficult for you. You rebelled, often. Now, as a young man of considerable fame and success, your life is a living testament to what can happen when one believes in Self and follows his heart.

Here on the Hillside, you made many friends and touched many hearts. Despite your "unusual" disciplinary record, we all knew you had a kind and gentle soul and we loved you for it. Something of South Kent touched your heart as well. That is why you never let it leave your thoughts--even after all these years.

Today, it gives me great pleasure to hand you, finally, your South Kent diploma and to welcome you officially into the Class of 2004.

Congratulations, Servant Well Done!

April 3, 2015
Date

Andrew J. Vadnais
Head of School

as much money as I could busing tables at Red Lobster. Ha!

At about the halfway point of my senior year, I decided I wasn't going to graduate. There was just no way it was going to happen academically and I wasn't prepared to stay back and repeat another year. My mom wasn't about to tell me what to do—she was asleep every day until well after I got home from school. And my dad was nowhere to be found, so he had nothing to say about it, either.

Everybody in school liked the music I was making, and I was thinking about making music my career. But then I had a better idea: I was still obsessed by tattoos, so maybe I could give that a try. Since my cousin Chris had always admired my fake Burberry jacket,

I offered to sell it to him for $250. I knew the chances of becoming the next Eminem were slim (get it), and academics obviously weren't working out for me, so with that money, I bought a tattoo kit COD from Joe Kaplan Tattoo Supply.

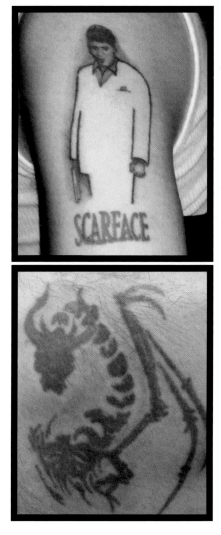

From the second I unwrapped that package, I was addicted. I started off tattooing myself, moved on to friends and family, and just never stopped working. I became obsessive about tattooing the way I'd never been about schoolwork.

The very first thing I tattooed was a Japanese kanji on myself. I etched the English translation underneath it: "demon" (stupid).

After that I moved on to other people and made a tribal dragon on my cousin Chris. Incredibly, it's still there and still looks like a tattoo. Ed and Chris have all my first tattoos. The first three days that I tattooed, I did about forty hours of work on the three of us in my mom's kitchen. The Scarface on Ed is the second tattoo I made.

This was winter 2004. I would just sit at the kitchen table for hours, tattooing friends, relatives—anyone who would let me. Looking back, I was kind of stupid— I was lax about sterilization, and I'd take my machine

and inks to friends' houses and do tattoo parties. Anywhere and anytime I could work, I did.

The only picture I have of myself tattooing back then was taken when I was tattooing my former boarding school roommate Jay in his living room. Now, Jay's house wasn't like my mom's or any of my friends'—it was big, nice, and super clean, only forty minutes from Wilmington, but it may as well have been in another world. As we got close to Jay's house, I realized I had forgotten to pack gloves. But we'd come so far, I didn't want to go back to get them. (Or find a drugstore nearby and buy them for a dollar.) Because I was self-taught, I didn't have anyone telling me that I was being an idiot. I used to pour ink back in the bottles when I was done with it. That's some nasty-ass shit. I would save needles and reuse them on the same people. So wrong. **That's why you don't teach yourself how to tattoo.**

And seriously, shame on me. I'm so appalled by this past behavior that I now make it a point to use my platform to be vocal about hygiene so other aspiring artists don't make the same mistakes I did.

Luckily, all my amateur tattooing paid off quickly, because by Mother's Day 2005, I had my first real job as a tattoo artist, at a place called Rage of the Needle. Located right beside a trailer park in Delaware, it was exactly as gross as you might imagine. Most people start off apprenticing—answering phones, making appointments, and cleaning up "real" artists' stations for free—but I was going straight to my own station and would be getting paid to do something I loved.

Meanwhile, I had saved money when I was living at my mom's and bought a car that I never drove, because it was a stick and I never learned how to drive manual. So I sold that and used the proceeds to rent an apartment in Wilmington for Ed, Chris, and myself.

My apartment in Brooklyn is nice, but damn, New York is expensive. When I think about the amount of space we had back then for just $625 a month—two floors, three bedrooms, huge living room, kitchen—it was just *so cheap*. But then, we *were* in Delaware.

Anyway, as soon as Pat McCutcheon offered me the job at Rage of the Needle, I quit busing tables at Red Lobster. **I was eighteen and I was going to be a full-time tattoo artist.**

THREE

+

BECOMING BANG BANG

Just having a job I loved wasn't enough; I felt like I needed to make a commitment. I decided to make sure that tattooing would be my *career*, and to my eighteen-year-old brain that meant going all the way. So I asked Chris Sweetman at Explosive Tattoo in New Castle, Delaware, to tattoo a gun on either side of my neck.

Don't ask me why I picked guns—to this day, I'm not sure I know the answer. But that tattoo signified my promise to myself, because who but a tattoo shop is going to hire a high school dropout with two pistols on his neck? Maybe the post office? More likely I would've wound up selling drugs and getting arrested, because it's not easy to blend in when you have guns tattooed on your neck—especially ten years ago.

Incredibly, neither my parents nor my friends said anything negative about the tattoos. (To my face, at least.) But I mean, what can you say? Of course it was a stupid thing to do! It's a huge mistake to make that kind of commitment at eighteen, six months into a career that you taught yourself in your mom's kitchen in Delaware.

Not a good look. But did I mention that the tattoo shop I worked at was also just outside a trailer park? Yeah.

The art, plus the lettering reading "Bang Bang," took Chris about seven hours, spread

out over two visits. I'm sure it hurt, but I don't remember and I didn't care—I was going to be a tattoo artist. I was going to be a *great* tattoo artist.

But I was still Keith McCurdy.

The name Bang Bang started as a joke. The piercer at Rage of the Needle was a young girl named Rachel. She and I were the youngest by decades, and we would just avoid the old guys to talk and flirt all the time. So when I came in with the neckpiece, she laughed and said, "Hey, *BANG BANG!*" in this fake sexy voice. Pretty soon everyone in the shop was calling me Bang Bang, and even though they were mostly mocking, it was certainly a more memorable name than Keith.

After I made the decision to go all in and get the guns tattooed on my neck, I knew that building a great portfolio had to be my top priority. Since I'd started tattooing, moving to New York had always been a goal, but I knew that the competition there would be a lot stiffer than it was next to a trailer park in Delaware. If I was going to be serious about my career, I had to truly commit myself.

And in that respect, working at Rage of the Needle was amazing. At least at first. I couldn't believe I was getting paid to tattoo. My boss, Pat, and I would talk a lot of shit to each other, and it started to get testier in tone as it became obvious that I was getting better, quickly. The other guys were all in their forties, and I couldn't even legally buy a beer yet. I tried not to get too cocky, but I remember hearing the other guys talking, saying, "This kid's the next Paul Booth." Paul Booth, who runs a shop called Last Rites in New York City, was like a tattooing god to me, so this was the ultimate compliment, as well as the ultimate pressure.

Up until Rage of the Needle, my only "regulars" were Chris and Ed. But then this old Creole biker dude named Cajun started coming to see me. Cajun was huge. He'd been a welder his whole life, so his skin was like pitted leather. Working a needle across his skin was like tattooing the surface of the moon, there were so many craters in it. But Cajun was up for anything and let me do my first realistic tattoos.

There were some months where I would tattoo Cajun just about every day. He was a nice guy, and he provided an amazing learning experience because he just had so many different types of skin—burns from welding, spots from the sun, scars, stretch marks, wrinkles from age. The underside of his forearm was a completely different landscape

from his biceps, which might have been from another person. No matter how much I fucked up—and Cajun was definitely a learning experience—he loved everything I did. I even did my first color tattoo on his wife.

But at the shop, things were getting tense. What was once lighthearted smack talking started to get a little ugly as my ego grew and I stopped taking everyone's shit. One day Pat got tired of my smart-ass attitude and said, "All right, mother-fucker, you think you're better than me? Let's do the same tattoo on two different people at the same time."

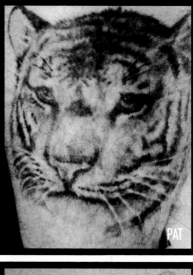

He was so certain that he was going to win that he decided the loser would get the words "Who's your daddy?" tattooed over a little caricature on roller skates with the winner's face where its head would be.

The day of the contest, we decided that we'd each do our version of a tiger.

When we finished, even though we had both drawn tigers, the results were so different stylistically that it was a draw. So we sent the two people who'd been tattooed down the road to Shane O'Neill's shop and let him pick the winner.

Shane—who later went on to win the first season of *Ink Master*—was a Delaware legend. His shop was down Route 40 from ours, and he had done some work on me a couple of years earlier. More on him later. That was my second tattoo;

my mom's friend and coworker Crystal took me in because she knew him from the strip club they danced at. (Sorry, Shane.)

My boss had been tattooing for twenty years and I'd been tattooing for three months. Shane picked my tattoo as the winner. (Sorry I'm not sorry, Pat.)

Pat didn't take losing well *at all* and refused to get the "Who's your daddy?" tattoo. I lost a lot of respect for him over that, because even though it would've killed me, a deal's a deal, and I would've sucked it up and gotten the tattoo.

The loss was humiliating enough, but to compound it by refusing to honor the bet meant Pat had no grounds to talk shit anymore.

As for me, I was so emboldened by the win, I couldn't stop. I decided I was moving to New York, even though I had less than a year of experience under my belt. While I was learning a lot at Rage of the Needle, I needed to add certain elements to my portfolio or nobody would hire me. I mean, who's going to hire a guy who only knows how to do the kind of work that Delaware bikers want?

To keep me driven, I gave myself a July Fourth deadline, so I needed to get a lot done quickly. I would work my ass off during my regular hours and then come in on my days off to tattoo whoever I could. Being on the losing end of the competition meant that Pat was being a bigger dick than usual, and he started giving me a hard time about tattooing nonpaying customers for practice. So back I went back to my kitchen table—this time at the apartment I shared with Ed and Chris. Practice, practice, practice.

Even starting out, I knew that it'd be good to have a specialty. I also knew that I needed to show I was able to do a range of styles or else I might as well get real comfortable at that kitchen table.

Not surprisingly, Pat, who seemed to still be holding a grudge because I beat him, began giving me shit, nonstop. I was at the shop nine hours a day for five days a week, and I would want to practice on my days off. I still needed a few specific pieces for my portfolio before I could feel comfortable showing it to anyone in the City. I wasn't getting anywhere tattooing Tasmanian Devils on drunks, so I quit Rage of the Needle altogether and moved all operations back to my kitchen until I got to a point where I could feel good about my book.

Pat eventually quit tattooing and is apparently still pissed off at me. Because he was a big part of my career, I called to see if he'd take part in this book—I mean, the guy gave me my first break, and I'll always be grateful for that. But when I told him I wanted to include him in the book, he just yelled into the phone, "Fuck you, fuck Justin Bieber, fuck Katy Perry, and fuck Rihanna!"

I guess the lesson is, don't get better than your teacher, or he'll hate your guts. Every time I got better than a teacher, I felt like they started to resent me. I was never disrespectful; I just grew. What am I supposed to do? Stagnate? I would love it if someone I was teaching got better than me. I wouldn't be jealous. You congratulate success, even when it's not your own.

I've heard it said that I walked all over people to get to where I am. I don't feel like I did that, but I definitely walked right around people who weren't moving fast enough.

Truth is, I got where I am by practicing 25/8. If I didn't have paying customers, I tattooed for free. If I needed a certain kind of style for my book, I'd talk someone into getting that style so I could photograph it later. If someone came in with a great idea but not enough money, I'd invest my time in their work for the experience and practice. Ever since I started, nobody has worked harder than me. I have killed myself for tattooing and I continue to do so. I am in constant competition with my own expectations of myself.

I work my ass off because I feel a responsibility for my gift, so I am relentless about it. Every day that I go to work, I try to pack in a day and a half. Sometimes I take a nap in the middle of the day, because I know I could be working till three in the morning. I want to be the best, but I know someone's always getting better. Practice, practice, practice . . . I'm still practicing, and I'll continue to practice until I exceed my own expectations.

But I won't tattoo you for free anymore.

Unless I want you to tattoo me back.

+

KING OF THE SEWER

When I rolled into New York, I moved in with my dad. He lived at Twenty-ninth and Broadway in a studio apartment in the Breslin. It was kind of a dump at the time, but also loaded with interesting characters like opera singers, actors, and weird old people who'd wander the halls.

Since that time, the Ace Hotel has taken over and kicked out most of the longtime tenants, and now a room for the night costs more than most of us paid for a month's rent back then. And "back then" wasn't even that long ago.

I'd never lived with my dad for longer than the occasional weekend before this. He moved out quickly and I took over the place, which was probably ten by twelve feet, with a tiny adjoining bathroom, but it was awesome.

Even though I'd worked on my portfolio and had about a year of tattooing under my belt, I didn't have much confidence. I spent three weeks walking around the city, going into every tattoo shop, showing them my portfolio. Some of them wouldn't look at my book, and a lot of the ones who did assumed because I was so young that I had just filled it with other people's work. My tattoos weren't great, but I was already better than a lot of people who had been tattooing for years.

Absolutely nobody would hire me.

Not at first, anyway.

Even though I'd stopped going by Keith and changed my email address and cards to read Bang Bang, now that I was in New York City, I wasn't confident enough to introduce myself as Bang Bang, so I introduced myself as Keith. And no one wanted to hire Keith.

I was turned down dozens of times until one day I walked into this tiny shop on West Fourth Street and Sixth Avenue called Crazy Fantasy, and they hired me. If you're unfamiliar with lower Manhattan, a decade ago that little stretch of Sixth Avenue, between West Fourth and West Third Streets, housed several different tattoo parlors and a few sex shops as well. A couple of the storefronts did double-duty as both. Most of the tattooists would rotate shops, and so did I. Now it's slightly less seedy, but in 2005, that block was the kind of low-rent, one-stop-shopping mecca that meant you could buy albino midget porn, have your taint pierced, and get back on the C train with your girl's name tattooed on your ass.

Crazy Fantasy was the dirtiest, most disgusting, shittiest, most dilapidated vomitorium on that little strip. Maybe they've cleaned up since, but back then, the autoclave never worked, their employees were more likely to be nodding off than actually tattooing, and our stations were made of wood. It's so unsanitary I can't even think about it. The manager was this Israeli asshole who would rail for hours about how much he hated Arabs. There were four of us working in this tiny spot, and I was "the kid."

And sure enough, people started calling me Bang Bang again. This time I made it stick. It's to the point now where it feels weird to say my name is Keith McCurdy. I feel like I haven't been him since I was in high school, and I often feel like Keith and Bang Bang are two separate people who had two different paths.

To be honest, Bang Bang doesn't have many real problems. Bang Bang is hitting layups. From career choices to talent to getting shit done, Bang Bang knows what he's doing. I'm not cocky, but that side of me is excellent.

But all the personal shit—the real-world shit that's not inking tattoos—the Keith stuff is a mess, and I'm always trying to get Bang Bang to clean it up.

The big difference is that Bang Bang's problems are easily solvable, because they're all business-related. How irresponsible would it be to close the shop to tattoo Justin Bieber and his friends? Can I reschedule appointments to go on tour with Katy Perry? These are amazing problems to have.

Keith's problems are more along the lines of "I need to fill out this paperwork or my

kids won't have health insurance." "Shit, my driver's license is expired." Bang Bang's problems are way more interesting.

The exception is, of course, my kids. The kids get Keith and they love the shit out of me. My daughter Kumi is six and she calls Bang Bang "Daddy's silly name." She thinks the whole thing is hilarious, and she has a point.

Being a dad is my number one job, and it's a difficult balancing act trying to make sure they don't get unhealthy notions about who I am and how I got here. I remember we had a magazine with me on the cover lying around and Kumi asked if I was famous. I told her, "No, baby, I'm not famous. I worked really hard and I'm recognized for the hard work I do." I always want to stress the importance of hard work to her, but it's hard to know how to help her understand some things. I mean, I know how to not do some things my parents did, but I'm not always sure how to explain to Kumi the unique position she's in. It's normal for my daughter to meet Katy Perry, and if I want her to hang out with Rihanna, she does. Kumi doesn't understand that that's not most people's reality, because that's *her* reality.

If we're walking together around SoHo, people will occasionally stop me. So my daughter equates that with being famous. She doesn't understand *why* people know who I am. And I want her to know that working hard is more important than attention, but a lot of times when you work hard, you're recognized for it. It's something I'm still trying to figure out how to explain to her. I think not believing your own hype is the most important thing.

Of course, when I first started at Crazy Fantasy, I might have been Bang Bang, but no one knew who the hell that was. They hired me when nobody else would, and that's where I began gaining confidence. The first couple months or so, I was so

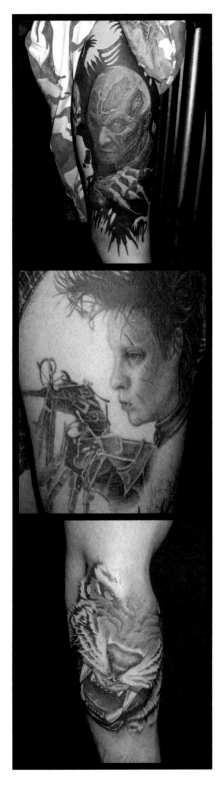

unsure of my work, I would push a lot of jobs off onto other artists. But once I settled into the job, I was booking more than anyone else and looking to move on.

Moving on meant about twenty feet away to a still shitty, but not *as* shitty, spot called Whatever Tattoos. Whatever was managed by a chick named Banger, and you just know that someone named Banger isn't going to give you too much shit.

They let me do what I needed to do, and I quickly became the King of the Sewer. Right away, it was clear that I was the best tattoo artist at any of the shops on this stretch of Sixth Avenue. I got a lot of love from everybody—it was like high school all over again, but I wasn't just passing, I was getting straight As and earning MVPs.

As my work got better and I started to get known, it began to get back to me that I was also widely disliked in the insular tattoo community.

See, the tattoo world is run by (mostly) men, often over forty, who have been recycling the same tired art for the past fifty years. They don't like change and they don't like younger people coming in and disrupting things. I'm not the only up-start who's had to deal with a bunch of grouchy grandpas—if you read Kat Von D's books, she's been up against similar problems and probably had it worse because she's a woman. Respect, girl.

But despite the side eyes from the old guys, a lot of great things happened to me. At Whatever, because I was the best tattooist in the shop—not bragging, just telling the truth—they would put me in the window to lure in new clients. One day I was tattooing someone in the window and when I looked up, I noticed this couple standing outside, watching me intently. After a little while they came in.

They were a couple named Lucy and Richard.

Most people just know about the celebrities I tattoo, and

while Lucy and Richard may not be famous, they're two of my all-time favorite clients. They weren't the first people I tattooed when I moved to New York, but they were certainly my first repeat business. No matter where I was working in my first ten years in the city, these two have moved along with me. I've tattooed them in my house and I've even tattooed their kids once they were legal. More than clients, Lucy and Richard are like the parents I wish I'd had. They're funny, smart, and incredibly loyal. I would do anything for these two, and I'm so proud to have them in my book and in my life.

Because they're completely unlike anyone you'll ever meet, I wanted to give you an idea of what it's like to hang out with two of the most entertaining people in New York City. Here's a conversation from the day we photographed them in the shop, ten years after I started working on them.

LUCY AND RICHARD

BANG BANG: There are so many tattoo artists in this city, how did you find me?

LUCY: We were in the Village and we were going to get a tattoo at the shop next to yours—a guy there had done a tattoo for me, and it was all messed up. And we saw you tattooing in the front window and we said, "Let's go to him!"

RICHARD: You did tattoos on both of us and it was OVER. They were flawless. The koi was my first Bang Bang tattoo and it still looks great. Each one of these is about nine years old.

The samurai fighting on my back is my favorite—you say it's not finished . . .

BB: Nothing's ever finished.

R: You wouldn't let us get any matching tattoos, because you did everything freehand—there weren't any stencils. Even the tribal is all freehand.

L: Anywhere I go, people stop me because they love my tattoos. But it's Mary with the rosary that really stops them and makes them stare.

BB: This is a lineless illustration that was done freehand.

L: Remember what I wanted?! I wanted a girl with her legs open and the diamond would be her pussy. You said, "I'm not putting that on you!"

BB: No, I'm NOT putting that on you!

L: One of my favorites is a puzzle I created and you tattooed. It has all my grandchildren's and godchildren's names on it. I have two more grandchildren you need to put on it.

BB: Remember, I spelled one of their names wrong, but I fixed it!

L: It was Nastasia, and you messed up the "s."

BB: I took white ink and went over it so many times, I almost scarred you with it.

L: You can't even tell. We'd come see you and say, "Bang Bang, we want you to do this!" and we'd show you a picture, and you'd say, "Nah, I'ma do something else."

BB: Yeah, well, sometimes I have better ideas. The thing that's always driven me crazy is that you can't stop singing when I'm tattooing!

L: You're so mean—you tell me I can't sing for shit and to shut up! And I'll put on my earphones . . .

BB: And you still hum!

L: I just like to talk and you don't let me. So I sing and you hate that, too!

R: That's why you get tattooed first.

L: At first I used to come get tattooed sober, and then one day I had a drink first. Now you won't let me come sober anymore, because alcohol makes me quiet.

BB: So many of your tattoos are so different than my style now. You can really see how it's evolved over the years. What are some of your favorites? That is, if Lucy will let you talk . . .

R: I love the Samoan tattoos that you did, but my right leg is covered in military tattoos—my dog tags, "semper fidelis" with a sword handle, and those are really important to me.

L: In the summer when we walk—forget it. I was at Macy's and someone wanted to take pictures of my puzzle. You know how I am about my puzzle—nobody gets pictures of that.

BB: Yeah, I know. How long have you two been together, anyway?

L: On June 1, it'll be twenty years.

R: And we've been with you half of that time.

BB: You're just such an amazing couple. Your arguments are awesome—just witnessing your fights is fun!

L: You don't know the arguments we had coming here.

R: Now I know what to do. I ignore her.

L: And I don't bother arguing because he doesn't give me mouth back. He zones me out.

R: This is the nicest place we've ever seen you at. I remember at Whatever, you were the best one there—

L: You were fixing other people's mistakes—

R: —and tattooing the employees! We followed you wherever you went—from East Side Ink, to Paul Booth, to that basement apartment where I got the initials for "Kick Ass Warrior" on my butt! I used to take a cab there and back, from Manhattan to Bensonhurst.

BB: And that's how I paid my bills. I'd be in my kitchen, working away. You're how I fed my kid.

R: Remember when you were staying in that one room? We even got tattooed in that little room in the hotel on Twenty-ninth Street.

L: That hotel—the bathroom was connected to the room and the room was so small we would sit on throw

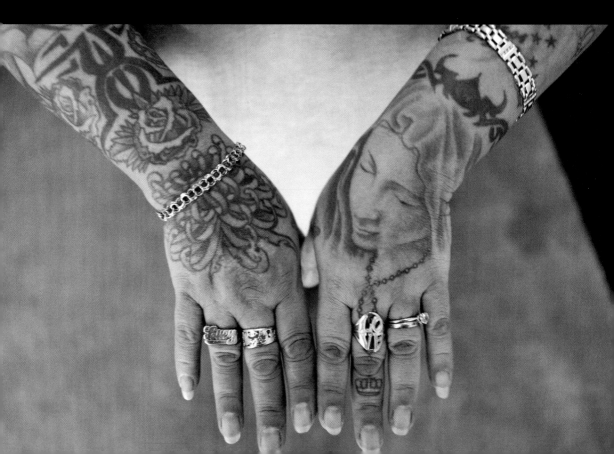

pillows just to get tatted. We couldn't even stretch out, it was so tiny!

BB: Whenever I was broke and needed money, I knew I could call you and see if you wanted to get tattooed. Even if you didn't, you'd still come get work done. You guys have been so nice to me. You bought out the entire registry when Kumi was born, then you asked for the other one and we had to say no, so other people could buy her things! I love you guys.

R: We consider you family, and you do for your family. If you ever needed anything, we'd say, "Let's go get a tattoo," even if we'd just gotten one.

L: You're like my son . . . even though you won't talk to me on the phone and make me text you instead.

BB: Wherever I worked, you always tipped me a hundred dollars. And now that I own a store I wouldn't charge you, but you still tip me!

L: Because that was time that you put in—you have to appreciate good work!

BB: What are we doing next for you, Richard?

R: You're going to do more work on my back, and then that's it, I'm finished. No hands, head, or neck for me.

BB: What about you, Lucy? A little something?

L: You don't know how to do little!

BB: How many times do you have Richard's name or initials tattooed on you?

L: I have a bunch of Richards . . . I'm not sure how many.

BB: I just remember every tattoo I do, you always want Richard's name or initials in there. I say, "Lucy, you have Richard's name on you in so many places!" And with every tattoo you tell me, "But it's for him." You're a living example that it's not bad luck to get your wife or husband's name tattooed on you. You guys will never break up!

L: That's a lie!

R: We break up all the time, but I don't leave the house. I go to the living room.

L: I stay in my bedroom and then he'll bump into me in the kitchen. And then he'll make me laugh. We can't stay mad at each other.

BB: I want you to tell the story of how you two met.

R: You really want to know? I was sitting in the hospital, and she walked past. I was like, "Damn, she got some nice titties!" And she just stopped right there and said, "Yeah, you wanna see?!" Then she just pulled down her shirt! In public! In the hospital!

L: And let me tell you something . . . the first date we went on, after that, he never left my house.

R: The next day I took her to get her hair done and two weeks later we got married. We didn't know, but we knew.

L: We just took a shot . . .

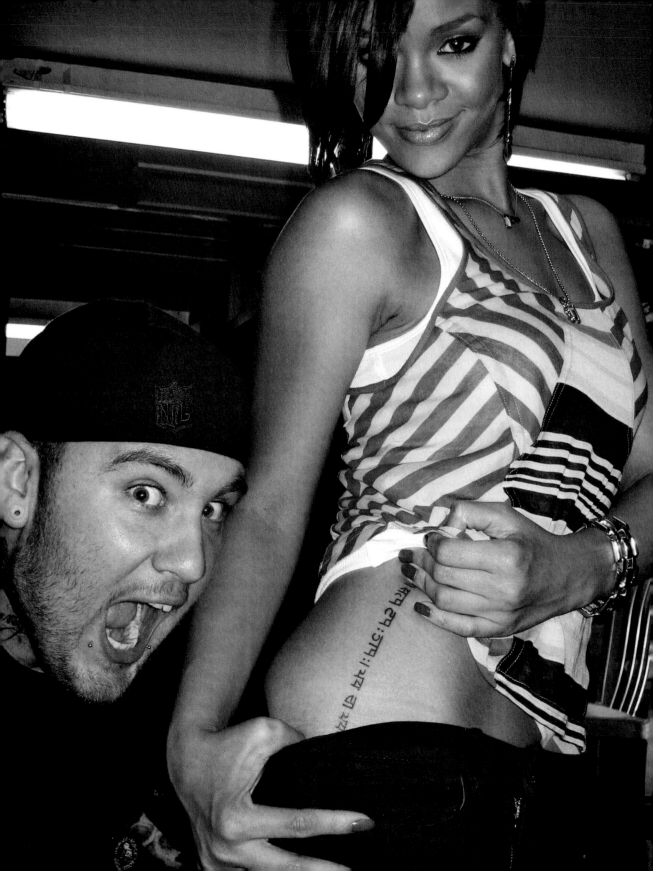

✚

GAME CHANGER

When I wasn't tattooing in the window at Whatever, my setup was down in the store's dingy basement. One day Joe Snake, the store piercer, told me that some singer had come in to get her nipple pierced. **Her name was Rihanna. She had asked him for the name of the best tattooist in the city. Being both a good friend and an excellent liar, Joe told her there was only one guy to talk to: me.**

After he finished piercing her, Joe called Banger over and asked her to show Rihanna the Freddy Krueger I'd done on Banger's thigh. It was my first color portrait, and looking at it today, there are a lot of things I'd do differently, but it's still pretty good. Rihanna was sold, so a couple of days later I met the woman who would change my life.

On the day of our consult, this group of seven beautiful black women comes walking down the stairs. I'm still not sure who they all were, but one was Rihanna and another was her best friend, Melissa Forde.

I had never heard of Rihanna, but then again, back in 2007, most people hadn't. I was nineteen years old and I *thought* she was eighteen—though now she says seventeen,

which means either she lied to the manager or the manager never bothered to ask, because in New York City (and most of the country) you have to be eighteen years old to get tattooed.

Rihanna told me she wanted me to tattoo this necklace made up of Sanskrit writings onto the back of one of her legs. I took the reference and told her I'd draw it up that night. A day or two later, she and Melissa came back, but they weren't alone. Normally I'd never allow this, but a reporter from *Paper* magazine was with her and Rihanna said she wanted to do the interview while she got tattooed.

She originally wanted the Sanskrit to run down the back of her leg, but it didn't work. When we put the stencil on, it did not look sexy. I had some idea of where it would look best, so I asked her to strip down so we could find a better spot for it. She was an excellent sport, so within seconds, there's Rihanna, down to her underwear in this crappy basement on West 4th street, as we moved the stencil all over her body. I finally convinced her to get it on her hip, because the way it was laid out, it fit her shape whether she was standing upright or bending in any direction.

These days Rihanna can take the needle like a champ, but back then she was horrible. I was already nervous with a reporter standing there, but Rihanna was moving, talking, she's getting ticklish . . . Her tattoo came out perfect, so it wasn't impossible, but she sure didn't make it easy. As it turned out, I did more than one of them. Melissa had been getting the same tattoo (they have a bunch of matching ones) by a different artist upstairs, but she stopped him in the middle and came back the next day so I could finish it.

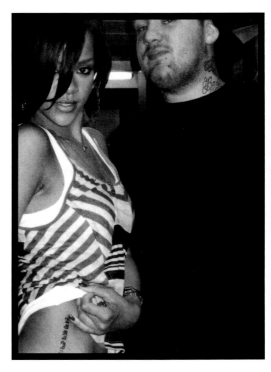

Honestly, I still don't really know what the tattoo means; I just copied it and traced it. I have since

heard that it is wrong, but seriously—I don't know Sanskrit! I can only work with what people give me, and **I tattooed it perfectly and it looks sexy. That's my job.**

When the magazine came out I was excited until I read the story. I mean, I'd never had any press before, so this was a big deal to me. But then I read the piece and the writer described the shop as "completely rundown, and not in a kitschy way. Nothing cute about it." True, it *was* rundown and it *wasn't* cute, but my station was spotless and I worried that having that out there made me look bad. I tried to concentrate on the good part of the story, where the writer mentioned that when Rihanna came in, she gave me a big hug like we were old friends.

I thought being in *Paper* might bring me new business, but that didn't really happen. I was pretty busy already, and there's only so many hours in a day you can work. The best thing to come out of the experience is that ten years later, I'm still tattooing Rihanna and she is a forever friend.

I was a little let down that that first media appearance didn't do anything for my career, but I figured out later that while conventional media *may* help grow your business, word of mouth is still your best advertisement.

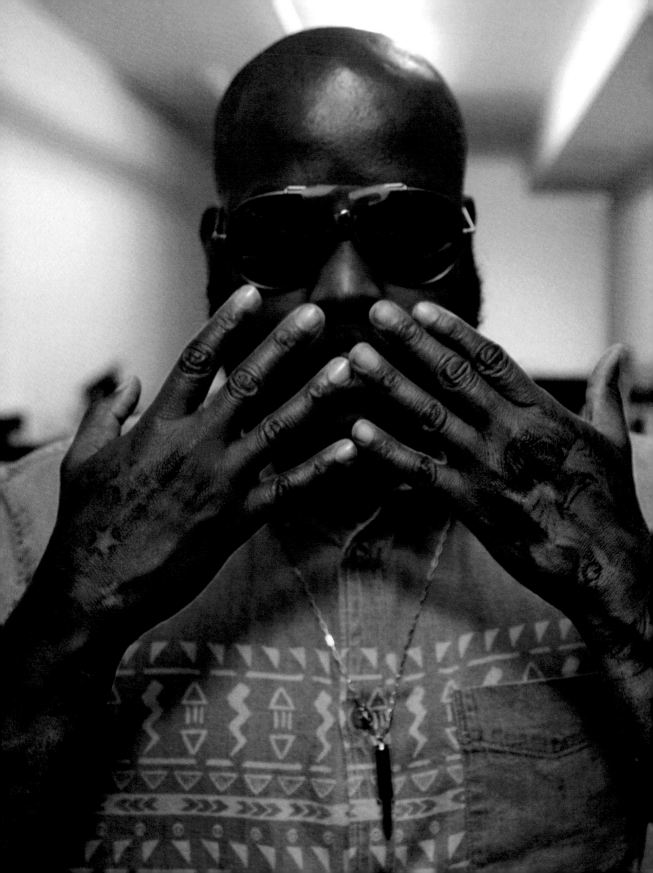

SIX

+

THE CLIENT CHAIN

My schedule at Whatever continued to get intense as my work improved dramatically. I didn't have any more high-profile clients for quite a while, but Lucy and Richard still came in nearly weekly, and I was always booked. Between clients, me and some of the guys from the surrounding shops would stand outside, smoking weed and playing hacky sack. I didn't have a lot of responsibilities. I was starting to get complacent, and that was not a good place for me to be.

One day this guy about my age walked in, wanting some stars tattooed on his hand. His name was Yusef and he was a celebrity hairstylist to clients like Oprah and Tyra Banks. In a weird coincidence, he later went on to be Rihanna's hairstylist, but I don't think they even knew each other back then. Small world.

I thought about what Yusef said he wanted, looked at his hand and arm, and then suggested we do it differently. I've been like that since I started tattooing—I crush people's dreams and then give them a new one. People who aren't artists may have an idea of what they want, but most of them don't know much about *designing* a tattoo—where it should go, how it should look, how it will and won't work with their skin tone and body shape. I don't want to just *do* tattoos—I'm not a tattoo *doer*. I want to *create* tattoos, I want to

figure out tattoos, I want to sculpt tattoos, I want to fuck up tattoos—but by no means do I just want to *do* tattoos.

Yusef may have been a little surprised at first that I didn't just sit down and do what he told me, but I think he was happy that I was giving it so much thought. Instead of just inking in a constellation, I used negative space to form the shapes. He loved it so much, we wound up doing most of his arm.

It turned out that Yusef wasn't just working for Oprah and Tyra—Yusef also wound up working on Swizz Beatz's ex-wife, Mashonda. Mashonda was a singer with some bad tattoos on her hand, so I fixed that right up. And when Swizz started talking about wanting a tattoo, Mashonda sent him my way.

Now maybe I didn't know who Rihanna was back then, but Swizz Beatz's music had been a huge part of my life for years. I remember being a kid and having this mix tape—I'd spend hours switching my tape deck over and listening to DMX and early Jay-Z. Early on, Swizzy hid behind his sounds; he wasn't out front, he was a producer. He made beats, he made music . . . he was the mastermind behind the songs. Everything I listened to and loved was produced by Swizz Beats. So in my mind—and many others'—he was *huge*.

I don't usually get starstruck, but meeting Swizzy . . . I kept thinking, "It's me, bitches!"

Whatever wasn't that comfortable for an extended visit, so we wound up doing a lot of it in his apartment, which, by then, he was sharing with Alicia Keys. We spent a lot of time together, so I felt like I really got to know him. I always ask successful people questions. I told him about an argument me and another guy were always having—Kanye versus Swizz Beats. Obviously, I was the big Swizzy fan. So I asked Swizzy what he would say if someone picked Kanye over him. He answered, "I would say I produced records that sold over 150 million copies. Not that Kanye isn't talented . . ."

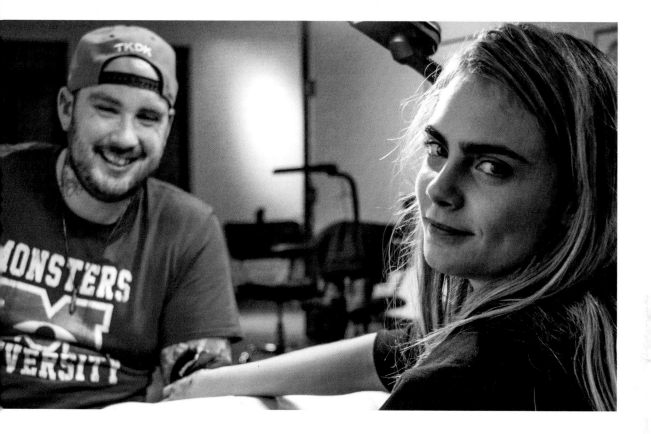

And that's really how the whole celebrity tattoo artist thing snowballed—my man Joe Snake told Rihanna she should come see me, and she in turn led me to Katy Perry and Cara Delevingne and dozens of others, while Yusef hooked me up with Swizz Beatz, who led me to Thierry Henry and a bunch of Knicks. Word of mouth makes the world go 'round. And when you broadcast that word of mouth through press *and* social media, it can make your world *explode*.

PART II

STRIVING
FOR GREAT

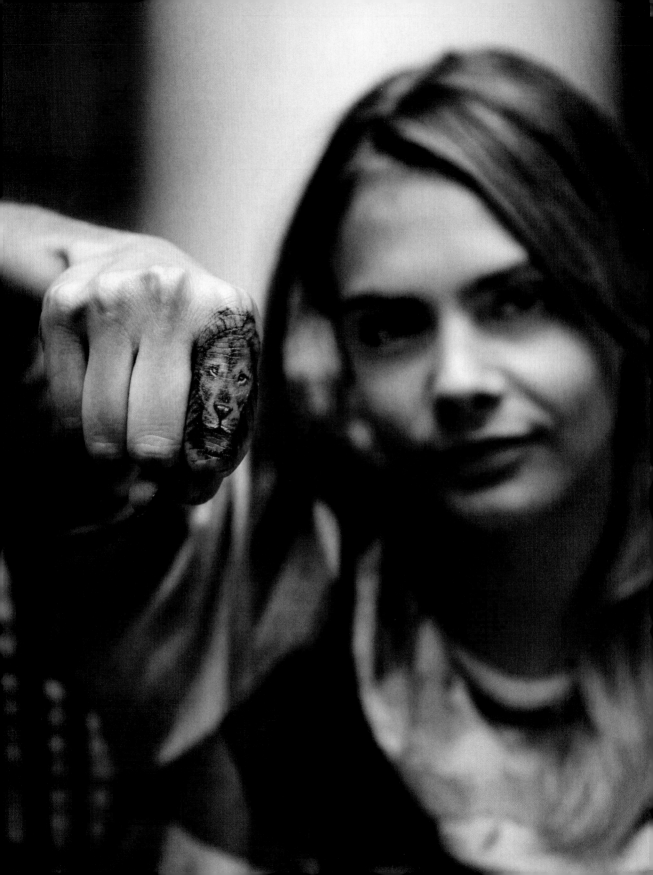

SEVEN

+

MYSPACE, FACEBOOK, INSTAGRAM—BANG!

Since that brief appearance in *Paper,* I've been in *People, Rolling Stone, New York, Vogue, Glamour,* and *Cosmopolitan,* and have appeared on MTV, VH1, CNN, and E!, among hundreds of others. What I've learned from all that exposure is that mainstream media attention is great, as long as you can keep some sort of control over it.

I didn't really understand this at first, but I learned quickly. If a media outlet contacted me, wanting to use my photos, I would put conditions on it—they'd need to hyperlink to my site, and they'd need to credit me appropriately.

The world of tattooing is very insular—it's like a small cookie jar with thousands of hands jammed in looking for the same thing. I didn't want to exist in that world. I wanted a *big* cookie jar (mainstream media). I'm not unique. Plenty of people tattoo celebrities, but how many tattoo artists can the average person name?

This isn't because I wanted to be some sort of press whore—I want people to hear my name so they'll see my work and remember it. Using the media was one of the most

efficient ways for me to get my name out early in my career. I don't get paid to do interviews or wake up early to go film something. I do those things to build my business and brand. And that all banks on me being the best at what I do.

Because the way people decide on a tattoo artist today is the same way they decided a hundred years ago and the way they'll decide a hundred years from now: word of mouth. And press is just another (albeit more far-reaching) kind of word of mouth. But as great as the mainstream media has been for my business, the thing that kicked it into high gear was social media.

Social media changed the way people communicate. What an influential blogger in London says reaches Istanbul, Brooklyn, and Nova Scotia simultaneously. It used to be that my cousin would show you the super-cool (not really) cluster of eyeballs he got inked on his calf and, suitably impressed, you'd go to the same shop once you decided to get your girlfriend's name tattooed across your throat.

Likewise, when high-profile people talk you up, other celebs are more likely to listen. But while I have a large celebrity client base, most of my customers are everyday people. How do *they* hear about me? A young aspiring fashion publicist isn't going to pick up a copy of *Tattoo Magazine,* but she probably does follow Cara Delevingne on social media. Which is why, more than any other outlet, I rely on Twitter, Facebook, and—most important for my line of work—Instagram, to share my work with the world.

When I first met Rihanna, I had a Myspace page. In 2014, I got a little more serious about Facebook and Twitter, but not overly so. As I was writing this book, we had about forty-five thousand "likes," and that's great, but the medium that put my business over the top was Instagram.

From the start, Instagram was a different story—it's the perfect social media platform for artists. You don't need to write clever captions or spend a lot of time going through your feed. You take a picture, post it, and there it is, for all your followers to see. **It's an immediate, easily accessible portfolio that proves not only quality, but consistency.**

I was a little late to the game, but once I started, I quickly got a few thousand followers. I post all our artists'

work on the @BangBangNYC account, so we began to gain followers steadily. Slowly, at first. But then someone like La La Anthony posts a photo of the two of you hanging out and suddenly you have thousands more followers and the front desk at the studio can't keep up with the requests rolling in.

Because believe me, someone like La La or Rihanna or Justin Bieber is showing your work to a lot more people than my cousins ever managed to. Hundreds of millions more. And these fans are so devoted, they'll not only buy tickets to their shows and download their music, they'll also buy the same clothes and get tattooed in the same shop.

Our most incredible growth spurt happened the night Rihanna and her supermodel friend Cara Delevingne Instagrammed the infamous lion I did on Cara.

My phone rang one night . . .

Rihanna asked if I'd come to her room at the Gansevoort Hotel to tattoo.

I said yes immediately, assuming I'd be tattooing *her*.

Over the years I've tattooed Ri in the Dominican Republic, Los Angeles, assorted hotel rooms—anywhere, anytime she asks. So cabbing over to my old neighborhood was nothing.

When I got to her room (Room 420!) she was with a blond girl I didn't recognize. All I knew was that she was a friend of Ri's, and really, that's all I needed to know. Her name

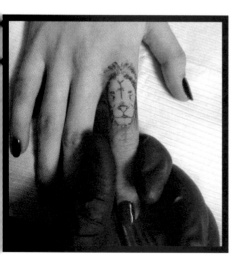

was Cara, and she told me she wanted the word "Lion" spelled out down her index finger. I looked at her, and at her finger, and asked her why.

When a client tells me what they want and that image doesn't immediately pop into my head, I need to know why, so I can better understand their motivations and how it might work. Cara told me that she was a Leo, so she'd always wanted something related to a lion.

I showed her the hanya on my finger and told her we should do something more like that . . . something that would look like a beautiful piece of jewelry.

She looked at me and said, **"I trust you."**

I got to work. **Tattooing a finger—especially a supermodel finger—isn't easy.**

Your canvas is tiny and wrapped tightly around small bones. Yeah, it's that hard. No pressure. But we did it and she loved it.

I didn't overthink the lion any more or less than any other work I've done, but I don't think I'm exaggerating when I say that lion tattoo turned out to be the most iconic tattoo in the world. I've seen it in ads, on magazine covers . . . it's incredible how many people know this tattoo. This girl is everything.

But as I left their room that morning—the sun had long come up by the time we were done—I still had no idea how famous Cara was. It had come out during the night that she was a model, but in New York City, half the beautiful women you meet are models. Over the next few days her fame started to sink in. Early that same week I'd had about twelve thousand Instagram followers, but by the end of it, that lion had been "re-grammed" so many times, I had several hundred thousand. And, unlike the people who may have skimmed across my name in a magazine, Cara's and Ri's followers were *fans*. They wanted what their girls had, and our inquires shot into the stratosphere, where they thankfully remain.

THE MOST IMPORTANT THING TO REMEMBER WHEN YOU'RE WORKING ON A BEAUTIFUL WOMAN IS TO MAKE SURE THAT YOUR WORK COMPLEMENTS HER BEAUTY, RATHER THAN OVERWHELMING IT.

EIGHT

+

TATTOOING 101

Obviously there are many peaks and valleys along the road that leads from tattooing bikers outside a trailer park to inking supermodels in hotel rooms that cost more for a night than a month's rent did back in Delaware.

During those months that I was practicing constantly at my mom's kitchen table, then at Rage of the Needle, I worked with as many different styles as I could—no matter what I faced in New York, I wanted to be ready. And, for the most part, I was. At Crazy Fantasy and Whatever, there wasn't anything I encountered that I couldn't do. More important, though, was that I was able to get a better sense of what I excelled at.

Over the years, I've refined both what I'm good at and what I enjoy doing. Like most artists, I've also developed a style of my own. There are many things I excel at and many things I don't. Some I love and some I loathe. Here's a **brief** overview of the styles I've worked in over the course of my career.

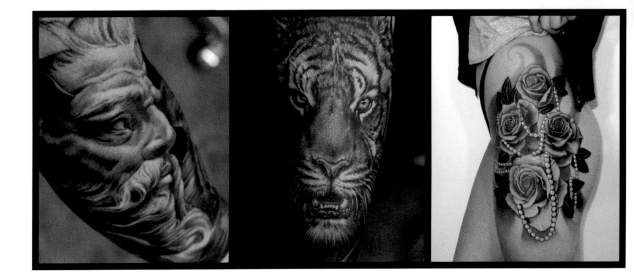

BLACK-AND-GRAY REALISM

Black and the many shades of gray are something I excel at and am known for. It's not easy to make a realistic tattoo, but my black-and-gray realism pieces are some of my favorites.

I love this style because gray feels timeless. It feels like I'm changing tones *within* the skin, not rendering a painting that lies on top. I'm sculpting shapes and making illusions— moving my hand and mind quickly creates motion. The delicate nature of the technique is really freeing, because I get more passes over someone's skin in black-and-gray than I would be able to in color. Black-and-gray is much less traumatic to the skin.

Technique-wise, when I do color realism, it's like scrubbing a floor. It requires more pressure and repetitive pushing of the needles into the skin, with the goal of adding as much ink as possible with the fewest passes on each area of skin. Black-and-gray requires more subtlety—solid black application is similar to color (scrubbing), while grays are more delicate, like sweeping. To shade, I brush the needles across the skin—back and forth, back and forth. It's much looser and you're able to convey much more movement in the work.

The ability to apply different saturations of black perfectly and alter your hand pressure can add incredible depth and movement. Changing one of the variables can make all the difference. Forcing the eye to focus on the foreground while relegating the background to the distance, and maintaining flow, movement, balance, unique design, contrast, and delicacy. **It's a challenge. But I like that shit.**

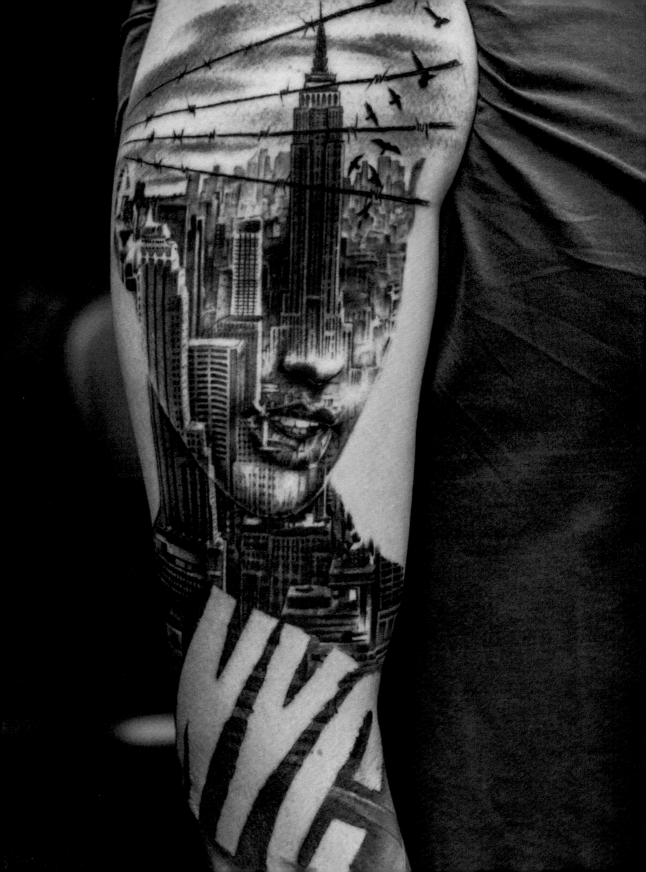

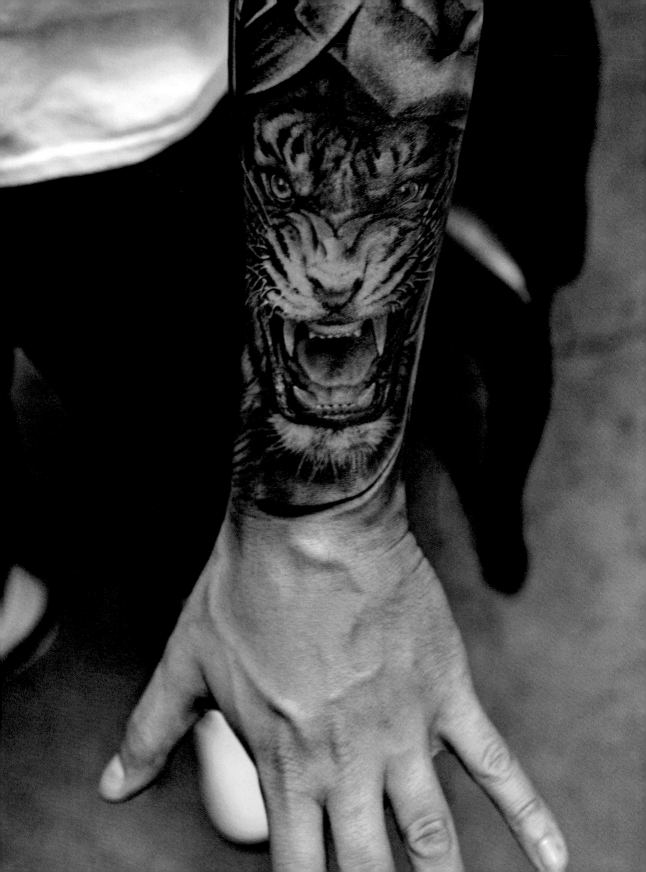

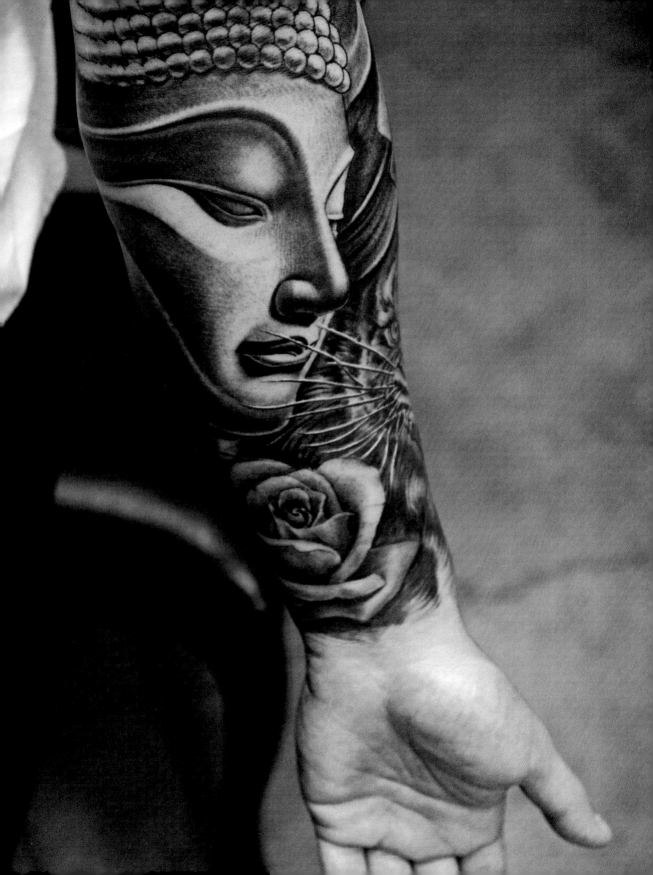

COLOR REALISM

Color realism tattoos are real crowd-pleasers. They're bright, bold, and beautiful, yet I rarely do them anymore.

Like many artists, I've done a bunch of them, but I far prefer working in black-and-grays. Color pieces are very complicated undertakings. You can't just tattoo like you're scribbling in a coloring book—the entire spectrum of colors you're using has to be gradated and carefully blended. And because of the pressure needed to get as much pigment in the skin as possible, you only get so many passes at that area before you scar it. It's much harder on the body than black-and-gray. You also need to know how colors are going to heal. How colors work with a client's skin tone, how much sun they get, how old they are—this all comes into play.

Because I don't use blank skin as a tone in color realism, the skin in one of these tattoos winds up completely saturated in ink. In black-and-gray realism, the skin may be 80 percent covered, sometimes less. In color, it's mostly 100 percent coverage.

When I worked a lot in color, I used to lose the delicacy I got with black-and-gray. And there are just so many variables—machine speed, spring length, coil wraps, needle groupings, the pigments you're using, hand pressure, hand speed, and at least a dozen others. They also take so much longer to do that they wind up being really expensive. Color also doesn't age as gracefully or consistently as black-and-gray, because the hues change with time. It's interesting to see how color realism ages, but it may not be "interesting" in the way that a client wants.

There aren't that many people who do color realism well, so I admire those who do it on a day-to-day basis. The bottom line is that after doing a bunch of them, I realized that color realism isn't something I'm passionate about. I only choose to make about one a year.

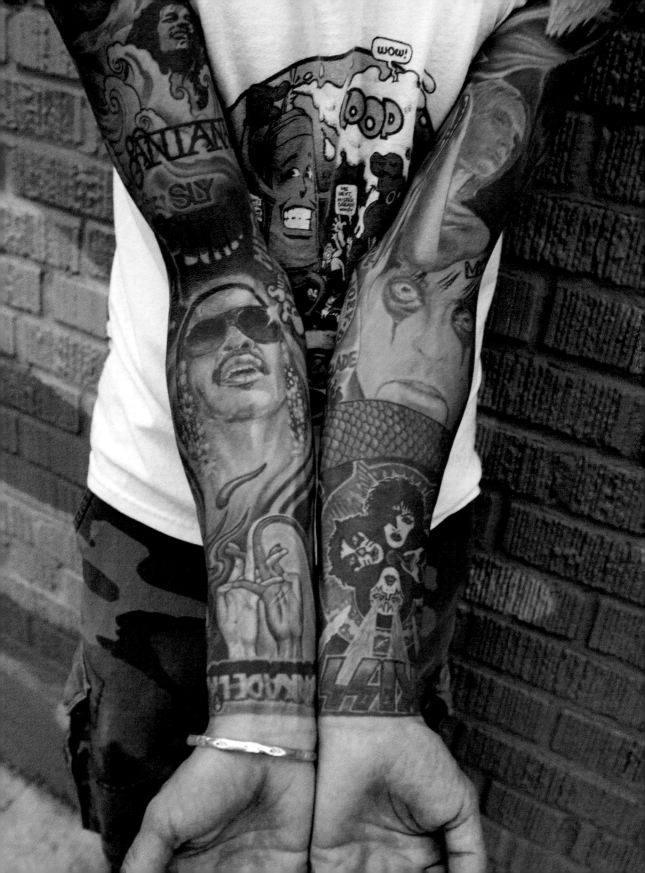

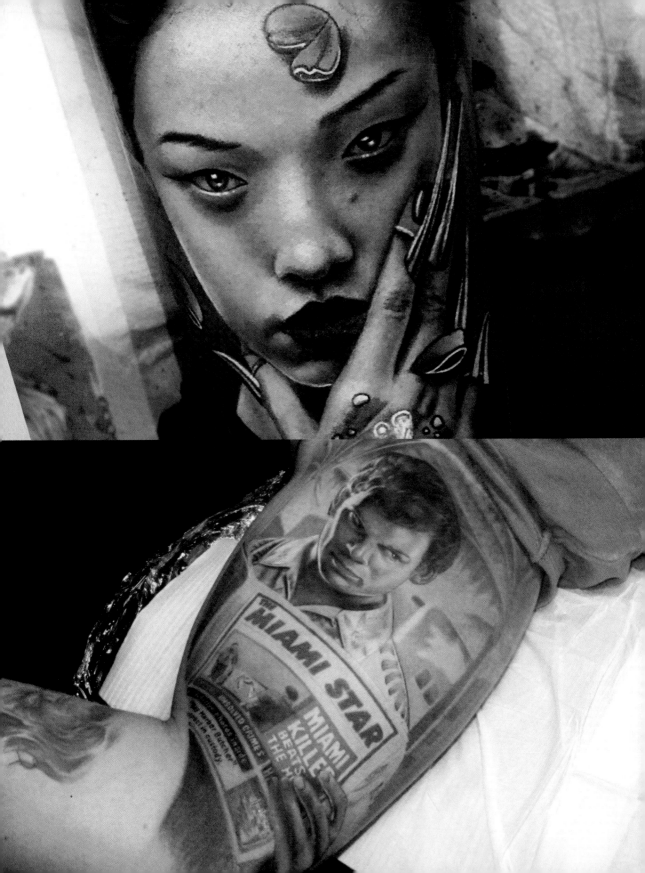

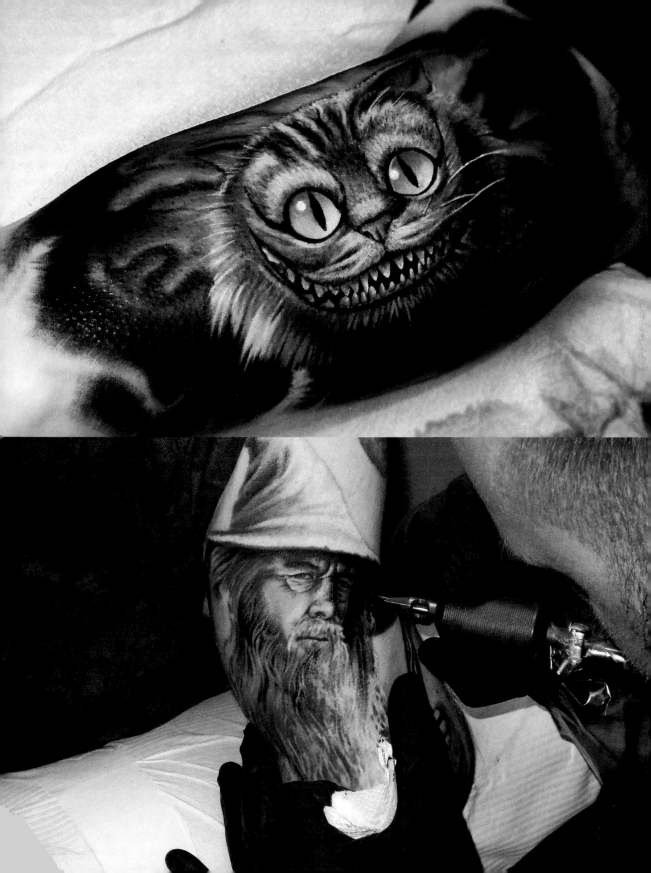

SMALL TATTOOS

As tattooing has reached the masses and become more accessible, far more people want to be tattooed. Sometimes they're a little nervous and intimidated by the thought of something big. I find that women especially are more likely to start off small, and since my clientele is about 70 percent female, my shop does a *lot* of small tattoos.

It's funny: throughout my career, I've heard a lot of complaining about these little jobs from more traditional artists and new-school purists who swear that if it's not a skull or an awkwardly floating color portrait, it's lame. I never felt like I was above any tattoo. If I can do it well, I'd love to do it. Often people apologize when they ask me to do small, simple jobs, but I'm just grateful they want me to tattoo them.

Besides, it's a real skill to do something that's both artistic and legible, the size of a quarter. For example, Katy Perry has four of my little pieces—a prism, a strawberry, the Super Bowl logo, and a peppermint. Is she less of a client because I've never done a full sleeve on her? No way. **Katy's great. Like, *real great.***

Tattooing Rihanna really made me understand the delicacy needed to tattoo on beautiful women. How do I decorate someone who's already so perfect? Through working on her, I learned that since she has such amazing style, people are going to be influenced by what she does. So I'm going to make delicate, iconic tattoos that complement her natural beauty, not distract from it. And it's true that nearly every day I see a tattoo in a similar placement as Rihanna's: the collarbone, the side of the finger, the ribs . . . the list goes on.

It's not just celebrities who get this level of attention, either. Anyone who's ever been tattooed at my shop will tell you we give them everything we have.

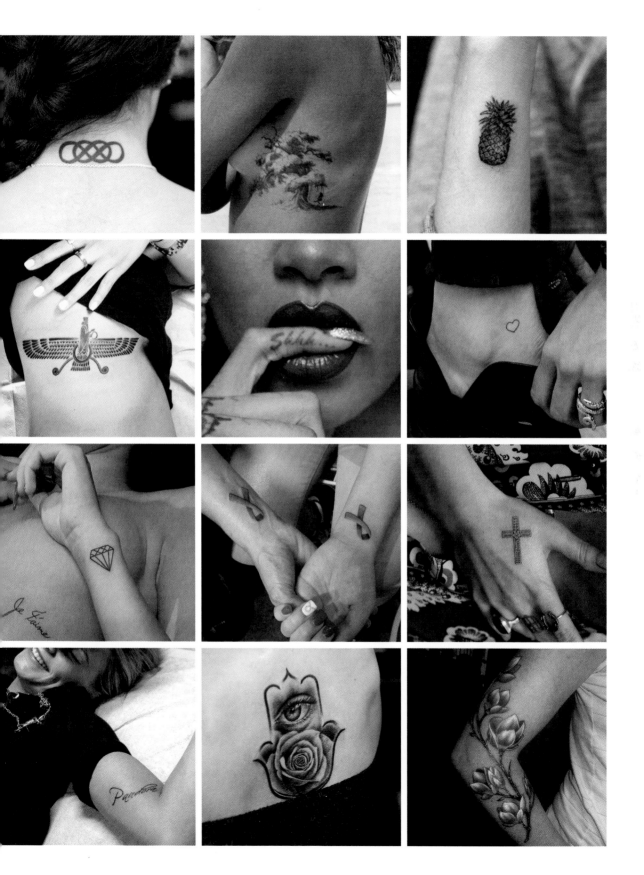

LETTERING

A decade ago when I was learning tattoo, I was told to letter one way: big, fat, wide-open letters, twenty-point Edwardian script, forming angry, screaming words. While they might look okay on an MMA fighter, giant Gothic script can easily overwhelm a woman's body. So I've evolved my lettering style to be sexier and more feminine.

By cutting the ink with water, using tiny needles that barely scratch the surface of the skin, and employing a very light touch, I'm able to make some really beautiful, subtle work. Like with Rihanna's collarbone tattoo—I used the smallest needle I could, and we first compressed and then stretched the text in Photoshop. Legibility isn't always the point—*fashion first*. We wanted the shape of the words to be as delicate and linear as possible, so all you catch at a distance is a line that snakes along with her when she moves her arm. That's a curve people don't usually highlight. We're used to working with hips, ribs, muscle structure, so this one is beautifully unexpected. To further turn lettering on its head, we wrote the phrase "Never a failure, always a lesson" backward, so she can read it when she looks in the mirror.

The hilarious Whitney Cummings also wanted lettering, but she wasn't looking for sub-tlety. She asked me to ink "I love you" on her forearm, but she wanted it upside down. This went against everything I know is good and right about tattooing! I tried to argue her out of it, but she eventually wore me down and the girl got what she wanted.

Of course, when the job calls for it, I'll still do big, bold lettering.

RELIGIOUS

I hesitate to call religious tattooing a "style," because it's just realism with a biblical theme. But they're such a niche that I'm separating them out. I never really gave thought to the impact of religious work until I worked at a studio where it was expressly forbidden, which is just ridiculous. I respect people's beliefs, even if they're not my own.

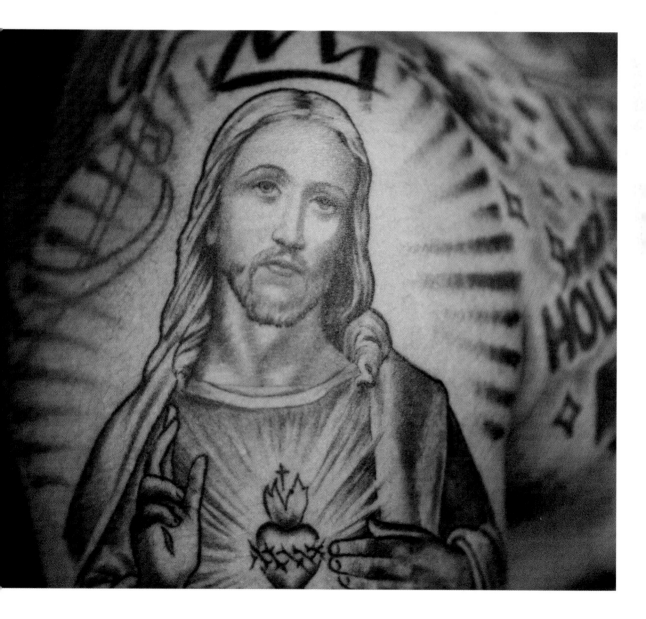

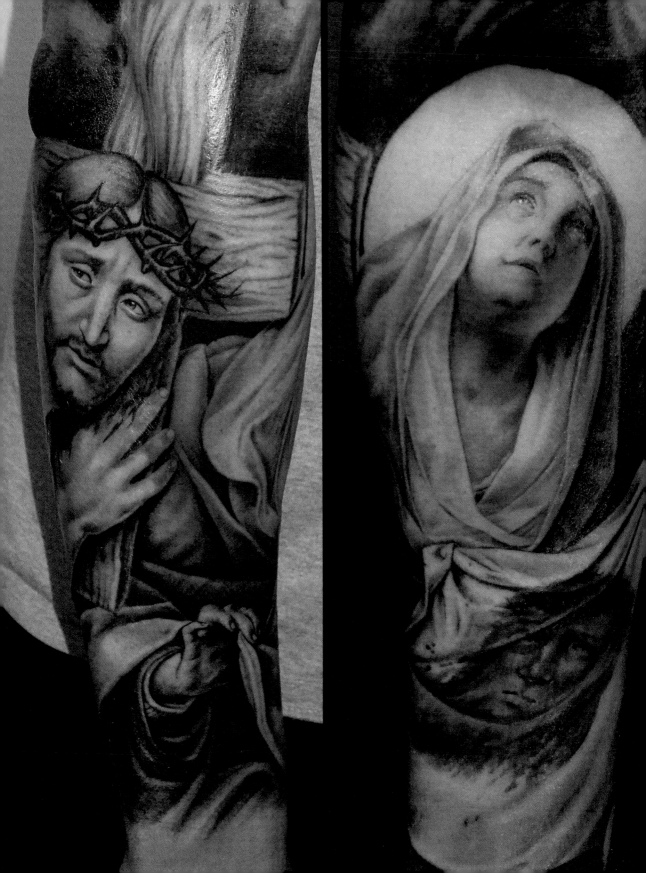

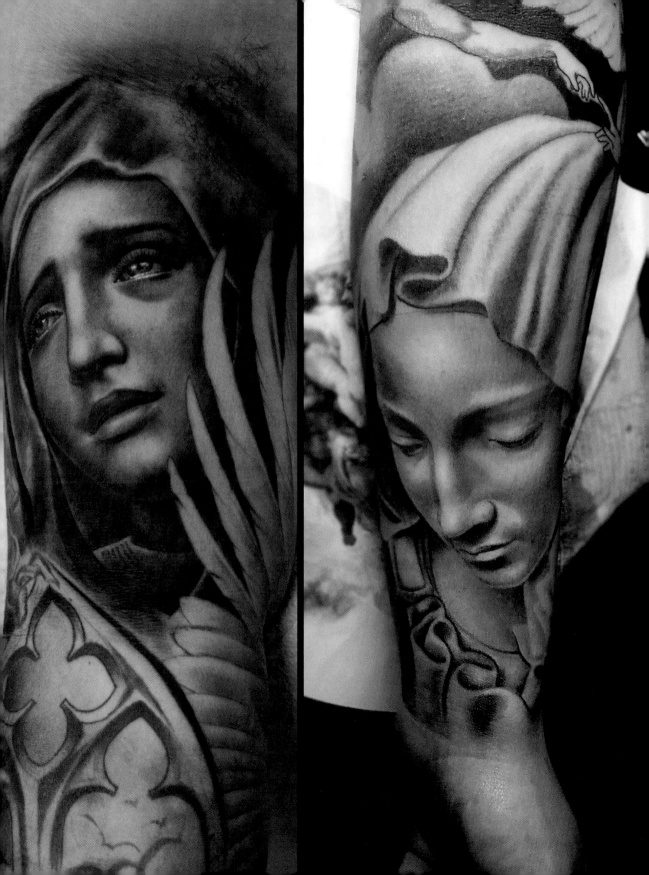

JAPANESE OR NEO-JAPANESE

While the USA has a deep tattoo history, Japanese artists have been doing incredible work since long before Sailor Jerry's grandparents were even born. Accordingly, they're the masters of the art as far as I'm concerned. I'm nowhere near educated enough to call any of what I do traditional Japanese, but I'm deeply influenced by these artists, and you can see that sense of movement and beauty in a lot of my work.

There are a lot of rules that define traditional Japanese tattooing; I don't know many of those rules, and I'm not ready to learn them at the moment. The artists I gravitate toward are those who push the limits of the traditional, like Shige or Jeff Gogue. Though I've never met either of them, I've learned so much from studying their work.

There's a perfect balance to a great Japanese tattoo. You have to fill all areas, but without cluttering the skin. It's intricate, like a puzzle of elements; your foreground, your background, and your focal point all have to interact in unique ways and still flow naturally. It's the most difficult work I do, which is why I love it. I'm a good designer and renderer already, but Japanese work inspires me to work on my illustration.

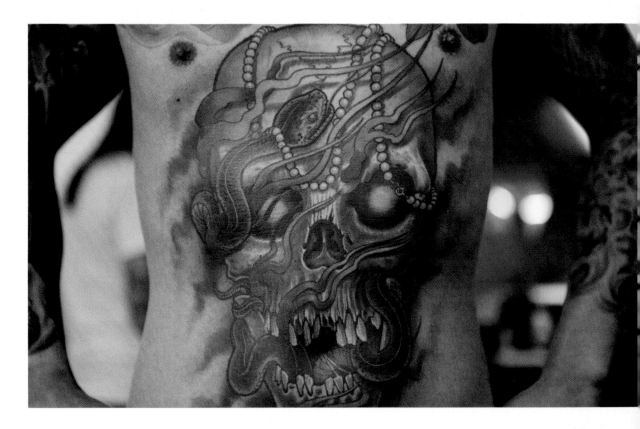

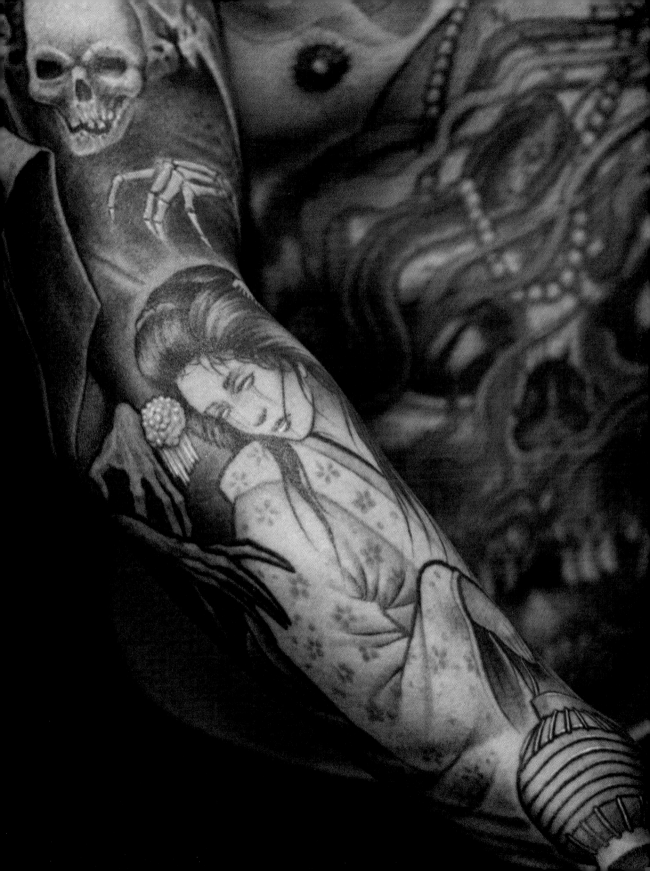

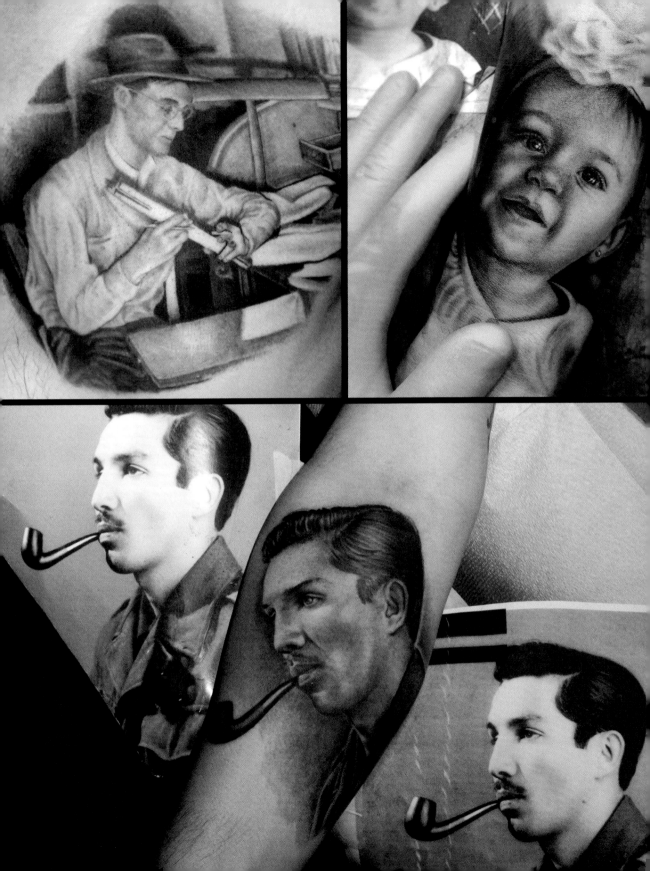

PORTRAITURE

I learned to do portraits by doing realistic animal tattoos. You can make tons of errors in a lion's face and it'll still look great, but distort someone's wife's face and you won't be in business for long.

When I do portraiture, it's not usually someone getting a family member; it's part of a bigger design. For example, I'll add the Statue of Liberty to a New York sleeve or a saint's face to a religious piece.

Thierry Henry's son was an integral part of his sleeve, but kids are easy to do because they're all circles. Everything is round. But as people age, those circles become lines. Some collapse, and you get all sorts of textures at different depths. It requires precision, a delicate touch, and knowledge that can take a lifetime to acquire.

When you're tattooing someone recognizable, the subtlest deviation is very apparent. I say Japanese is the most difficult style for me, because I'm stronger as a portraitist than I am as a Japanese artist, but portraiture took me years to master. For a long time it was the hardest thing for me to do, but now it's one of the things I excel at.

Very few people wow me with their portraiture ability, but Tye Harris is one of them. The portrait of my daughter Kumi on my forearm took Tye twenty-two hours; it's my favorite tattoo.

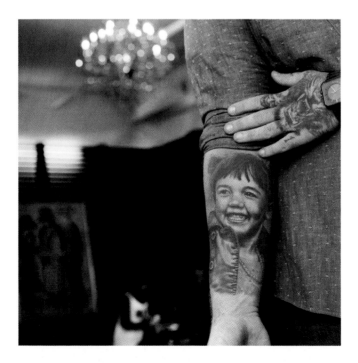

COVER-UPS

Covering up tattoos is one of the most challenging aspects of my job, which is why I love doing it so much. And it's not just turning bad tattoos into art—I've also worked on scars and other imperfections. I love doing this kind of work, making something beautiful out of something less than. It's like a puzzle; you just have to figure it out. Whether I'm disguising tribal work on Thierry Henry's biceps or designing a Indian-inspired design over a tribal Maori tattoo on Rihanna's hand, I have never met a tattoo I couldn't save.

There's this body dysmorphia that can develop when someone has a tattoo they don't like. It's like this spot on their body that they hate, but they're afraid to get it worked on because they think they're going to wind up with a big black spot or something even uglier. So they actually end up keeping their bad tattoo and feeling shitty about themselves, rather than fixing the problem.

But my goal with cover-ups isn't to put a black blob over the old piece; my goal is that you never even know there was another tattoo there to begin with.

We do our homework at this shop. We take photos of the tattoo that needs to be covered. We talk to the client and figure out what kind of person they are. What is their personality like? What do they do for a living? My lawyer friend does not want a black panther cover-up on her forearm, but my barber friend might.

We do our best to get you to stop thinking about covering it up and instead concentrate on what appeals to you. Do you like florals? Traditional Japanese? Once we know your style, then we look at your current tattoo and figure out not how we can obliterate it, but how we can work with it, incorporating it into the new design and drawing your eye away from it, so it's not destroyed but camouflaged, incorporated into your new design in a way that complements it. That doesn't sound so bad, does it?

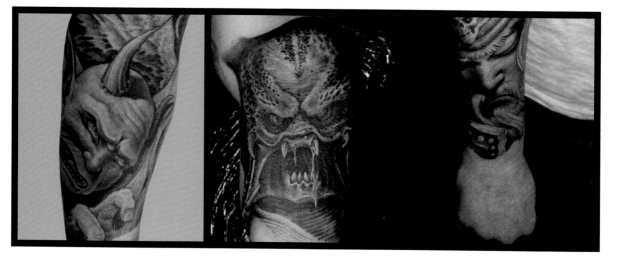

HORROR

Like religious tattoos, horror isn't really a style of tattooing as much as it is a genre.

It was a dream to get hired by Paul Booth, the Master of the Macabre, at Last Rites, but what I quickly learned there is to be careful what you wish for. I genuinely enjoyed tattooing gore—it's very similar to doing animal portraits, because there's a lot of room for error. With horror, things are loose, covered in blood—they're easy. Maybe a little *too* easy.

There are few who do horror as well as Paul, but it got to feeling like everyone I met in that genre was constantly pushing to do the darkest, most evil thing they could think of, and I lost the inspiration. Which isn't to say I can't still throw down—I didn't forget how to make a badass tattoo. I didn't forget how to do something creepy or how to make something gross. I just mastered that style quickly and moved on.

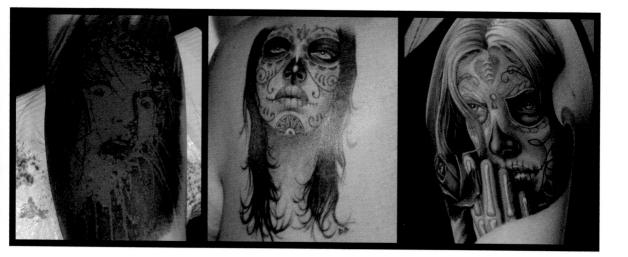

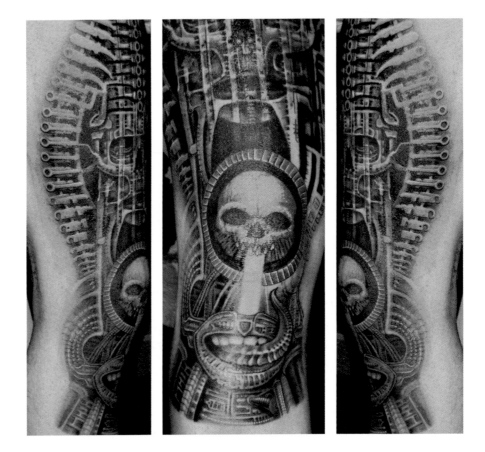

BIOMECH

These tattoos are full of gears and gristle and extremely difficult to do. The late Swiss surrealist H. R. Giger—who won an Academy Award for the visual effects in *Alien*—pretty much wrote (or drew) the book on the topic. And far as I'm concerned, that book is *closed*.

The best Giger-inspired piece I did was back when I was twenty-two, and it's hands-down the best one I've ever seen, and I'm still proud of it. I worked my fingers to the bone on this piece. I might be tempted to give it another go someday. But there's too much repetition of tiny intricate lines involved, and with the speed and flow that I tattoo at now, I don't have the passion for the kind of repetitive intricacy that it takes to do this style well. Respect to those who do.

AMERICAN TRADITIONAL

Even when I was just starting out, I hated the ubiquitous American traditional tattoo. Simple clunky pinup girls, swords wrapped in banners, or the anchors that made legends like Don Ed Hardy and Sailor Jerry so famous leave me cold. But it's like that Brand Nubian lyric, "What more could I say? I wouldn't be here today if the old school didn't pave the way."

American traditional tattoo artists do bold, solid, sharp tattoos. When I was trying to get my realistic tattoos to be more solid, I studied the machines the traditional guys used. How were they putting ink in skin more solidly than I could? I learned how to tattoo—not to design and lay out, but needle-to-ink-to-skin—from the traditional guys.

They taught me how to do black and line work. Realism doesn't use much line work, and I struggled to get such solid blacks. It sounds weird, but solid blacks are the most important part of realism. Black establishes depth, and the further you can force depth (i.e., the darker you can make the black) the more realistic you can make your tattoo. Studying this style I didn't particularly like helped my realism and drastically improved my Japanese work, since that's full of lines and solid colors.

I have a lot of respect for those pioneers, even though my work is very different from theirs. Some of America's first tattoo shops were on the Bowery, which is why I moved my store down there. Respect.

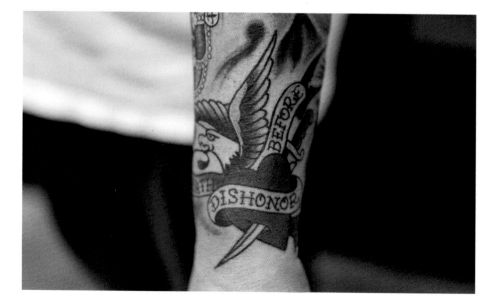

NINE

+

BANG BANG STYLE

While a lot of what I do falls in and around the category of black-and-gray realism, the fact is, over the years I've perfected my own way of doing things, and I'm still tweaking and changing my approach every day.

I like the way black-and-gray realism looks, but I also incorporate Japanese influences into a lot of my work. You'll see movement and shades that are unique to the bodies the tattoos live on. Because I work with the shape and flow of the client's body, my work is mostly multidimensional, or at least trying to be. The struggle is real.

There's no school of tattooing, and even if there had been, I couldn't have afforded to go back then anyway. But I was a motivated learner. What started at my mom's kitchen table moved logically from one place to the next, and my style followed suit. From Rage of the Needle, I learned about shading and the nuances of tattoo machines. Crazy Fantasy was all flash, so it wasn't particularly creative, but I learned how to do good work under extreme pressure: Sixth Avenue and West Fourth Street was a pretty intimidating place for a nineteen-year-old.

Whatever Tattoo was a small but important step—for the first time in my life, I felt like a tattoo "artist." It was here where I started to design my own work and get paid for it. I

learned how to be the best. But that feeling of being the best was short-lived. I moved on to West Side Ink, where I was basically an intern, which was very humbling. As my work improved, they started respecting me more, so when the rest of the staff transitioned over to East Side Ink, after West Side closed, I went with them, learning new techniques and slowly building my confidence. A bit later, I got hired by the legendary tattoo artist Paul Booth at Last Rites, which was a huge step. I felt like his endorsement validated that I was a great tattoo artist. Believe me, a confident tattoo artist is a much better artist than an insecure one. When I eventually returned to East Side, I worked on monetizing my talent and figuring out how to work the press.

But leaving East Side to start my own business was the best lesson of all. I figured out that I'm not just a talented artist, I'm also a great business owner. Every single thing I do and everything I've learned from working in so many different places has led me to this point in my career. I made my opportunity and learned a lot at every step along the way.

LEARNING CURVE:
THE EVOLUTION OF MY STYLE

Nobody starts off making amazing tattoos right out of the gate, and I'm no exception to that rule. Even when I look at something I did a week ago, I see things I could've/should've done differently, so looking back at my first tattoos is kind of humbling. But it also shows me where I came from, how much I've improved, and how far I can and *will* go.

I spent the first three months of my career tattooing at my mom's kitchen table. I didn't know what I was doing. I didn't know what a "mag" (also known as a shader) was, so I did everything with a thin lining needle—and I shouldn't have! The environment wasn't sterile, the room was usually filled with blunt smoke, and I was doing everything I wasn't supposed to, but then I met Pat McCutcheon, which led me to Rage of the Needle. Pat taught me about the shader and diluting ink with water, and I took those lessons home. I did a good enough job that Pat was impressed.

Mother's Day, 2005, I was hired at Rage.

RAGE OF THE NEEDLE

Though I didn't have a real portfolio, the collection of photos I showed Pat, owner of Rage of the Needle, illustrated that my hand was steady and I was capable of learning. I knew that in order to get the job I really needed to nail a few tattoos that would be important to the clients who lived near the shop—this was the one by the trailer park in New Castle, Delaware. It wasn't a glamorous place, so I tailored my sad excuse for a portfolio accordingly. What I needed was work that bikers, wannabe bikers, and the women who loved them would want to have etched onto their bodies: lettering, praying hands, flowers, butterflies, spiders, and everything in between.

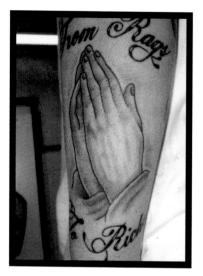

I'd make sixty dollars on a bad night, eighty or a hundred on a good one. I spent it all on weed and pizza.

The pair of praying hands above was one of the first tattoos I did at Rage. When you look closely, my line work's really poor, my needle was really loose, my shading is super light, and what that lightness hides is my inability to render. If everything looks light and flat, it's because I was scared of putting in black—I had a real fear of making something too dark. My earliest work is all really light because of that fear. But the lines are close enough to where they should be that your eye assumes the rest. Amazingly, our brains create these connections for us, so you might not notice how incomplete the tattoo actually is. Looking at it now, I would never hire me.

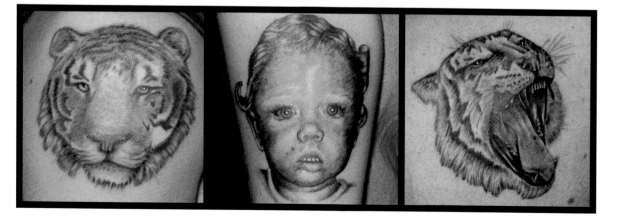

I would also tattoo at customers' houses or have them come over to my apartment. There was one customer named B from the Hill who let me practice portraiture and praying hands on him for practice. I did his dogs on his chest and his daughter (previous page, center). It was done in his attic under really poor lighting, which may be why the baby's missing an ear. Not great, but it made it into my portfolio and helped me land my first New York City job.

None of these are particularly good tattoos, but I got to practice black-and-gray realism, which was very important at the time.

CRAZY FANTASY

It was seriously gross, but since Crazy Fantasy Tattoo was the only place that would hire me when I moved to New York, I didn't have a choice. The owners also owned Fantasy Party, the adjoining sex shop, and our bathroom was inside the porn store, connected to Papaya Dog through the basement. Classy. While it was a nasty place to work, it's where my work really started to evolve and improve.

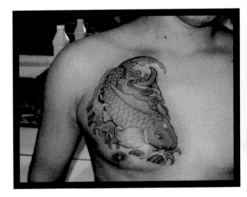

This koi turned out great, but I didn't draw it, because Crazy Fantasy was strictly flash. This was done on a regular. By the time I left, he had a lot of my pieces, but nothing original—I traced it, tattooed it, and everything I did was solid and good, but inking other artists' work isn't very gratifying or respectful.

I had done a large Japanese piece on his stomach, and he kept asking me to do cherry blossoms between the koi you see and his stomach. I hated his idea and kept assuring him I'd make it look great. Instead of waiting for me, he went behind my back and got another artist to execute it. Not surprisingly, it turned out horribly and he expected me to fix it. I had busted my ass to do his tattoos and charged him next to nothing because I wanted them in my portfolio. I was so pissed, I kicked him out of my house and never finished his tattoo. Byeeee!

It became clear quickly that I was capable of doing solid tattoos. I wasn't working

with great material, but I was working my ass off, do-
ing consistent, clean work, and I wasn't slow, which
was key for a shop built on hustle. This was a piece of
David Bollt flash. Clients loved his work and we had to
do the same ones over and over again. It was difficult
to do all that different shading in the small area you
have for a tramp stamp, so at least it's well executed.

The dragonflies are a silly little tattoo that I did as
an experiment in line weights. I wasn't just banging out
tattoos—I was really trying to learn how to be a better
artist. It's not good, but it shows that I understood line
weight and where that takes your eyes. Thin lines, thick
lines, an absence of black lines . . . I was just playing
with different techniques.

Early on, it became clear that I was better at real-
ism than traditional. That's why I don't do American
traditional—they're not fun. Now I could do a way better
traditional tattoo than the sparrow pictured, because I
understand them. But I don't want to.

I also picked up some bad habits during this time—
namely, cocaine. I was smoking it, sniffing it, just being
crazy. Quickly, it led me to an overdose. I had a series
of panic attacks that cycled off and on for three years.
It's really stressful to develop panic attacks, but that's
what the overdose did to me. I got my shit together and
became very close to Joe Snake, who moved in and
took care of me, because I was messed up for a really
long time. Since then, I haven't done any drugs (I don't
think of marijuana as a drug, especially since half the
country considers it medicine).

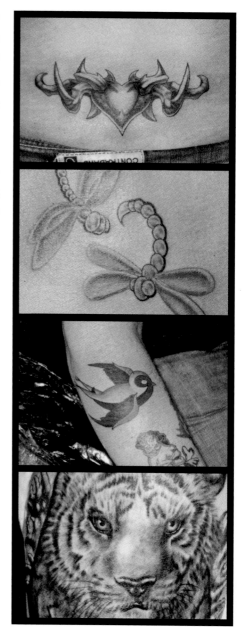

Not all my attempts at realism are good, but this tiger (right) is where I started to sepa-
rate from the herd. It's a lot better, and a lot darker, than the one-eared baby I did. It's not
composed well, but it shows that even then I understood lighting, and for a nineteen-year-

old who'd been tattooing less than two years, it was pretty good.

What I learned during this piece was how to tattoo fur—it's all about repeating the same hand motion over and over again, and staying very consistent. As I gained confidence, my tattoos got darker because I wasn't as afraid of leaving someone with a big black permanent mistake. Compare this with the praying hands I did at Rage of the Needle and you can really see the difference.

This tiger marked me becoming the best tattoo artist at Crazy Fantasy, because nobody else could do realism.

I still wouldn't hire this kid, but at nineteen, I was so proud of this piece.

Smooth gradations are difficult because it requires a bunch of different variables working in tandem: repetitive hand motions, a consistent machine, needles that break skin consistently, the right tone of pigment, along with the correct amount of hand pressure. It's like airbrushing times a thousand. There are so many variables—a person's skin type, skin tone, sun exposure, pain tolerance, the body part, age, how tight that skin is, how muscular they are, how fat they are, do they use lotion, are they hairy, and if so, is that hair coarse?

So while this looks like just a simple little tiger tattoo, it was a really important indicator of how my technique had improved by leaps and bounds.

WHATEVER TATTOO

I wanted to work at Whatever because I respected the artists, and instead of an angry asshole who treated us like garbage, they had a cool woman named Banger managing the shop.

Rob Green, who works with me now, had been working at another shop on the strip called Dragonfly. All our shops were small, but Dragonfly was so tiny that only one artist and one client could fit in there at a time. It was a closet—like six by ten feet, if that. Dragonfly was the only shop with an awning, so all the artists from the shops on that strip would gather under it and smoke weed during our downtime. I also met Liz and Hector—both of whom I later hired to work at my shop—under that smoke-choked awning.

Rob moved to Whatever and I decided I wanted to work there too. I was good, fast, and popular with clients, so Banger moved me into the window—I did days, Rob did nights.

I really wanted to do a color-realistic version of Freddy Krueger, so when I asked around

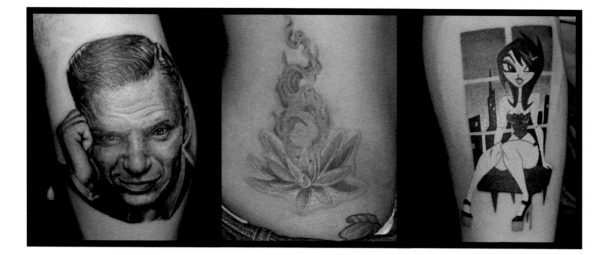

the shop to see if anyone wanted it, Banger didn't hesitate. It took me eighteen hours and I did it for free. Looking at it now (see page 40), I see how I would rework it and make it better. For one thing, there wouldn't be a floating head in a claw inside some weird silhouetting cloud of nonsense, that's for sure.

Frank Sinatra happened because I wanted to do black-and-gray portraiture with some easily recognizable imagery—not somebody's girlfriend or baby. Everyone knows Sinatra, and my cousin Chris loved him, so he let me tattoo Frank on his calf. This piece won second place at the Atlantic City Tattoo Convention. At twenty, that's a heck of an accomplishment. Shane O'Neill won first and third places. Funnily, this is my only award. I never liked conventions much, so I never went.

WEST SIDE INK/EAST SIDE INK

Tattooing is one of those businesses where you don't have to fully quit one place to start working at another. So when I started working at West Side Ink, I was still working at Whatever. Then West Side Ink closed, moved across town, and became East Side Ink. So for quite a while I was working at East Side Ink two days a week and then working at Whatever four to five days a week.

I really liked the artists at West and East Side Ink, but I was finding it hard to keep busy

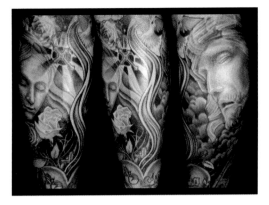

there back then. There were so many days I spent just petting legendary tattoo artist Andrea Elston's dog.

I think the guys at the shop didn't even believe that I'd done this piece because I was such a kid, but they gave me a chance. I wasn't even twenty-one yet—not even old enough to go out drinking with them after a shift. This was a really hard tattoo to pull off because there's so much involved.

When I look at this piece, I know there are imperfections, but finally, we're at a point where I would hire this kid in a heartbeat.

LAST RITES

When I told East Side Ink I was leaving to go work for Paul Booth at Last Rites, Andrea Elston was the only one who congratulated me and wished me well. I really liked everyone who worked at ESI, so that really bummed me out. They knew what an honor it was to be asked to work at Last Rites, and it disappointed me that nobody else congratulated me, and

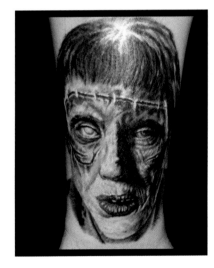

some even yelled at me for leaving. But in hindsight, I'd be disappointed to lose me too.

This is from a 1950s Frankenstein movie. I was really excited to get an interview with Paul Booth, but when he looked through my portfolio he didn't immediately offer me a job. Instead, he said it was between me and two other guys. I went home and told Ed I'd blown it. Ed was really confident and laughed it off. He was positive I already had the job.

I knew I was still in the running, so I told Ed I wanted to do a color portrait on him. That was one area that Paul was looking for, and my portfolio was lacking. Ed has more of my tattoos than anyone else, and has never once tried to art

PEOPLE ASK ME IF I'M FROM NEW YORK CITY AND I TELL THEM, NO, BUT I MADE IT HERE.

direct. Instead, he's always been 100 percent willing to let me do whatever I wanted. This was an incredible opportunity and I didn't want to blow it. So we got up at six in the morning, got to Whatever by seven, and I tattooed Ed until noon. As soon as I cleaned it up, we jumped on the train uptown and got to Last Rites just as Paul was opening up the store. It's a good tattoo, but I think that even more than my talent, he admired my determination, and he hired me on the spot. I was twenty-two years old and suddenly having this platform for my work made me feel like a master. I was the youngest person who worked there by at least a decade.

Booth was one of my tattoo heroes, and I imagined working for him would be the apex of my career. It began to filter back to me that people were saying I wasn't good enough to work at Last Rites. I remember being so offended at the time, but the truth is, I *wasn't* good enough to work there back then. I got that job because I showed tremendous initiative, but also I lived up the street and a bunch of artists had just walked out. And I was young and dumb enough to put up with Paul's crap.

Paul has a reputation for being a bastard, but that never bothered me much because I could see how stressful his life was. He's huge, heavily pierced, with a big bald head covered in tattoos, so he just naturally intimidates people. But I was never bothered by him, and I would just laugh it off if he bitched at me.

Unlike most businesses, which take a customer's-always-right approach, the workers at Last Rites would mock would-be clients who came in wanting anything non-gory. And forget about religious imagery; Jesus, Mary, and their ilk were strictly forbidden.

This pissed me off, because I just want to make my clients happy and I tattoo without prejudice. I don't invest much in religion, but I love religious art, along with the history associated with different religions.

I hadn't been at Last Rites for long before it became clear that going there had been a huge mistake. My old regulars like Lucy and Richard still stopped by, but I had to make sure Paul didn't see that I was giving them the tattoos they wanted—not Vampira or Swamp Thing.

By the time Rihanna wanted her third and fourth tattoos from me, I was still there, but by then I didn't care much what Paul thought—as far as I'm concerned, Rihanna gets what Rihanna wants (as long as I think it'll look fly). She came in and we did the "shhh" on her finger and Roman numerals on her shoulder. The Roman numerals are Melissa's birthday—Melissa has the same one, but with Ri's birthday.

Since then, I've worked at a couple of different places, and I finally opened my own shop in 2014. My style is ever evolving, but I've continued to concentrate on realism. And whether I'm tattooing a bunch of pro basketball players or an old friend from back in the day, I'm always pushing myself to work harder and do better. I'm relentless, diligent, confident, and focused.

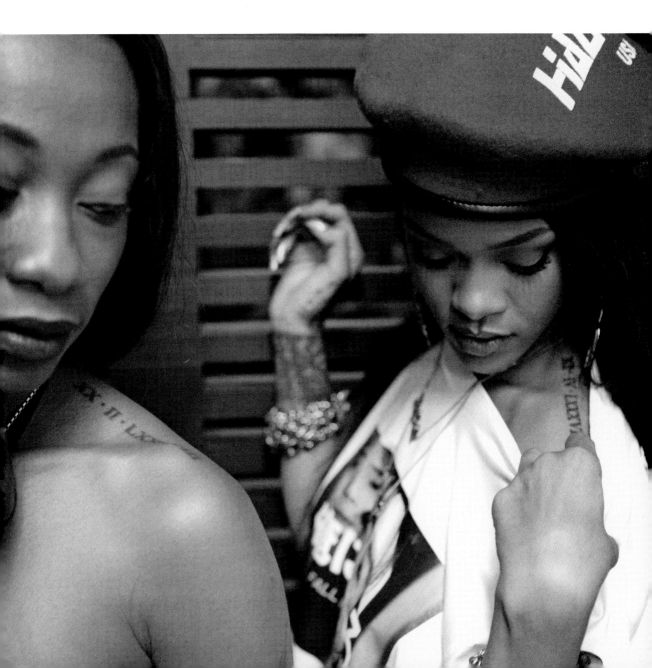

THE BANG BANG DIFFERENCE

Back when I was working in New Castle, we never had a client walk in wanting a tattoo to commemorate their visit to Delaware. Good thing, because I wouldn't even know where to begin with that. But New York City is different; whether they're visiting or have lived here their entire lives, people often want NYC-themed tattoos. And along with the Empire State Building and the Brooklyn Bridge, the number one request is the Statue of Liberty.

There's no way to even count how many I've done

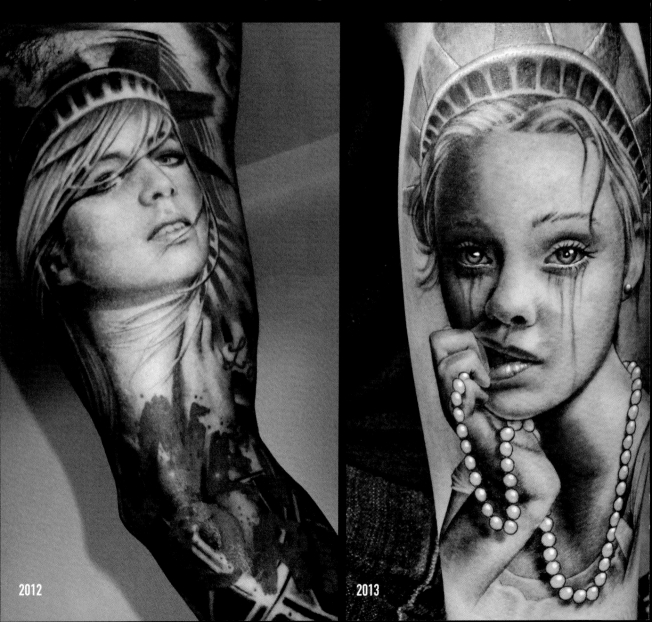

2012

2013

over the years, but years ago I ditched the idea of doing exact copies and started giving her Bang Bang make-overs.

If you've ever taken a good look at Lady Liberty, you must have noticed she's a handsome woman, but apparently the sculptor, Frédéric Auguste Bartholdi, and I have different tastes. So instead of re-creating that mug a million more times, I decided to make her beautiful.

Now when someone requests her, I scroll through model portfolios, looking for beautiful women shot by great photographers. If you look at any of my more recent Liberty pieces, she still wears the same headdress and robes, but there's one big difference: she's pretty.

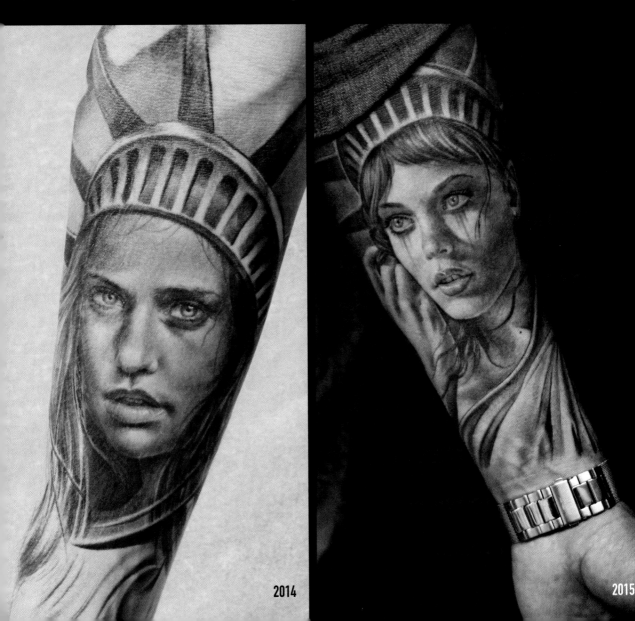

2014

2015

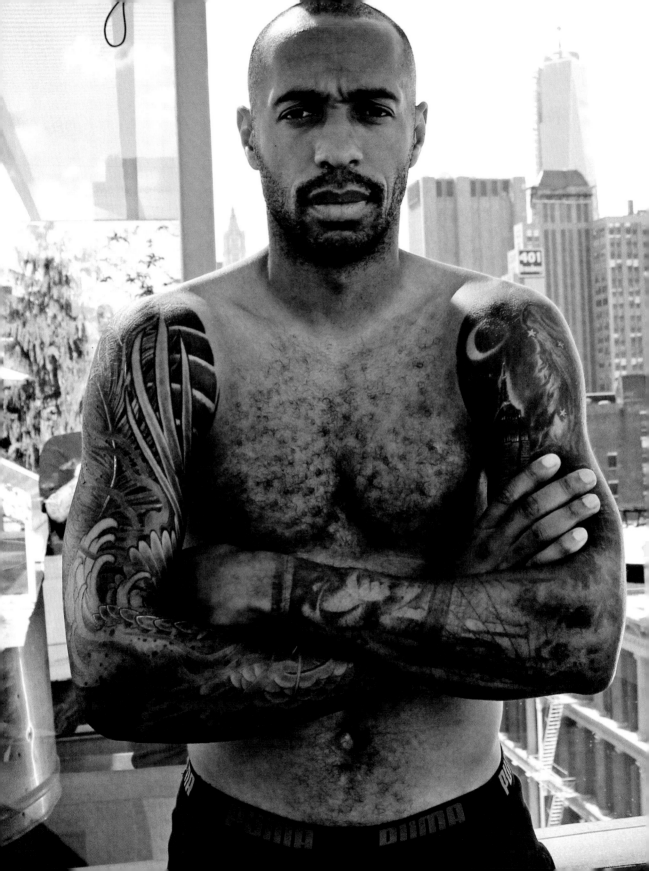

TEN

+

SLEEVES

I'm always looking for challenges, so there's nothing I like more than combining a bunch of different styles in one piece. Which is why I always jump at the chance to do a sleeve.

Doing two sleeves on Thierry Henry was not only an incredible challenge, it was also a great honor.

I had already been in New York for about eight years when I met Thierry. My cousin and closest friend, Edward, had moved to New York shortly after I did, and after spending seven years working for the world-famous chef Jean-Georges Vongerichten at The Mercer Kitchen, Ed had left to become my manager. He's moved with me from place to place, and I honestly wouldn't be where I am today without him.

But, much like what happened the first time I met Rihanna, I had no idea who Thierry Henry was when he walked into the store. Thierry and his girlfriend, Andrea Rajacic, had loved Swizz Beatz's tattoos, which led Andrea to check us out on Swizzy's referral. Edward remembered her from all his years at The Mercer, where she and Thierry were regulars.

Ed found me in the back of the store and told me some big soccer player was looking to get tattooed. I like American football, not European, so I had no idea that Thierry was

basically the Michael Jordan of the rest of the world. The consult was basic, but he wanted to know if we could do it at his house. Though I didn't know exactly how famous he was, I assumed his place would be clean, which is the most important requirement if I'm going to leave the comfort of my studio.

I estimated that the sleeve would take three full days to complete. The pain involved with getting tattooed for that many days in a row is intense, so I suggested we split it up over a week or two. Thierry assured me that the pain would not be a problem, so a couple of days later I went to his house.

Getting any tattoo hurts a little. Getting your whole arm tattooed in three days? With the kind of needle groupings I use and the machines I'm pushing them with? Ouch. I tattoo fast and direct, and for something as big as a sleeve, it's *not* a delicate process. Imagine continuous rug burn until your adrenaline gives out and your nerves are traumatized by the needles going in and out at warp speed. Your skin does become numb eventually, but then it gets sore. Very, *very* sore.

By about the third day, the tattoo starts healing, which sounds great, except we're not done yet, so now I'm digging needles through skin that's already started to heal. Thierry's pain tolerance is unlike anything I've ever seen. He's the toughest person I've ever met.

By the time I met Thierry, I'd been to some pretty incredible homes: Rihanna's house in the Hollywood Hills, Amar'e Stoudemire's penthouse, Swizz Beats (another of the toughest people I know) and Alicia Keys's apartment . . . but Thierry's place was and is the nicest place I've ever seen.

It's gigantic, but also simple and incredibly comfortable, which is a good thing, since we were going to be spending a lot of time together. I remember walking in and being so blown away by the place that I assured him that one day I would buy it off him. Thierry laughed because that's not generally people's reaction. A lot of people see

someone doing well and they want to undercut that success. Instead of high-fiving them for doing well, they say shit like "Must be nice" or "I wish." I've had many people give me backhanded compliments or make similar comments about my life. To me, success is something to be admired and to congratulate.

Obviously, I'm nowhere near Thierry's level of accomplishment, but all my success is my own doing. I come from nothing. Thierry, too. Rihanna also came up all on her own. That's the common factor with all the people I really click with. We don't talk about it often, but you know when that feeling is mutual.

I'm really impressed by the kind of people who follow their heart and are happy, successful, driven to do something they love, and always striving to be the best at it. I want to be around *those* people. And I think those people recognize those same things in me and know that I'll give them my very best.

Thierry was born to an underprivileged family in the Paris suburbs and went on to become one of the top soccer players in the history of the game. He played forward and was Arsenal's all-time top goal scorer during his time on that team. I cannot overstate what an incredible talent he is—I mean, there's a bronze statue of the guy outside the Emirates Stadium in London. When I met him he had moved to New York to play for the New York Red Bulls.

Even though I had no idea who he was, walking through SoHo with him was like being out with LeBron—the neighborhood is always filled with European tourists who'd either want to stop and talk or at least just stare and try to sneak an iPhone photo surreptitiously.

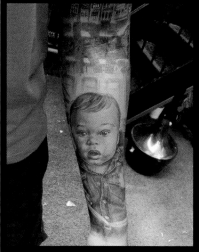

Thierry wanted his left arm to be an homage to his son Tristan and his adopted hometown. We put Tristan's face on Thierry's inner forearm and then wrapped iconic NYC images like the Statue of Liberty, the Brooklyn Bridge, and the Empire State Building up the rest of his arm. Most of it is black-and-gray, so we stamped Tristan's name in abstractly beautiful bright red lettering across the middle.

I love the way it came out partly because it's a beautiful tattoo, but also because of how much it means to someone so great.

Thierry and I spent a *lot* of time together doing that tattoo,

and over that time we became friends, so when it came time to do the other arm, he felt pretty comfortable coming into the studio.

The second sleeve was a lot more complicated because we had to cover up some old tribal work. Thierry wanted something Japanese inspired, so we decided on a phoenix, which figures big in Japanese mythology (and all mythology, really) and marks the beginning of a new era. I didn't know it then, but Thierry was getting ready to retire.

If you look closely at the piece, you can see there are areas that are set back in the tattoo—that's where the tribal work was before.

I want all my tattoos to have depth and dimension, not just a series of thick black outlines and solidly filled shapes. I'm trying to explain this so anyone can understand, because it's very complicated, but I use the existing tattoo as a starting point and build from it. I'm able to establish depth, which works to draw your attention away from what was originally there. I use open skin for my closest points. It's far more complicated than I can adequately explain in a paragraph—next book!

Because of the intricacy involved in this sleeve, stencils weren't going to work. I needed to use both the contours of his arm and the existing artwork, so I spent the first several hours using markers to draw the design directly onto him. As bossy as I sometimes am, doing something as huge as a sleeve is a collaborative effort, and I don't want to start tattooing until we're both happy with the direction.

Japanese tattooing, to me, means a traditionally inspired subject, bold outlines, and a lot of motion. The artwork aims to occupy every portion of the skin. And it doesn't just lie there on top like you slapped a sticker on your skin—it needs to become an integrated part of your body. Thierry's phoenix was super saturated, with flames streaking across it. Neither the phoenix nor the fire were done realistically, but instead blended elements of realism and Japanese.

Once again Thierry was in the chair for three consecutive eight-hour days. By the third day, his hand was so swollen he couldn't move it, and I was really glad he relied on his legs and feet for his career and not his grip. The view at the studio wasn't as cool as his apartment's, but we had a great time talking about music, success, and growing up humble.

Thierry's not only a really good friend, he's become a mentor. I know I can always ask him questions: How do you handle *this*? How do you do *that*? After we finished tattooing he'd still come hang out in the shop. We'd go to dinner, see some basketball. If I was having a hard time, Thierry was there for me. More than anyone will ever know. T is family.

He loves hanging out in the shop and we love having him around. Thierry is so famous, there's nowhere on earth where people aren't gawking at him, wanting something from him, whether it's a photograph, an autograph, or just some attention. He's always extremely gracious, but at the shop he can just be himself. We don't want his picture or his autograph or anything else. We just like him. He's a cool guy—we laugh, we joke, we clown. I feel really lucky to know him.

David Wilson was another fantastic sleeve. He was an incredible running back for the New York Giants. Moving to New York didn't kill my allegiance to my Philadelphia Eagles, but I just love football. So I'm not gonna lie, I was excited the day David Wilson walked in and said he wanted me to do his sleeve. The only problem was, he wanted it done the following day, and I'm booked months in advance.

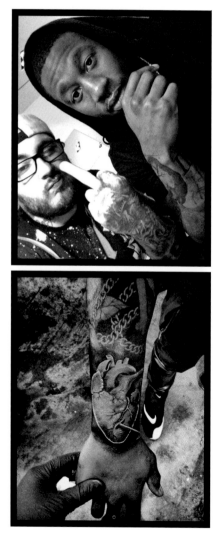

I managed to clear my calendar and we made an appointment for the next day. A sleeve involves a lot of pain, and most people can only take it for a few hours (including me!). But Wilson was tough and we got it done in three eight-hour sessions. Like Thierry, he's incredibly hardworking, talented, and the most gracious, humble guy. Polite, great sense of humor—he carries himself like a great soul. You can just see it in him and you want to be like that. He's the friendliest, kindest guy—and you never hear a curse word out of his mouth. He's the kind of guy you want to grow up to be.

The next season he had to retire because of a neck injury. Bear in mind that this guy was a first-round draft pick and only about twenty-two when he was forced to step down. His retirement speech was one of the most inspiring things I've ever heard: "Don't for a second think I'm pitying myself or sad. I got to live my dream. I'll set another dream and be great at that. I always look at trying to be great at whatever I do." I cried as I listened to him make that speech. He's such an amazing person. To hear him announce that he can't play football anymore, and yet he's the one reassuring everyone else.

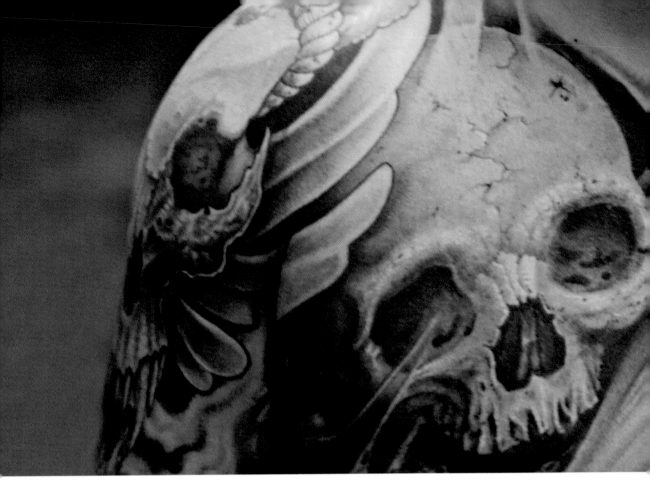

Of course, most of my clients aren't professional athletes. I tattooed a favorite pair of sleeves on a New York City firefighter named Eric Roldan. Whereas Thierry Henry's sleeves were each done in a few days, in Eric's case, the entire job took about three and a half years from start to finish.

When Eric first came in, he said he wanted a Mayan sleeve up his right arm. This was one of the first opportunities I'd gotten to do an entire sleeve, so I didn't want to copy anything that had already been done. So I did research, drew it on with markers, and just added elements from references of original Mayan art.

We started on the front of his forearm and moved up, leaving it undone between sessions. There's a dragon skull on it because it appears in a lot of Mayan sculptural art, so I kept reinterpreting the idea. We took the idea of a traditional tattoo and rendered it realistically. The jaguar and the eagle represent two different kinds of warrior.

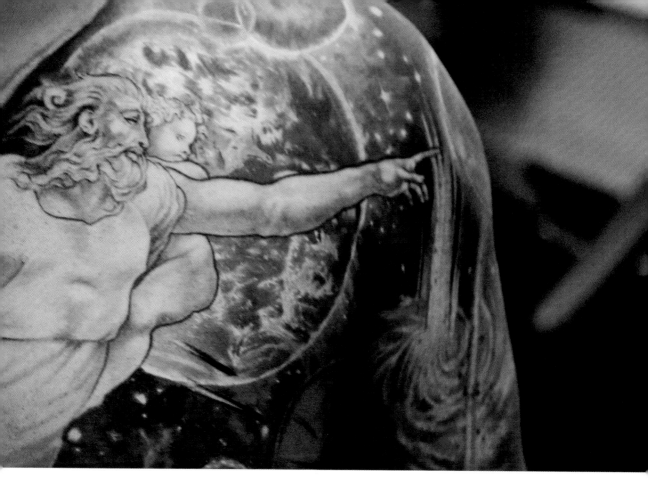

When Eric was ready to do his other arm, we needed to cover up a tattoo of a dream catcher that said "Semper Fidelis." Eric was a marine before he became a firefighter. If you look hard, you can still see pieces of the old tattoo that I kept and used as part of the design.

The inspiration was creation, which we showed by referencing Michelangelo's *Creation of Adam* and then blending in symbols of a few different belief systems, along with Sirius, the star that the ancient Egyptians believe we sprang from. And when you look under Eric's arm, there's an astronaut, paying homage to the belief in ancient astronauts. I feel like the mix is both sacrilegious and, at the same time, very respectful of the *idea* of God.

Religions often divide us, but when you look at them as an outsider, you can see that they tell many of the same stories. I have no idea what the truth might be, but I do know that the stars touch me the same way a photo of someone I miss touches me. And I think this tattoo reflects that.

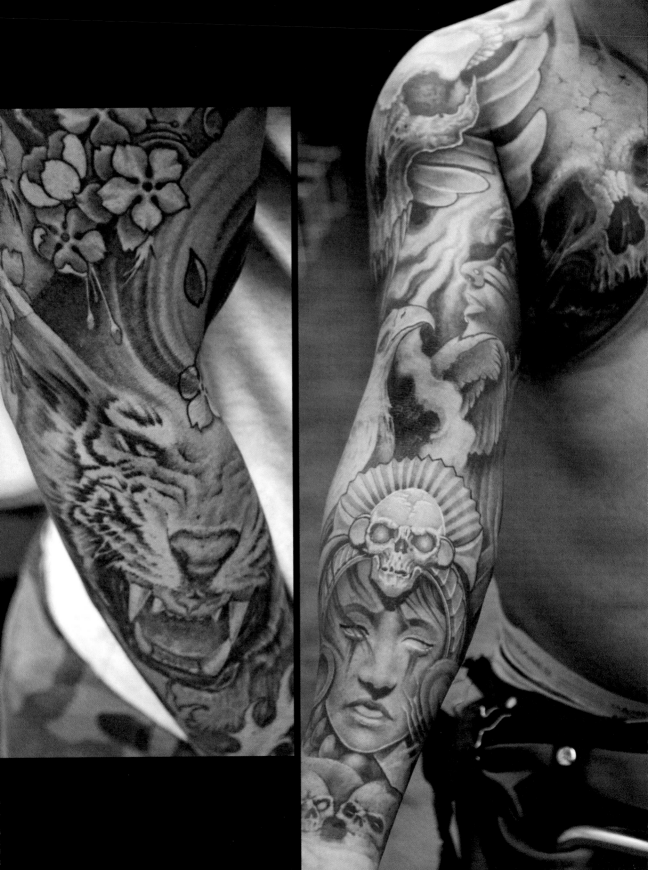

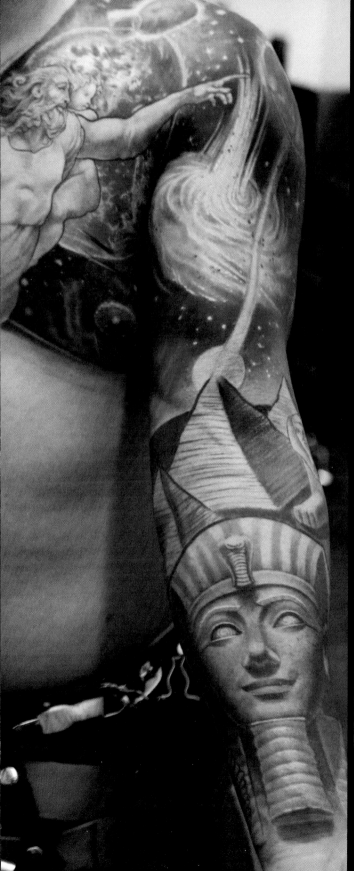
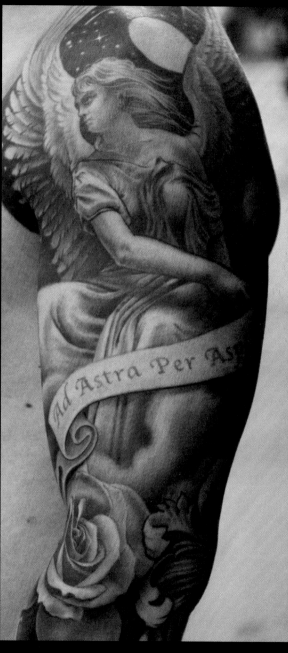

Unlike a lot of my clients, entrepreneur Aleksandar Zunzurovski had no intention of getting an entire sleeve done. When this guy walked through the door, he had just a couple objectives: cover the ugly basketball some chump had put on his arm, and pay tribute to his two favorite U.S. cities—New York and Los Angeles.

I told him there was no way we could fit all that into one little tattoo and, as usual, I asked him to trust me. He'd been screwed over by a few artists in the past, who'd over-promised and underdelivered when it came time to show him the artwork, so I think he appreciated that I was realistic.

Aleks is a big tough guy from Macedonia, but when it came to the physical pain of getting tattooed, he was up front about how much it bothered him. And this took nearly thirty hours. During the process, he told me, "I hate *getting* tattoos, but I like having them."

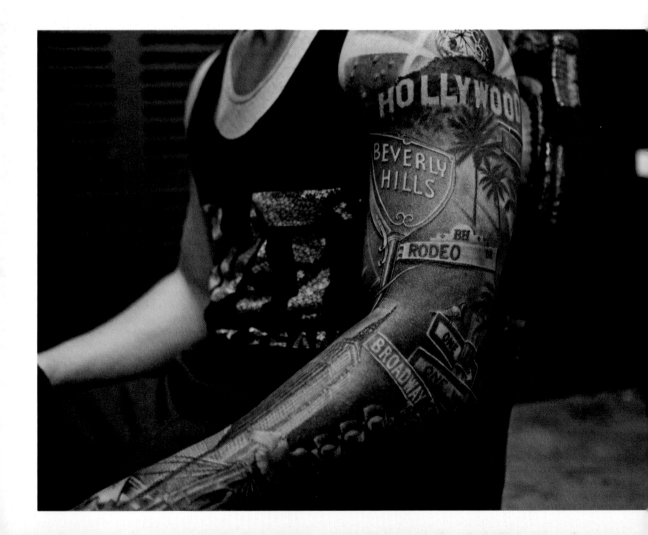

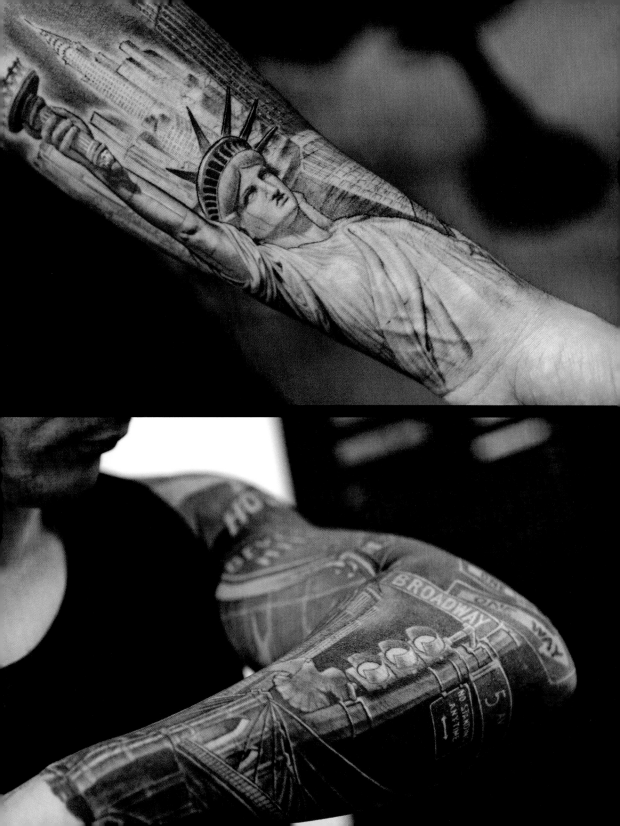

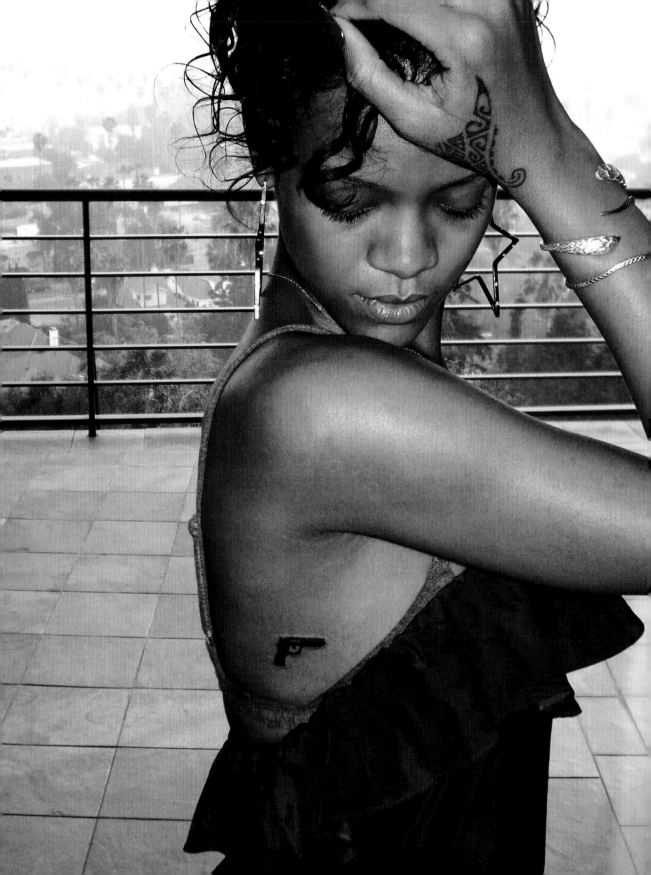

+

BUSINESS BLOWS UP

Eight months after I was hired, when Paul and I realized that Last Rites wasn't for me, I went back to East Side Ink and came up with a new goal: becoming a partner in the business.

I wanted to prove myself, so I needed to work. Even though I was still getting press from the latest Rihanna tattoos, it was nearly ten months before the shop even got around to putting me on their website. I think keeping me off the site was more laziness and/or ineptitude than spite, but it bothered me daily. And it wasn't until the next time I tattooed Rihanna that things really started to change.

She and Chris Brown had just been all over the news, and nobody had seen her in weeks when she called. I didn't ask her what had happened that night and she never told me. As far as I'm concerned, it's none of my business. She wanted me to come out to L.A. and tattoo her assistant's boyfriend for his birthday. So I did just that.

I hated to fly at the best of times, but Etsuko was about eight months pregnant and I knew she'd be pissed if I went. But when life hands me opportunities, **I *always* say yes.** So Rihanna flew me out to L.A. and put me up at the Roosevelt. It was the first time I ever traveled to do a tattoo, and despite the whole being-in-the-air part, I loved it.

I arrived and did a bunch of different tattoos on her friends. Rihanna and I had been talking about doing a gun tattoo on her ever since I saw her wearing a gun necklace a few years earlier. I mean, my name is Bang Bang—I like guns!

So we agreed on what kind and I made a stencil. *Where* a tattoo is placed is just as important as *what* it is, so we tried it in a bunch of different places. We had originally thought we wanted two guns—one on the front of each of her shoulders, just above the armpit area. But when I placed the stencils, the guns were all you could see. Rihanna's face is beautiful and the guns drew your eyes away from her. Putting something so blocky and dark too close to her face made *it* the star of the show, not her. That's one of the reasons I diluted the ink I used on her collarbone and neck tattoos with water. Tattoos around her face can be made lighter and less distracting. Think about the paw prints on Eve's chest. It's what a lot of people remember about her. It works for her—she's the "Ryde or Die Chick," but that's not Rihanna's style.

So we kept moving the stencil around until we decided on her rib cage. It's subtle, small, and you don't see it unless she wants you to see it.

We did what we always do—tattoo, smoke, and eat Chinese food. I tattooed her assistant Jen's boyfriend and Melissa, we bullshitted for a bit, and then I flew home to Ets.

With Rihanna's permission—I *always* ask—I put the photo on Myspace. (These were the pre-Instagram days.) I loved how this one turned out, and I honestly had no idea it would ignite such a shit storm. But no sooner had I uploaded it then everything blew up. Because I don't really pay attention to the news and never read gossip sites, I hadn't realized she hadn't been in the press in weeks. This was apparently one of the first photos anyone had seen of her since the incident with Chris.

This was also the first time anyone *really* connected "Bang Bang" with Rihanna's tattoos, because it went everywhere. This was also the first time I really understood how many people were *really* interested in what this girl was doing.

She is such a good person. She knew how hard it was for me to get away when she asked me to come to L.A., and she paid me so much money that I was able to take two months off when my daughter was born. Rihanna is so generous to so

many people in so many ways. Most people will never see that. And she doesn't care.

The morning after I posted the photo, I was awakened out of a sound sleep by a buzzing noise. My phone was blowing up. I hadn't even put on my pants and suddenly I'm answering calls from TMZ, MTV, CNN . . . news anchors are calling from Australia, Germany, all over the world. They all want to talk about the gun. This craziness went on for two weeks. I don't know how they got my number, but they all got it.

Rihanna was cool with me talking. I'd clear up any misconceptions about the tattoo while also introducing people to my work. When I did interviews, I'd have them filmed out in front of East Side Ink and I'd always be sure to drop the shop's name to journalists. I thought they'd appreciate the publicity, but inside, all the other tattoo artists were just burning.

It didn't matter that I was cranking, working my ass off, and getting better every day—I was still just "the kid" to them, because I was only twenty-three.

Meanwhile, my patron saint Rihanna told her friend Katy Perry that she should come see me. And Katy did just that.

Katy was super sweet, as she's always been. Like a lot of women I work on, Katy likes smaller tattoos, so we did a strawberry below her ankle, on the side of her heel.

We took a couple cool photos inside, but when she went to leave, the paparazzi were already waiting because they follow her everywhere. As soon as she walked out the door, they went nuts pushing each other and snapping away. The press from that day alone got the shop more publicity than they'd ever had before.

The craziness that erupted when Katy came to East Side and the insanity over Rihanna's gun tattoo showed me that along with what restaurants and clubs celebrities

go to, and what brand of shoes they wear, the media are also desperate to know who does their tattoos.

Up until that point, I had been mentioning the shop's name whenever I got interviewed about Rihanna's tattoo. I did it not because they asked me to, but because I loved those guys and I wanted them to be part of my success. I wanted *them* to succeed. What I was doing was so good for them, but nobody seemed to care, or even notice. My dream of becoming partner one day was looking more and more unrealistic.

Finally, I'd had enough. When magazines and websites would call asking for photos, as part of the release I started telling them to credit "Bang Bang, NYC tattoo artist," instead of mentioning the store's name. As a result, my business was booming, and nobody else could keep up.

The owners did not seem to even notice that I'd stopped mentioning them, because as far as I could tell they'd never cared that I had in the first place. I felt a little vindicated

when, a few months after I stopped crediting them in any press, they called a store meeting where they announced that they'd had their slowest winter since they'd opened the shop. I didn't have firsthand knowledge of how well they were doing then—I could only go by what they told us—and I can't speak to how they're doing today.

Apparently they hadn't realized that when their free PR stopped, their bookings slowed down along with it.

The one good thing that did happen after that dip in business was that East Side finally got around to putting me up on their website. Even if they didn't notice that their name wasn't in *Us Weekly* anymore, they couldn't help but notice that I was busy working while many other artists were busy complaining. As soon as my portfolio was on their site, it was over: I was booked for eight months in a heartbeat and busier than any other artist in there, including guys who had been tattooing longer than I'd even been alive.

Suddenly, to some, I wasn't "the kid" anymore; I was that asshole.

IT'S A CHALLENGE BUT I LIKE THAT SHIT.

THE TEN BANG

1. INVEST IN YOURSELF.
2. ALWAYS SAY YES.
3. IF YOU LEARN WHEN YOU LOSE, YOU WIN.
4. THE EYE OF A MASTER WORKS MORE THAN HIS HANDS.
5. COMPETE WITH YOUR OWN EXPECTATIONS.
6. FILL YOUR HEART

COMMANDMENTS

WITH APPRECIATION.
7. CONGRATULATE
SUCCESS EVEN WHEN
IT'S NOT YOUR OWN.
8. WHEN SOMEONE
GIVES YOU GOLD,
TAKE IT.
9. WHEN NO ONE GIVES
YOU GOLD, TAKE IT.
0. BECOME YOUR DREAMS.

PART III

LIVING THE

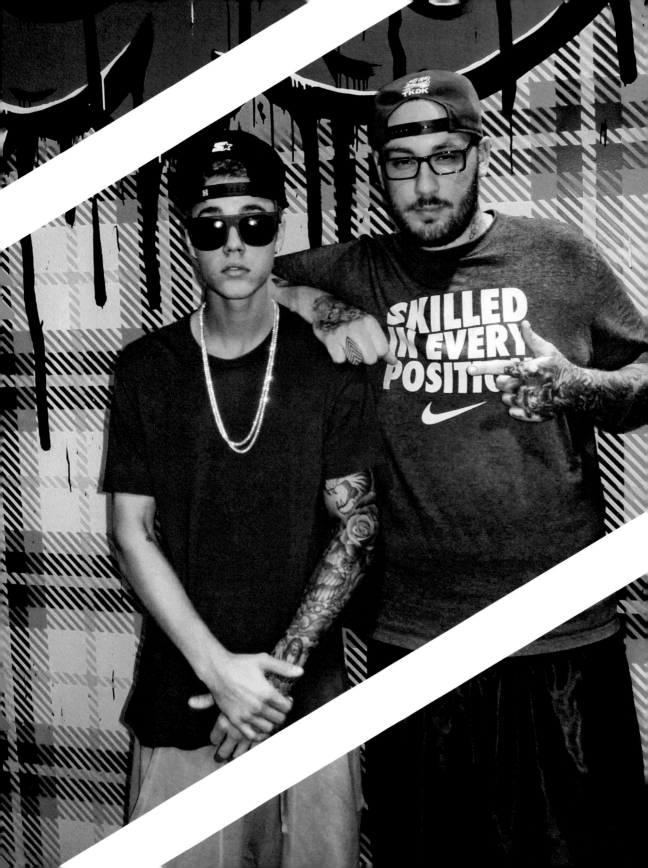

TWELVE

+

JUSTIN BIEBER

When I was growing up, vacations weren't really on our radar. We flew out to California once and Orlando a couple of times when I was a kid, but other than that, it was the occasional day trip. The idea of someday having a job that would require travel was completely foreign.

Yet here I am today, Bang Bang, Business Traveler. Unlike most guys who fly for work, I don't wear a suit or carry a briefcase, and I'm probably the only one traveling with a suitcase full of machines, needles, ink, gloves, green soap, and a bright red sharps container.

I used to hate flying, but over the years, I've grown to . . . well, *love* may be too strong a word, but not hate it with every fiber of my being. Part of that has come from being introduced to the amazing world of first and business class. I'm six foot two, so folding myself into economy seats is torturous. Learning that I can just request an upgrade from clients has changed my world. And private? That's a whole other level . . .

One of the most fun "business trips" I've taken was going to Panama to tattoo Justin Bieber.

Before I start, I need to be clear: I genuinely love Justin Bieber.

He's the kind of guy you meet and you just wish he was your little brother so you could pick on him and give him shit all the time. When I was his age, I was a goofball, except I

didn't have $100 million. If I'd had $100 million, I would've been so much worse—I wouldn't have been pissing in a bucket (as Bieber reportedly did), I would've been shitting in the street.

Meeting Bieber was a trip. The guy doesn't walk—he dances through the room. It's hilarious, and I mean that in a good way. Justin Bieber is feeling himself. Hard.

I know some people hate his guts, but any time he makes a mistake or does something stupid, it's on the cover of every magazine and gossip site. Teenagers are idiots by definition—at least most of us were. He's young, talented, and superrich—of course he's going to be kind of a jerk. Imagine being in his shoes for a day—fuck that.

Besides the fact that he cracks me up—and he *is* funny—I know all the vitriol directed his way really does hurt him. We were smoking weed in the back of the shop one day, and I told him that I'd started having different celebrity clients tattoo *me*—we'll get to that later—and that Adele had just done one on my calf. He asked what I thought of her and I told him. I think she's incredibly talented. I told him we talked about being parents, and how she's happy now and is over writing sad songs about breakups. That James Bond theme she wrote is probably the best Bond song ever written. It blew me away.

So anyway, I'm sort of lost in my story, telling him how much I liked her, and I notice he's just kind of looking down. Then he muttered, "Yeah, I met her too . . . she wasn't really that nice to me."

Judging from my interactions with her, I couldn't imagine Adele being mean to anybody, but Justin looked genuinely bummed. I felt really bad and asked him what happened. He said, "I don't know, man, sometimes people just don't like me." He genuinely felt bad and I felt like a jerk for going on about her in front of him.

Despite what you might have read, I've always found Bieber to be a good guy. He takes great care of his friends and I've never had the slightest issue with him.

Another time one of my clients brought his young Belieber

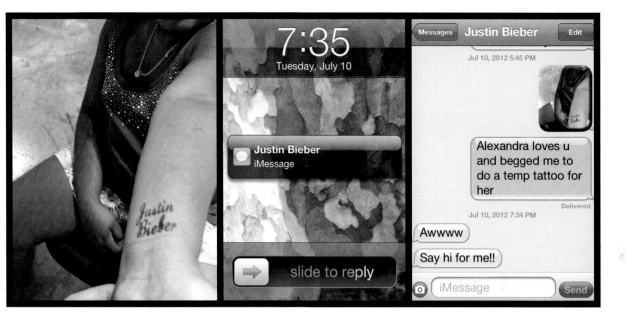

daughter in with him. She knew I'd tattooed her hero, so I drew a Justin Bieber "tattoo" on her arm and texted it to J.B. The guy is super busy and people are always after him for something, so I didn't expect to hear back. But a couple hours later, I hear the telltale "ding" indicating a text. He'd written back, "Awwwww . . . Say hi for me!!"

I showed the little girl and she absolutely lost her mind. She was so excited she was practically crying. That's something that kid is never going to forget. Bieber could've just rolled his eyes and deleted it, but he took a minute out for a fan, which was super cool. So quit hating on Bieber!

Most of my regular clients either text me or call the shop, because I hardly ever pick up my phone anyway. But Bieber somehow always manages to get me, and I'm inevitably caught off guard.

Every time he calls, it's the same thing: "Yo, it's JB."

Then I go, *"Who?"*

And he yells, "BIEBER!"

Then he's like, "Yo, I'm trying to get tatted."

Every time.

But in January 2014, he called and wanted something else. He didn't want to come into the studio, he wanted me to come to him. He'd just been in the news for that DUI and drag racing arrest, and had been released from jail in Miami. He wanted me to come see him in Panama. I thought he meant Panama, *Florida,* but no. He meant the country.

So I dug out my passport and caught the next flight. Once I landed, I was met by a driver in a four-wheel-drive something or other who took me on a crazy two-hour drive through the jungle.

Eventually we wound up at a place called Nitro City. Nitro City is an extreme sports resort owned by X Gamers. Everywhere you look, someone's speeding around on a motorcycle or dirt bike. There are no real safety regulations in Panama, so it's a bunch of young guys going nuts on wakeboards, Jet Skis, and four-wheelers. **You just jump on something and ride. If you die, that's your problem.**

Nitro City is on a slim peninsula called Punta Chame. Most of the peninsula is populated by shrimp farms and mangrove forests, but this is a compound, so aside from the drive, you could be in any beach town—albeit one equipped with a skate park, motocross tracks, and a man-made lake. It's totally geared to young guys who love extreme sports. But I was there to work, so I checked into my room and set up my equipment.

I got a little restless and had no idea where Bieber was, so I went for a walk on the beach. I ran into this hilarious group of young Bieber fans who were so devoted, they actually recognized *me*!

Bieber and his boys were at a campfire down on the beach. It got to be late and I was wiped from the flight and crazy jungle ride, but I just sat outside and looked out over the water, since along with no air conditioning, the room didn't have cable. But it was cool, because I actually saw a shooting star for the first (and hopefully not last) time. I could've gone down to the beach, joined them, and tried to hurry things along, but I stayed put. No matter how much I like a client personally, I don't like to overstep when I'm working. I try to keep it professional, because I need to be focused. When I have tattoos to do—at whatever time of day or night—I keep myself prepared to do them.

By the time they rolled in, it was pretty late and I was tired, but it was really cool to meet Usher. The first record I ever bought myself was an Usher record! He didn't stick around, though.

Eventually, I tattooed Bieber and one of his friends. Bieber got that iconic cross in the middle of his chest. The room was hot and I was sweaty but I still pushed myself to do a great tattoo.

The next day everyone got off to a late start, but eventually we all straggled onto Bieber's private jet, back to Canada.

These guys don't want Hennessy and steaks. Bieber and his boys had the plane stocked

with trees and junk food—KFC, McDonald's . . . it was all there. The plane was so choked with pot smoke that the pilots put their oxygen masks on so they didn't get high. Funny stuff.

Justin wanted to be tattooed while we were in the air, so I set up. Tattooing on a plane wasn't easy. In fact, it's probably one of the more difficult places I've worked. Imagine trying to draw a straight line—with a tiny needle—on someone's flesh, in a moving car. It was definitely a challenge. One of the pilots knew what we were up to, so he'd warn us if we were about to hit turbulence.

I wanted to tattoo "Fly" or an airplane on him, but he insisted on "Forgive." My ideas were cooler. Just sayin'. Next time I tattoo on an airplane, I'm going to tattoo myself, and I'm going to do one of those ideas.

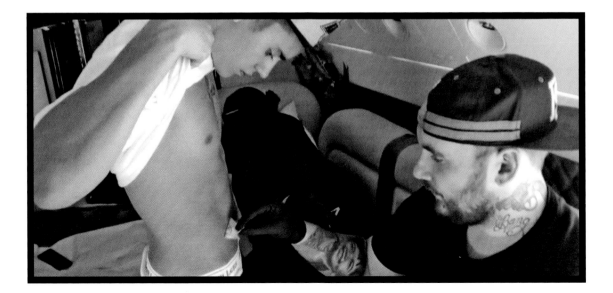

It's not my most complex work, but if you look at the "Forgive" I did on his hip, you'd never guess under what circumstances it was done. So I'm pretty proud of that. Justin told me he meant it to refer to Jesus forgiving and dying for our sins. The press tried to make it seem as though it was done for Selena Gomez, but if it was, he didn't tell me that. He'd gotten the cross the day before, and I think both were pretty meaningful tattoos for him.

Landing in Canada was a little nerve-wracking because we were met by Border Patrol and their drug-sniffing dog. They didn't find anything, because by the time we landed, that weed was *smoked*. ;)

The next week I read a story about the pilots on his private jet using their oxygen masks because of all the pot smoke, but it was for an entirely different flight.

The first time I worked on Bieber, it was a couple years earlier—sometime in 2012. He got my number from his then-girlfriend, Selena, and called to say he'd be there in thirty minutes. About an hour later he walked in with his then-manager. It was a little surreal because the shop was empty except for my manager, Ed, me, Bieber, and his manager. He wanted the word "Believe" on his arm, to commemorate the *Believe* album and tour. This was before he had many other tattoos, and I'd never met him, so we sat at the computer, going through fonts, trying to figure out what style he liked.

It came out kind of cartoony, but I like it. He was a little difficult to tattoo back then because I don't think he was used to the feeling, so he'd fidget.

I tattooed Bieber two other times—once we did a realistic eye based on his mom's eye. Because of where we were placing the piece, Bieber was in a lot of pain, so I had to really tear through it. When you come in for a tattoo, you need to be physically and mentally prepared for it. You need to be well rested, fed, and in top form, physically. The inside of your elbow—we call it your "ditch"—is generally a tough place to get tattooed, and on this day, Justin just wasn't having it. So instead of taking the time to do something detailed, he wound up with a more stylized, less realistic image. (But it still looks great.)

Having a front-row seat to the kind of attention and scrutiny Bieber is subject to is fascinating. It must be strange being that famous. One time he came to the studio with a bunch of people, including a few girls they'd picked up somewhere along the way. We're all smoking weed and his security guy is trying to get everyone there to sign agreements, saying they won't blab to the media or whatever. The girls who won't sign papers, they gotta go. It must be such a shitty feeling, always having to look out for people trying to get something from you. I always ask before I post any photos, and believe me, I see plenty of

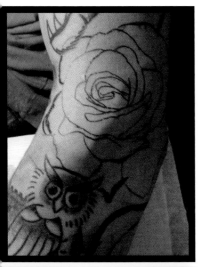

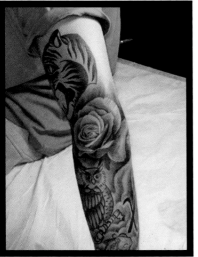

stuff I'd never talk about. Not even in a book. Sorry—I'm gonna rub in that there's some shit I can't even say.

Which isn't to say Bieber's always easy. I've waited on that kid for hours. This little motherfucker called me one night at 3 A.M. for weed. I lived in Bensonhurst or something at the time. And he was all, "All right, I'll be right there." (No, I don't sell weed . . . usually.)

Nothing.

Another time he called me at 7 A.M. As usual, he's like, "Bang. It's JB."

This time he wanted to get tattooed. I asked him what time.

He said eleven. So I get up, get dressed, and go to the studio. I'm sitting there waiting. Hours later he calls. "Can't make it."

I could bitch at him, but that's not going to accomplish anything. Instead, I tell him straight up, send me some bread. I'm not angry, because it's not personal; it's business. And he sent me some money because I canceled other appointments to work on him. Say what you want about the kid, but he's not cheap and he's always done right by me.

Another time, I did a rose and some shading in between a couple of existing tattoos he'd had done by other artists. What he didn't know (and maybe still never noticed), is that as I was tattooing, I noticed I'd subconsciously folded an "S" (for Selena Gomez?) into the petals of that rose. Come to think of it, I don't think she knows I did that, either.

Hiding something within a tattoo—like an Easter egg on a DVD—isn't that uncommon. Sometimes an artist will hide something awful, like a penis, on a client the artist hates, but this one was done with only the best of intentions, because I didn't really know that I was doing it until it was done. They're both such sweet kids and I know even though they're apart, they really love each other. I may not have done it intentionally, but I'm glad it's there.

THIRTEEN

✝

KATY PERRY

After Katy Perry's first tour, she started a tradition of having me close out her run with a tattoo. For the first one, she came to the shop and we tattooed a strawberry on her foot.

The next tour—California Dreams—ended in California (naturally), so Katy started a new tradition of flying me out to go on the road with the band for the last week of the tour.

It's probably not surprising, considering how big her shows are, but everyone who travels with Katy is really professional and extremely nice. The dancers, the band, the crew—I must've tattooed twenty to thirty of them on that tour.

The last night of the tour, at the Staples Center in L.A., Katy's then-husband Russell Brand showed up, wanting to be tattooed. He seemed like a nice enough guy, and even if he wasn't, he was Katy's husband, so of course I'll tattoo him.

He wanted the logo of his favorite soccer team, West Ham United, so I did that, and then, since Katy's logo was a peppermint, he asked for a white spiral inside the logo's shield. Even at the time, I thought doing it in white was kind of lame. His soccer team came first and his wife was an afterthought, done in white so nobody could see it? Not cool, man. Your wife's Katy Perry, SMH!

Before I went on tour with them, I'd asked Katy to tattoo me. She said yes, but when we

got to the last night of the tour, I was down to two gloves. That meant Russell Brand wouldn't be able to tattoo a Jeffrey (which is a doctored joint—see *Get Him to the Greek*) on me, like we'd planned. I'd already done Katy's tattoo the night before, so I wanted to save them for her to tattoo me.

I wasn't sure she'd have the time that last night, but she was adamant that it was going to get done. So she literally walked offstage, pulled on the gloves, and got to work.

Unlike most of the amateurs who've tattooed me, Katy wasn't nervous. I was kind of surprised until I found out that I wasn't the first person she tattooed. She told me she once tattooed a friend in high school with a pin and some ink!

When she landed the 2015 Super Bowl halftime show, I never expected to go with her. But the Monday before the game she texted to see if I could fly out and tattoo her after her performance. My schedule is nuts and I was booked up, but I'm not about to turn down Katy or the Super Bowl. My manager cleared the calendar and booked me a car to the airport.

I love football. The Eagles have always been my team, but since I started tattooing the Giants, I'm kind of professionally obligated to root for some of them as well (unless they're playing Philly—sorry, Odell). When I tattooed Malcolm Jenkins, he was a safety for the Saints. And when he signed to the Eagles, I texted him right away! He wrote back, "My man, you were the first person I thought of." So cool.

Unfortunately, my team didn't come anywhere close to Phoenix in 2015. But still . . . it's the *Super Bowl*! I knew the seats would be phenomenal, so it didn't even matter who was playing.

Getting out to Arizona was crazy. I flew out the morning of the game, not having slept because I'd tattooed the night before until 1 A.M. I knew if I tried to sleep I wouldn't make my flight, so I just stayed up and figured I'd crash when I got on the plane.

Maybe I got about two hours in my seat, but as we were closing in on Phoenix, the pilot announced that Phoenix was fogged in and we didn't have enough fuel to circle until it cleared.

WHAT?! At first I thought they were lying. Since when does Phoenix have fog? It's the desert! But our flight was diverted to Albuquerque, New Mexico, to refuel and wait it out. I was so tired, all I could think of was *Breaking Bad*—which is set there—and picking up

some crystal meth from Aaron Paul's character, Jesse. (Not really—my drug of choice is not meth.) After six hours in the air we spent three hours on that tarmac, still four hundred miles from the Super Bowl.

We finally landed and all my plans for taking a nap, organizing my stuff, and being vaguely coherent were shot to shit. I didn't even have time for a shower. I had great seats for the game—and Katy's show was amazing—but I had to leave after the third quarter to pick up my equipment from the hotel. I still hadn't slept and was just completely exhausted. Imagine doing any job on two hours of sleep. Now imagine your job entailed leaving permanent marks on iconic celebrities. Not an ideal situation.

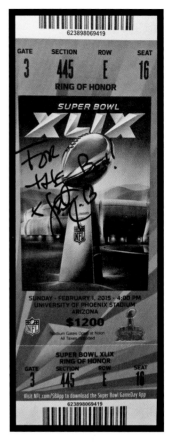

Katy wanted to be tattooed at the after-party, which was being held in this insane house built into the side of a cliff. The place had a pool and hot tub that looked like they were going right over the edge. If you fell out of that pool you would've fallen off that mountain. I set up on the balcony overlooking the pool. Yup . . .

Guests were just starting to trickle in as I finished setting up, and the first person to walk over was Lenny Kravitz. He did a double take and was like, "Oh shit, it's Bang Bang!"

Lenny had been in the shop about a year earlier to get a portrait of his mother done. I knew it meant the world to him, so I recommended that one of my guys, Tye Harris, do it. I'm a great portrait artist, but Tye is greater. I think he's the best in the country, which is why I trusted him to do the tattoo of my daughter on my arm.

But Lenny didn't seem to trust Tye. In the middle of his tattoo, he kept calling me over. "Do you think this is looking good?"

I know Lenny didn't mean to be rude, but I felt so bad for Tye. I kept telling Lenny, "It's a sculpture, and you can't see how it's going until it's done. Of course it's going to look weird when all you have are your mother's eyes." Looking back, I should've done the tattoo, because I can handle that kind of stuff fine. (Tye can, too; I just felt bad putting him in that position.) That's not to say that Lenny was being unreasonable, but his reality is different than our reality. He's this über-creative, space-minded guy, and he just operates on a different plane. He's like Jack Sparrow with a guitar. I mean that in the best way, Lenny.

So at the Super Bowl party, Lenny was there with his daughter, Zoë, whom I'd met with Miley Cyrus the night Miley tattooed me. I obviously didn't have time to do anything big, so I suggested he get a "Z" (for Zoë) on one of his fingers. He liked that idea and said he wanted it to look "a little African . . . a little tribal." I drew something on him and he loved it.

But just as I was about to start, Aaron Paul walked over.

You have to understand, I could meet Obama without losing my shit, but *Breaking Bad* is my all-time favorite show—I've watched every episode over and over, I own the box set in the barrel—and I couldn't believe Aaron Paul (Jesse fucking Pinkman!) was standing there talking to us. But he was.

I'm glad he did it first so I didn't have to, but Lenny hopped up, gushing, "Dude, I love you!"

Yes, Lenny Kravitz completely lost his shit in full-on fan mode. It was great.

I told Aaron the story of my flight into Albuquerque, and how I hadn't slept, and how I'd kept thinking about the show, saying to myself that I just needed to find some crystal meth.

Completely deadpan, he patted me on the back and said, "It's cool, I heard you were looking for something. I'm here for you."

ONE THING I'VE LEARNED ABOUT MYSELF IS I DON'T GET NERVOUS— NO MATTER WHAT.

Aaron, you're more likable than Jesse, and it was such a pleasure meeting you and your wife, Lauren.

I was so geeked out, but he was such a cool, regular guy. His Instagram handle is @glassofwhiskey, so I got us both a whiskey so I could have a drink with him. I managed to get a shot of him pretending to tattoo. He hopped right in—put on the gloves, picked up the machine, but he kept being worried that it was going to go off. I told him not to worry because it wasn't plugged in. He looks like a madman in that picture, but what a nice guy. Meeting him was way better than any football game.

After Lenny and I had calmed down, I finished tattooing Lenny, and a bunch of Katy's friends and family members lined up.

Katy had told me she wanted the Roman numerals "XLIX," commemorating the game, on the inside of her middle finger (Hello Kitty is on her index), so I was ready with a stencil when she got there.

People are always impressed that I get to go to these amazing places, and I completely

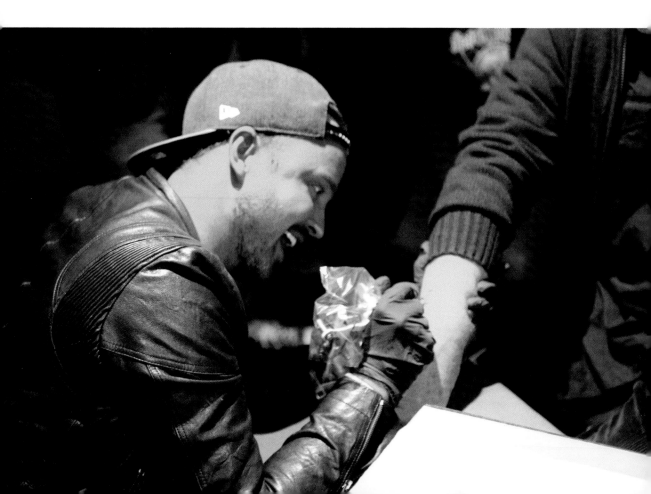

appreciate the opportunity. But the thing they don't always get is that I'm working the whole time. I'm not drinking and jumping into the pool. I did at least thirteen tattoos that night, after nine hours of traveling and very little sleep. So once I was done with Katy, I packed up my stuff and went back to my hotel and died.

There was a lot more downtime when I went to Scandinavia with Katy later in 2015, because the band doesn't play during travel days. Though we were moving every couple of days, the distances were short, so the flights were easy and I had time to walk around the different cities and hang out a little.

Again, Katy wanted a piece that worked with her tour logo, which was a prism, for Prismatic World Tour. One of the cool things about working in this industry at this point in time is how much Photoshop has revolutionized the business. Whereas before I would've been sketching and resketching to come up with something we both agreed on, now I was able to email her about fifty different interpretations of the logo before I even checked in for my flight.

I'd never been to Scandinavia before, so I was happy I was meeting the group in Helsinki, Finland. Traveling internationally always makes me nervous, because I'm carrying needles and ink, soaps and detergents, and you never know what's going to set TSA off. But this flight was uneventful, and business class meant I got a bed, so I slept for practically the entire flight, which is unheard of for this nervous flyer.

When I got into town, I was well rested for once. Instead of crashing, I met up with Leah, one of the dancers I knew from the California Dreams tour, and we went for a stroll.

We saw a couple of sights and then I set up to tattoo, but nobody really wanted anything just yet because they were still getting used to me being around. Oslo was our next city and we stayed at this amazing hotel called The Thief.

The Thief is owned by a billionaire art collector named Petter A. Stordalen. He named it as an homage to high-profile art thievery, mainly *The Scream* by Edvard Munch, which has been stolen and recovered a couple of different times. There's incredible artwork everywhere and a museum next door. This may be the best hotel I've ever stayed at. I mean, how often do you get to eat breakfast sitting next to a Jeff Koons sculpture?

That day I had a little time, so I met up with a friend from Oslo, and everywhere we went there were hardcore Katy Perry fans who were so devoted, they even recognized her tattoo artist. Such a strange feeling.

But things took a bad turn later that night when I tried to tattoo one of the dancers. I set up the converter, plugged everything in, and suddenly there's this weird noise. Shit. My converter stopped working and blew out my power supply. This was not good.

I called the shop, hoping one of my guys could FedEx a new one to the other side of the world. That wasn't going to happen, but luckily I had a Swedish tattoo artist friend who knew a guy who knew of a place that sold tattoo supplies in Oslo. So instead of sleeping in the next morning, I had to get up and track down a new converter and power supply. Oh well.

But eventually everything got settled, and that afternoon and evening I must've done about twenty different tattoos on dancers, band members—anyone and everyone! They all wanted their own unique version of the triangle, so it wasn't like I was doing sleeves or anything. It was really fun and everyone was in a great mood.

As usual, Katy had a party to celebrate the end of the tour—this time it was at ABBA: The Museum in Stockholm. I don't really understand how or why ABBA warrants an entire museum, but okay. . . . A couple of those blond wax figures looked like they were going to get up and walk out. It was cool, though—very Katy.

I got there early and discovered that the floor the party was on was way too dark to tattoo, so I set up downstairs, where I thought I could do a quick piece on Katy and then she could get back to her guests. But when she saw that, it was a no-go. The staff was super accommodating and rerigged the lighting upstairs so I could see what I was doing and she wouldn't miss a minute of her party. Tattooing her was a blast. We got to talk about things we love, like Disneyland and Universal Studios.

THE DOWNSIDES OF
BEING FAME-ADJACENT

I'm not going to complain about working long hours, losing sleep, or the occasional back or hand pain. I love my life and I'm happy to have a career doing something I love. The good things by far outweigh the bad.

When I tattooed Selena Gomez at my apartment, naturally I photographed my work. I posted a picture on Instagram, and the next week, I was in the grocery store and saw my photo of Selena on the cover of a tabloid. The story was all about how she was taking drugs, partying, and getting tattooed. It was both disgusting and infuriating—especially since she was the only person there *not* smoking weed that night. She's a good girl, and that pissed me off.

A couple of weeks after I tattooed Katy and Russell Brand at the end of the California Dreams tour, the two of them announced their impending divorce, and the headlines screamed "Even a tattoo couldn't keep them together!" Again, one of my photos was used without my permission, and I felt terrible about it.

Rock-star hours are fine when you're young and unencumbered, but I have two little kids who get up with the sun, so waiting around until four in the morning for someone to show up isn't always easy for me anymore. But then the upsides—like having Miley Cyrus FaceTime with my little cousin or getting my daughter an all-access pass to the Katy Perry show—kinda make up for that.

+

INKING MICKEY'S GIRLS

When even wholesome Disney girls are getting tattooed, you know tattooing has moved into the mainstream. Just in the little over a decade that I've been working, my female clientele has gone from maybe 25 percent to about 75 percent.

Even the popularity of tattoo reality shows didn't mainstream it as much, since most of the artists and clientele are male. **It took style icons like Rihanna, Cara Delevingne, and Angelina Jolie to transform tattooing into another aspect of fashion.**

So it shouldn't have surprised me when the Disney girls came knocking, but it still did. Ashley Tisdale and Vanessa Hudgens were the first ones I tattooed, but the Disney link also includes Selena Gomez, Miley Cyrus, and Demi Lovato.

SELENA GOMEZ

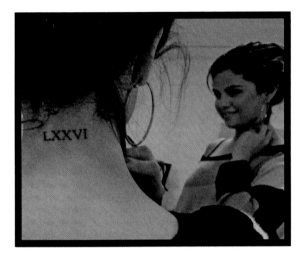

Selena is a special girl. She's incredibly beautiful and talented—just a sweet young woman. I was tattooing her in my house one time and Justin heard about it. He called me and said some funny shit.

Selena started her career on *Barney & Friends* and eventually found her way into a bikini in *Spring Breakers*. She's one of those people who you just like immediately. I didn't know it when I met her, but Selena also grew up poor and was raised by a single mom, like me and so many others.

I've done several tattoos on Selena, including one I've promised never to reveal. And no, I'm not spilling it here, either. I believe the first one I did was Roman numerals on the back of her neck. It's a tribute to an important family member. I'm not sure which one, and I figure if she wants anyone to know, she'll tell the story herself.

Mostly we did her work at whichever shop I was working at, but the night she got the tattoo across her right hip that reads, "God who strengthens me," she actually came to my house. That was the night Bieber called me to say "Keep your eyes off my girl, bro." Haha.

She kept that tattoo a secret for a really long time. I'm not sure why, because it's certainly nothing to be embarrassed about. I think these artists are followed by paparazzi all the time, and the tabloids will go through their trash and interview anyone from their gardener to a kid who went to third grade with them, so I imagine having a little secret—even if it doesn't make sense to other people—is a rare and beautiful thing for them.

In the summer of 2014, she asked me to do some Arabic writing that translates to "Love yourself first" on the right side of her back.

Selena came to me with the lettering already written out. It's only about four inches long, so it didn't take long to do, but figuring out where to put it did. It's important to me that tattoos move with the person, so we moved the stencil around a bunch of times until we settled on that part of her back. I'm glad we did, because it looks dope.

DEMI LOVATO

Before Demi came in for her first tattoo, we got word that she wasn't cool with having drugs or alcohol around her, so we were expected to extinguish our weed and dump any beer. Maybe I was having a bad day, but this put me in a crappy mood, so she and I didn't exactly hit it off that first time. That she came in with a group from *Glee* was another mark against her. Not that they weren't wonderful, but Etsuko always used to make me sit through that horrible show. I must've tattooed five people from *Glee* that night. I guess I figured Demi was just another spoiled showbiz brat. Or maybe I was being an asshole because I hate being told what I can and can't do. Okay, maybe I'm the spoiled kid.

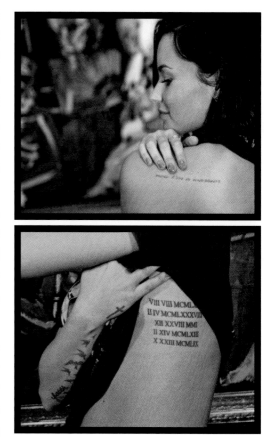

But I'm man enough to admit when I'm wrong, and I was dead wrong about Demi. The second time she came in we totally hit it off, even though I fucked up. She had asked me not to post any photos of what I did and I accidentally let one slip. She was cool about it, but I felt bad.

Demi was also the "victim" of another mistake, though this one wasn't my fault. The tattoo I mistakenly posted was a stack of Roman numerals on her side, each one signifying the birthday of someone she loved. When it came to one of these dates, she later found out she had made a mistake on the year. I offered to try to change it, but she laughed it off, explaining it was fine—somebody just got a little younger.

At last count, Demi has three of my pieces, and I'm hoping we'll do more. She recently told me she want to get tattooed at Disney World. She's awesome.

ASHLEY TISDALE AND VANESSA HUDGENS
(ADDED BONUS: RUBY ROSE)

As far as I know, Ruby Rose has never worked with Disney, but she's responsible for bringing two Disney girls into my life, so I'm including her. She's now one of the stars of *Orange Is the New Black*, but when I met her, she was working as a TV presenter for MTV Australia.

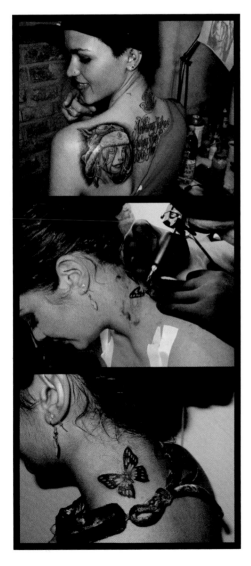

I was in the shop one day when she called, asking if they could do a story about me. She'd seen my work on Rihanna and was super enthusiastic about interviewing me and being filmed getting Tank Girl tattooed on her back.

Tank Girl is a comic (later turned into a movie) about this crazy Australian outlaw/superhero hybrid. The character Tank Girl has blue hair that she mostly covers with a crazy hat. Lori Petty played her in the movie, but Ruby wanted the original comic version.

She came in to do the segment and when she told me that MTV wouldn't be picking up the tab for her tattoo, I gave her a good deal. She was so happy with it that later that night, when she ran into Vanessa Hudgens, Ruby kind of peer-pressured Vanessa into getting tattooed that same night.

I knew who Vanessa was when she called. Who doesn't? I had a crush on her, and tattooing her did not make that crush go away. Vanessa's super cool and very talented. Bummer that her boyfriend is the nicest guy you'll ever meet!

She knew she wanted a butterfly, but didn't know where. We played around with the stencil, moving it around her shoulders and arms, when it finally landed on her neck. It looked amazing.

I mean, a Disney actress and her first time out she gets a neck tattoo!? That is pretty badass. But it looked great on her, and when something fits, you just know it.

The second time she was in the shop, Vanessa brought in another Disney girl, Ashley Tisdale. It's funny that these girls are just known as "Disney girls," because they're extremely accomplished, even outside of Walt's World. Ashley was touring in *Les Misérables* when she was eight years old and sang for President Clinton when she was only twelve. She's released albums, produced television shows, and starred in movies. Amazing woman.

During the time I was writing this book, Vanessa was starring on Broadway in *Gigi*. She's also been in movies (including *Spring Breakers* with her pal Selena Gomez) and countless TV shows.

The two of them were clowning around, laughing the entire time, because for some reason Ashley was wearing a short dress with no underwear. So she spent most of the time trying to cover her ass while I tattooed her foot. It was pretty funny.

Vanessa wanted another, so she got the "om" symbol split across both hands on her pinkies. It's only complete when the hands are pressed together as if in prayer.

We're talking about doing more, but that'll have to wait until she's off Broadway.

+

VANESSA HUDGENS

BB: Why'd you pick me for your first tattoo?

VH: I really trust you. You're amazing at what you do and you're just a cool, good guy.

BB: What do you like best about getting tattooed?

VH: It's such a thrill marking a moment of your life. Something to always remind you of a time you were inspired in a certain way.

I always say if I wasn't an actress I'd have you do butterflies all down my back. I love getting tatted. It's so addicting.

BB: Are you old enough to drink? You were drinking when you got that butterfly!

VH: Ha ha ha, yes! It was my first tat and it was such a random night. I've wanted the butterfly for years, and my New York night led me to you. I was just going with the flow and very happy where it took me.

BB: Are you going to get a tattoo to commemorate your Broadway debut?

VH: Maybe I should! I have two already that I want. I'm just waiting for the right moment. When you know, you know.

BB: Do they make you cover up any of the ink for Broadway?

VH: I cover up my butterfly every night. Sadly, no tats in a 1900s Paris high-society setting.

BB: Which is your favorite and what are we doing next?

VH: I love my butterfly. My "om" is so small, but I love it, too. I really want a bow and arrow. I'm a Sag and love the significance of an arrow—always moving forward.

BB: When are you going to tattoo ME? And what are you going to tattoo on me?

VH: I CAN'T! I'm scared. There's a reason why I'm not a tattoo artist. Ask me again in ten years.

MILEY CYRUS

I've seen some of the most beautiful, talented women in the world half naked, but they're usually wearing clothes when I meet them. When I met Miley, she was in the pool on the roof of her friend's downtown building. So there I am, holding my tattoo equipment, and there's Miley, basically covered only by a few strategically placed strings.

I may have blushed.

We were going to set up on the roof, but it was summer and way too hot for that, so we went down to her friend's apartment. She just wanted a little lettering done on her right arm—the title of a Flaming Lips song, "Love Yer Brain." When that only took a couple minutes, she said she wanted another one. She just wasn't sure what.

As we were trying to decide, friends kept stopping by. Zoë Kravitz was there, along with a few others I recognized. But I'm horrible with names.

While Miley was trying to figure out what she wanted, I tattooed a couple of her friends. One girl wanted a white cloud, which is a lot harder to do than it sounds. Unless you draw it perfectly, it ends up looking like a white blob or some weird skin condition. We nailed it.

I'd already decided I was going to ask Miley to tattoo me, so I suggested we do crescent moons on each other. I'd been wanting the moon on my thumb for a while, so why not have her do it? She loved the idea, so I did one on her inside left elbow.

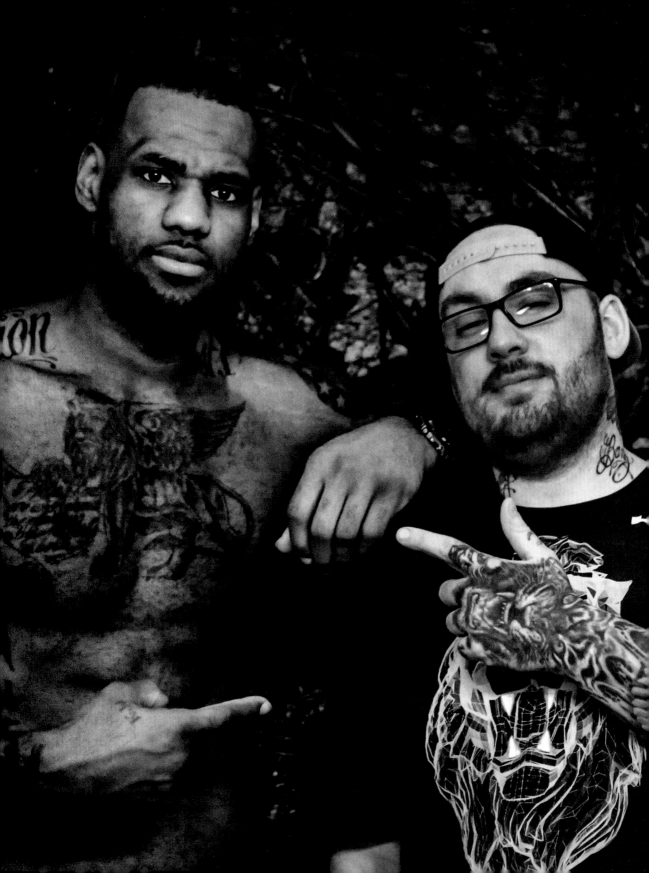

FIFTEEN

+

BALLERS

Growing up, sports were a huge part of my life. Not only was I a fan (I believe I mentioned my Michael Jordan obsession), I played them and played them well. Basketball, football, and baseball were my games, and I still play basketball every week.

So while a lot of people might go nuts upon meeting Adele or Miley, meeting someone like LeBron James is such an honor. I met LeBron after his people asked me to stop by the Barclays Center to see about tattooing him.

Rihanna's manager Jen had texted me a couple months earlier, saying that LeBron's manager, Randy Mims, had hit her up, asking for my contact info. Did I mind if she gave him my number?

DID I MIND?!

When Michael Jordan left the league, it was a huge loss. There was no clear-cut best player in the NBA anymore. The best basketball player is generally considered to be the best athlete on the planet, and at his peak, Michael Jordan was, hands down, the greatest athlete alive. So until LeBron came along, there was really nobody to fill that gap. LeBron had so much hype around him, it was hard to believe he'd live up to it, but he has. In fact, he not only lived up to people's unrealistic expectations, he surpassed them.

So no, I didn't mind if Jen gave LeBron's manager my phone number.

The night I met him at the Barclay Center, I brought along Anatole from the shop. We had great seats, and then we waited around outside the locker room afterward. All the families were there, and one by one the team walked out until LeBron was the only one left inside.

His manager summoned Anatole and me inside and introduced us. LeBron and his wife had just had their third child—their first daughter. He wanted a portrait of her, so we talked about our daughters for a bit. He didn't bring any photo reference—I think he just wanted to see if we connected. I knew one of his old Miami teammates, Dorell Wright, from high school, so I mentioned that. He was a great guy, but I left not knowing if I had gotten the job.

I had almost put it out of my mind when, a couple of months later, Randy—LeBron's manager—texted me at about nine thirty at night, asking if I could get to Cleveland the next day to tattoo LeBron.

One of my philosophies in life is ALWAYS SAY YES, so I quickly said I could and then set about rearranging my life. I called the shop manager and had him cancel my appointments. I called my daughters' mom and made sure she was cool with it. I tried to sleep, but didn't manage much.

The next morning, after about three hours of sleep, I drove to the shop to make my stencil and pack my stuff up. I am a total fan, so on the way to the airport, I stopped at a sporting goods store to pick up a basketball and hat in the hope that LeBron would sign them for me.

Traveling with tattoo equipment is kind of complicated. You need a *lot* of different stuff, and I didn't have a checklist, so I wound up forgetting ink caps. Duh, Keith.

This doesn't sound like a major calamity, but of all the dumb things to forget—and I've forgotten A&D Ointment, paper towels, or gloves—but it's not like I can pick up ink caps at a drug store. It was imperative that I find them.

After Randy picked me up and drove me to LeBron's house, I called a local tattoo shop. I very politely told them that I was a professional tattoo artist, in town for one day to tattoo a local athlete. I explained that I knew this was a weird request, but wondered if they could sell me a bag of caps. I could not have been more humble asking. Didn't matter. They said no without even considering it.

Which isn't surprising, because the vast majority of the people in this industry are

fuckheads like that. I really needed those caps, so I gave it another shot, explaining that they could check my work online and telling them I was in town to tattoo LeBron James.

The store manager said, "If you're a tattoo artist, you should really have your own equipment," then hung up on me.

I was so pissed. I knew it was a weird request, and I already felt like an idiot forgetting ink caps, this guy just rubbed it in. If someone called my shop and had proof that they were a pro in a bad spot, I would not just sell them the equipment—I'd *give* it to them. This is why I hate most of the the tattoo industry. That guy can kiss my ass.

LeBron and his manager couldn't believe it and were all set to jump in the car and go to the shop. Luckily, I found a head shop nearby that sold caps, so crisis averted.

LeBron's house is incredible. I set up in the barbershop downstairs, next to the bowling alley. LeBron's whole family was in and out of the room. His mom, his wife, his sons and new daughter, his trainer . . . even the cook checked in.

His daughter was so cute. Watching LeBron with her reminded me of my kids. The way

that baby looked at him was really sweet. It was a pleasure to tattoo her little face on him. Less of a pleasure for LeBron, who was going through it on this piece.

He's heavily tattooed, but the guy is all muscle and bone, and this piece was in a weird place on the side of his back where there's no fat to pad the impact of the needles. The portrait came out beautifully. Even his mom loved it. She told me, "LeBron is the best at what he does and you're the best at what you do." So sweet.

She raised LeBron on her own, so I felt a kind of kinship with her. She reminded me a bit of my mom. Such a nice, strong woman. I sense a pattern emerging . . .

Athletes' highest achievements are winning things like the Super Bowl, the NBA Finals, or the World Cup. Tattooing someone like LeBron—that's my Olympic gold medal.

THE KNICKS/CAVS

You can't live in New York and not like the Knicks. Yeah, the Nets have Jay-Z, but the Knicks are New York, and I've been lucky enough to tattoo a bunch of them. Though none of them are Knicks anymore, they were when I worked on them.

Oddly enough, my first Knicks connection wasn't with a team member—it was with La La Anthony. Carmelo Anthony's wife is a longtime customer, and one of the coolest perks of my job—and there are many—is becoming friends with such amazing people and even being invited to their son's birthday party.

Their son, Kiyan, is a couple of years older than my daughter Kumiko, and Kumi loves basketball. So she was thrilled to be out on the court, actually playing ball with the best players in the world. I mean, Carmelo Anthony taught my daughter to dunk! There is nothing cooler than that. La La and Melo are the sweetest people; it's easy to see why they have become so successful—they are so genuine.

Though I've never tattooed Carmelo, I have tattooed a bunch of his past and present teammates, including J.R. Smith, who's known for being the most heavily tattooed player in the NBA. J.R. is a tattoo artist's dream because he's open to anything. When he came to see me, he hadn't had any work in two years, which, if you've seen him, is hard to believe because he's so covered.

About a week earlier, Karmaloop had asked me to do a little video segment, and I

knew J.R. was coming in, so I asked him if he'd be all right with it, and it turned out to be a cool little segment. They even talked to his parents!

J.R. and I bonded over our mutual love of Michael Jordan, and it also turned out that J.R. went pro the year I got serious about tattooing and moved to New York. "We were rookies together and didn't know it," he told me. "Two artists, different crafts, same goal: to be great."

Like many people who've been tattooed a *lot*, J.R. wasn't wedded to any one idea for his piece. He knew he was going to see a pro and wanted to see what I came up with. Somehow we got on the subject of Egypt, and I told him I'd always wanted a pharaoh on one of *my* fingers. He thought that sounded dope, so we did that. J.R. loved it. He said, "It's so sick, I want to do the rest of my fingers, ASAP."

And I did wind up doing a bunch of his other fingers—an "off" switch on his middle finger (get it?) and "die for my team" on the knuckles of his other hand.

Before he left for Dallas, Amar'e Stoudemire decided he wanted me to tattoo him, so he invited me to set up at his house during a party he was having for some of his teammates and their wives.

I started off my career tattooing at house parties in Delaware, so that's nothing new, but as you might expect, Stoudemire's house was about 8.75 million times swankier

and cleaner, and his guests knew how to behave themselves, unlike my friends back in Delaware.

Amar'e is an incredible athlete. He was drafted into the NBA right out of high school, was named 2003's Rookie of the Year, is a six-time NBA All-Star, and won a bronze medal in the 2004 Olympic Games.

Along with Amar'e, I tattooed Iman Shumpert, who was just a rookie back then.

Because I'm such a big basketball fan, I really wanted Amar'e to tattoo me. I told him he could do whatever he wanted, and so he tattooed two things that are really important to

him: a basketball—for obvious reasons—and the word "Yahweh," to symbolize his recent discovery of his Jewish roots.

I've talked about how important Instagram has been for my business, but back then it was brand new and I'd just signed up the day before this party. So I was really happy that the photo of Amar'e tattooing me was my first post.

I've done a bunch of tattoos on Amar'e over the years I've known him, but probably the most significant one commemorated the date his brother Hazell passed away in a car crash. I've done a lot of memorial tattoos, and they never fail to break my heart. Even if you've never met the client before, these pieces always bond you to the person you're working on, and Amar'e was no different.

ODELL BECKHAM JR.

Odell came into the store one day to talk about getting a tattoo to fill some open space just below his neck. It was pretty straightforward, and he let me design something that fit. He had a lot of ideas, so we talked about those.

The idea of the collar was the birthdays of his mother and father because he's very close to his family. Just recently he brought me a copy of *Madden 16* with him on the cover and signed it.

He's a really inclusive dude. He's asked me to work on a collaboration with a clothing brand, and that helps my business.

I even started working on his entire back, which includes a *Planet of the Apes* theme—pretty cool. He's fine with the

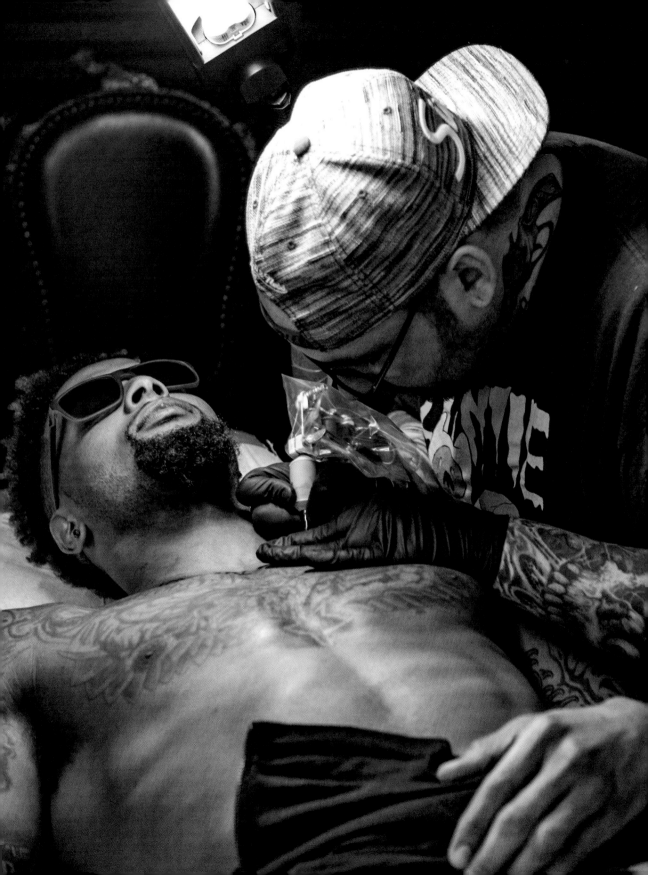

pain. We have a lot left, but we got a good start. We started to design for his stomach and ribs—he had a really great idea for that, but he wants to finish his back before we start.

Odell and I get along really well. I think we're cut from the same cloth. He's able to laugh a bit at his fame, which is really healthy because he can keep it in perspective and stay true to himself. He's genuinely very cool.

The funny thing about Odell is that when he comes, he brings his mini Segway and I bring mine and a mini Segway dance-off breaks out. We have this healthy competition about who has been to more theme parks.

New people are often tough to trust, so when you meet someone of such prestige, it's great that the only reason they're hanging around is because they want to hang around.

It's cool to have an awesome client. It's cooler to have an awesome friend.

MALCOLM JENKINS

When I tattooed Malcolm Jenkins, he was a Saint, and that was okay, but I'm much happier now that he plays with the Philadelphia Eagles. Meeting him and his wife was awesome. He recently sent me this signed jersey. Since I'm a crazy Eagles fan, I'm constantly texting him and he always puts up with me. Such a humble, cool guy.

IT'S AN AMAZING FEELING TO BE A FAN AND A FRIEND.

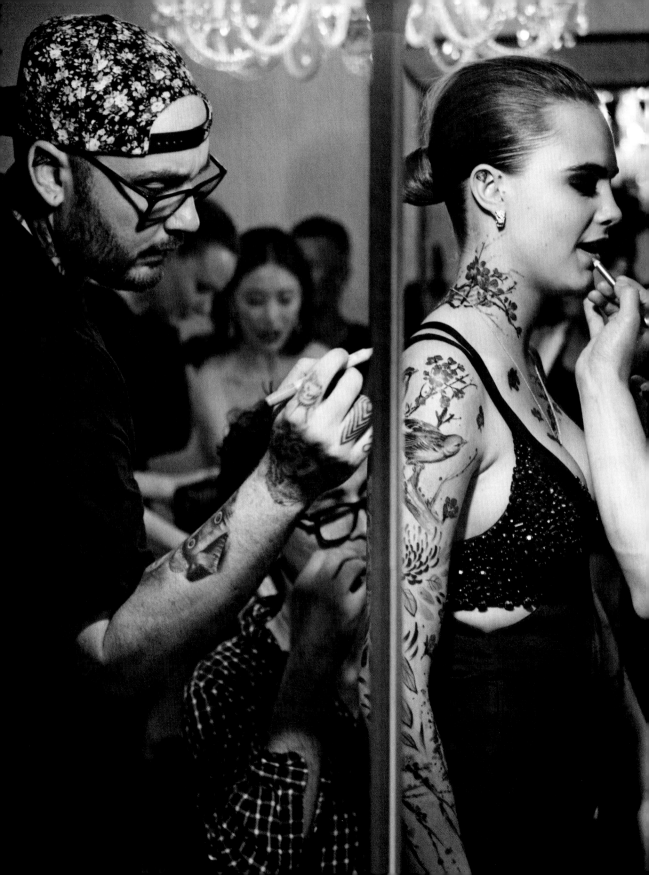

SIXTEEN

+

THE INTERSECTION
OF FASHION AND TATTOOING

Back in the not-so-long-ago day, the only people who had tattoos were bikers, sailors, metalheads, thugs, and punks. But over the past fifteen or so years, tattoos have not only become more mainstream, they've become another avenue of fashion.

I remember someone telling me that fashion is momentary, fleeting, and ever evolving. And while tattoos are the polar opposite of that, there are also many parallels between the two.

Obviously, like clothing, jewelry, and even cosmetics, you *wear* tattoos. Only you can't slip out of them and into something different. They're a way of adorning yourself that's been around for thousands of years.

If you think about it, tattooing and style in general can define culture. You can tell in what decade a photograph was taken from the styles of clothing worn, and tattoos have similarly evolved. In the fifties, sailors would come out of the service with a pinup girl or

an anchor on their arm; now you may see a similar girl tattooed onto a pop star like Rita Ora, but you're just as likely to see formerly verboten white text running up a supermodel's arm or a hyper-realistic portrait done with the kind of precision that never would've happened back in the day. The tools haven't changed much, but tattoo artists back then just didn't have the technique and information to do what we can do now—they were laying the foundation for our successes.

How a person looks and, maybe even more crucially, how they *feel* about how they look will always be important. I had teeth that I hated, so I got new ones. Some people get surgery to correct things that bother them about their bodies. So why wouldn't they choose to be tattooed? Yet I know people who put more thought into their haircut than they do their tattoo. That's silly.

There are some incredible tattoo artists doing cutting-edge work in the world, yet they're not as revered as fashion designers. And with all due respect to the fashion industry, there's something wrong with that. Think about it: fashion designers have teams of workers executing their designs; from conception to execution, tattoo artists do it all themselves. And we have to get everything right the first time around—there are no alterations if a tattoo doesn't "fit." **Tattooing is the most difficult medium in the world.**

And fit is important, whether it's tweeds or ink. Any artist worth your time knows how important it is to design to complement the client's body. Clothing is generally made for one body type and then sized up and down from there. With a tattoo, the artist has to customize their work to one unique body type. A tattoo that looks great on a professional wrestler is not going to look right on a suburban mom. We need to make sure the tattoo complements your shape and fits the curves, contours, and natural angles of the body.

Colors aren't one size fits all, either. A shade that looks great on pale skin with pinkish tones will look like mud on someone with more golden tones, and vice versa. Some tattoo artists don't take that into account, but a good one will.

As I said before, where you place the piece is just as important as the design of the tattoo. A beautifully rendered piece is a waste of time and energy if it's in a spot that doesn't accentuate its full potential. I mean, would you wear gloves on your feet?

There's a delicate balance that people need to find for themselves in the way they adorn themselves. Coco Chanel famously said, "Before you leave the house, look in the mirror and take one thing off." I love patterns, but sometimes I don't pay attention when

I grab my clothes in the morning. I think I look fly until I look in the mirror and realize I look absolutely ridiculous, and I have to check myself. SMH . . .

Of course, there are some people who look good no matter what they wear, but those people are few and far between. And they're probably not you or me.

But everyone has something beautiful about them. Every body is unique and everyone has a part of them that we can accentuate. Like the best-made clothing, *you* should wear the tattoo; the tattoo shouldn't wear *you.*

Over the past ten or so years, the world of high fashion has begun to embrace tattoos. Supermodel Kate Moss has birds on her back that were tat-

tooed by the great painter Lucian Freud. Gisele Bündchen paid tribute to her late grandmother by getting a star inked on her wrist. Designer Marc Jacobs has more tattoos than many tattoo artists, and I've even tattooed one of Karl Lagerfeld's male muses, Baptiste Giabiconi. At the 2015 *Vogue*-sponsored Met Gala, no fewer than *ten* people I've tattooed were in attendance, including Miley Cyrus, Jourdan Dunn, Lenny Kravitz, Rita Ora, Vanessa Hudgens, Selena Gomez, Katy Perry, Justin Bieber, and two of my favorite tattooed fashionistas, Rihanna and Cara Delevingne.

I know I've talked about her a lot in this book, but Rihanna is one of those incredibly special people you rarely come across in life. She's funny, sweet, and just so intensely talented. She's also one of the best-dressed women on the planet. In 2014, she was named Style Icon of the Year by the Council of Fashion Designers of America. Everything that girl wears is breathlessly noted by the fashion and entertainment press.

So I feel a great responsibility when I work on her. The most important thing to remember when you're working on a beautiful woman is to make sure that your work complements her beauty, rather than overwhelming it.

I make sure to never do anything too dark around Rihanna's face. When I tattooed "Rebelle Fleur" on her neck and "Never a failure, always a lesson" (written backward so she

+

JEWELS FOR RIHANNA

I'm not the only one who's tattooed Rihanna, and I mostly love the work other people have done on her. Whoever did the iconic Isis on her chest did an amazing job. But one piece I never cared for was the traditional Maori tribal piece on her right hand.

I never said anything about it, but when she texted to ask about a cover-up, I knew exactly which piece was going. I may hurt someone's feelings by saying this, but that thing needed me.

I get that many believe that traditions are to be honored and that to erase that tattoo might be a minor crime to some, but I put aesthetics before inspiration. If your visual is fucked up, who cares what it means? Know what it means to me? It's showtime.

Ri was staying at Casa de Campo in the Dominican Republic when she decided she wanted to work on it, so she flew me down. She was in the pool when I pulled up. I feel like we're friends, but she's paying me to be

there, so it's not like I'm going to hop into my trunks and jump into the pool with her.

Instead I went inside and scoured the house for furniture that I'd be able to tattoo on. I dragged a table over to a sofa and set up. When Ri came in, she was tired and I was still drawing, trying to work out exactly how to cover that thing. When I was finally ready, I reached over and grabbed her arm, and she just about jumped out of her skin: I hadn't noticed she'd fallen asleep.

I wanted the tattoo to look like a delicate bracelet or a lace cuff, so we decided to do a twist on the mehndi that Indian women wear during holidays and weddings. Only unlike the temporary henna that's traditionally used, this ink would be there to stay.

I've done a lot of intricate work on Rihanna, but this was the most difficult tattoo I've done on her. The falcon on her foot was hard because it hurt her the most, but this was the hardest because it was such a technical challenge.

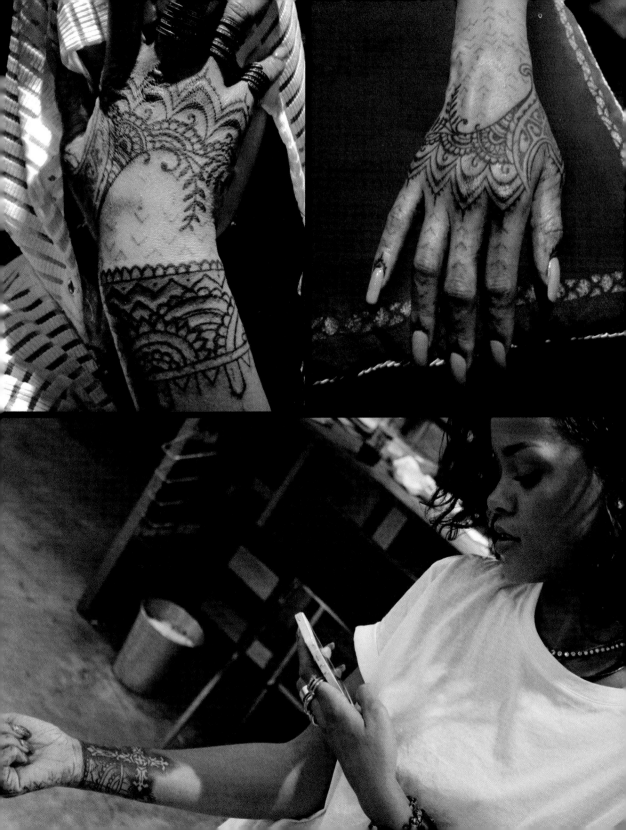

can read it in the mirror) on her collarbone, I was hyper-aware of how close to her face I was working. By using very small needles and a light touch, and by diluting the pigment, we were able to make something that's more like a delicate chain than a tattoo. Both pieces work almost like jewelry—moving with her body, never trying to steal the show.

Tattooing on anyone's hands—let alone a woman's—used to be only for the seriously hard-core tattoo addict. That all started to change after Rihanna asked me to ink "shhh . . ." on her right index finger. I don't know why she got that tattoo, but I did know I had to make something visual and decorative, like a secret ring on the side of her finger.

It's tiny, but a lot of thought went into the shapes and the angles of those letters. I feel like it really fit her finger.

None of us ever expected that Cara Delevingne's lion would blow up as it did, but it's everywhere. It, along with Cara's beautiful face, stares down at me from a TAG Heuer billboard on the BQE. She's not even wearing a watch in the ad!

It also shows up in her Chanel ads in magazines, the subway—everywhere I go I see that lion. I had figured some of her bigger clients might want to Photoshop it out, but far from wanting to cover up the tattoo, most of them seem to think it's an asset. The watch company even arranged for her to carry a lion cub when they launched her as the face of the company.

Since that lion, I've tattooed Cara more times than either of us can count—we even have matching diamond "earrings." Probably the height of tattooing-meets-fashion was when Cara asked me to cover her in Chinese-themed (temporary) tattoos for the Met Gala I mentioned earlier. From what I've been told, this annual event is like the Super Bowl of fashion, with designers and celebrities flaunting their best at The Metropolitan Museum of Art.

Cara had called the week before the gala and just told me she wanted to be covered in temporary tattoos for this "major" party. And that's all she needed to say—of course I'm in. I didn't get a lot of information early on, except I knew I had to figure out how to cover her in a HUGE temporary tattoo. The only reference I had was the theme—"China: Through the Looking Glass."

I'd never done anything temporary before, and with my crazy schedule, I didn't have a lot of time to explore how to do it. So I went to an art store and just started drawing on my skin, seeing which markers I could manipulate fastest and which produced the right kind of color on skin, because I knew timing would be tight, and skin is tricky.

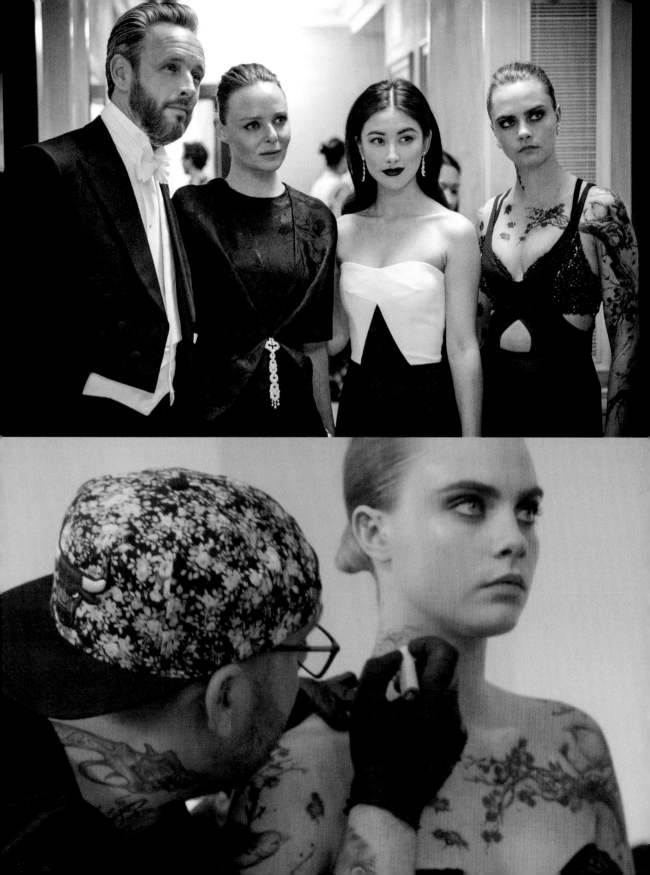

The people at the store must've thought I was insane—weird guy in aisle three draws all over himself, then turns up at the register with a thousand bucks' worth of markers. But I needed to be prepared. Ets is a makeup artist, so she helped me buy body makeup to try, too.

Cara emailed designs of the jumpsuit she was wearing and came in to talk about the "tattoo." Two days before the event, she came in for a thirty-minute test run. I had to see what kind of timing would be involved. I can usually estimate how long a tattoo will take, but this was something different. I tried the body makeup, but that was too much like paint, so I tossed it aside in favor of the markers.

The night before the gala, I didn't trust myself to get up on time, because I was tattooing until 2 A.M. the night before, so I actually slept at the shop. Cara showed up at nine thirty that morning and we got to work. Hector is an artist at the shop who does really amazing precision work, so he helped out, inking a fan I'd designed on the back of Cara's neck, while I worked on the rest of her. I thought it would be a cool opportunity for him, as well as a big help for me. He did a great job.

Then we took a break. Hector went home and Cara slipped into a jacket and went to her sister's birthday party. When she came back and took off her jacket, everything Hector had done was gone. Everything had to be done by 7 P.M., and I was out of time!

By this time we'd moved on to the Carlyle Hotel and set up in Cara's room. I worked on her for a while—now Cara has two people working on her hair, another person doing her makeup, someone giving her a manicure, while I'm trying to reach between all these moving people to draw blossoms between her breasts and up her neck.

At one point I feel someone kick me in the ass. It's Stella McCartney, who mouths "Amazing!" at me. That was pretty cool, because what I was doing wasn't what they'd

envisioned at all. They wanted something symmetrical because Cara's features are symmetrical, as was the jumpsuit she'd be wearing. But I knew that all that symmetry would just look strange, and Cara made the call that I could do whatever I wanted to do. Which was to abandon their design and do my own. Style.com said my "unconventional take on Chinese iconography struck the perfect balance between edgy and traditional."

One of the craziest times I tattooed Cara was on a rooftop in SoHo with her sister and a bunch of their friends. Cara put on Beyoncé, and all these beautiful girls are dancing around and pulling down their pants so they can show me where they want me to tattoo them . . .

I'm definitely not in Delaware anymore. Crazy life.

The thing about Cara is that yes, she's a supermodel, but she's also such a goofball. I mean, I tattooed the word "bacon" across the bottom of one foot and "Made in England" across the other. The girl does not take herself too seriously at all. She's so much fun, you can't help but love her.

Another time she arranged for me to tattoo her and another British supermodel, Jourdan Dunn, for Jourdan's web series, "Well Dunn." They were filmed eating Thai food, then having me ink double Ds (for Dunn and Delevingne) on each of their right hips.

It's funny to think that this kid from Delaware has created art that's being worn alongside Chanel, Burberry, and Balmain in international ads and has even appeared on the cover of *Vogue* a few times, but I'll take it.

✝

CARA DELEVINGNE

BB: Is there any place on your body you *wouldn't* tattoo?

CD: Um . . . probably not my face. I've already done my ears [she and I have matching diamonds], so anywhere . . . Hmm. Probably my face. I probably wouldn't do that. Or my vagina . . . probably . . .

BB: Why did you want a "bacon" tattoo?

CD: It's not just that I love bacon so much; I feel like something about bacon reflects my personality. It's salty and it's bad for you and it's delicious. I just love it so fucking much, that's why.

BB: What do the four white dots on your ribs mean?

CD: Each dot represents a member of my family.

BB: If you were to tattoo me again, what would you draw?

CD: A penis.

BB: A penis! Why?!

CD: A penis is just the first thing that came to my mind. Nah, I would draw bacon on you.

BB: How did it feel when you tattooed me?

CD: It was so scary at first. It was terrifying, but then I actually liked it.

BB: What's your next tattoo and where are we going to put it?

CD: I want to do something on my legs. Maybe behind my knee, kind of on the back of my calf. I want a nice symmetrical shape, I don't know exactly what though.

BB: How do you feel when you see girls who've copied your lion tattoo?

CD: At first, I'm like, "Aw shit, that's annoying." It's a weird feeling. But I guess imitation is the best form of flattery, in a way. But it's sad because it's for life and it's quite important to me.

I can't fault people for getting something beautiful on their body. So in that way it's cool, but at the same time, I hate it.

BB: Which is your favorite tattoo?

CD: God, each one has such a strong memory with me. I love the diamond because we both have it.

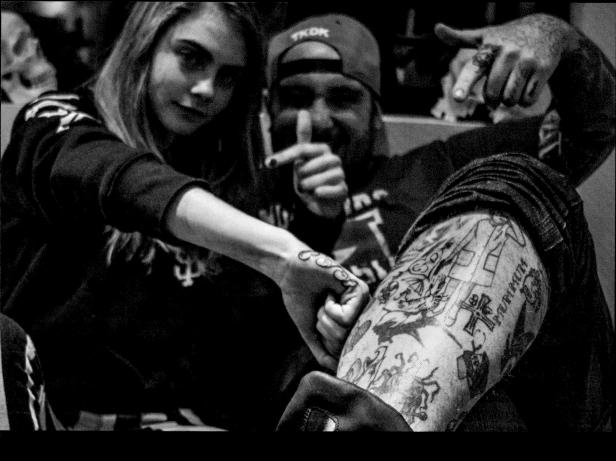

And "Don't worry, be happy" was a big one for me because it's my largest and I see it the most often.

Obviously my lion gets complimented the most, for sure. "Made in England" is also . . . Oh, I don't know. I don't have a favorite. They're all special.

BB: Have you ever gotten crap from modeling clients?

CD: No. Never. Just from acting jobs, because I have to go in three hours early to have them covered up.

BB: If you could convince Karl Lagerfeld to get a tattoo, what would it be?

CD: His cat, Choupette. Or the Chanel "C" on his butt.

BB: What about Anna Wintour?

CD: I would have her get a phoenix on her vagina.

SEVENTEEN

+

MY "REGULAR" REGULARS

We've talked about my celebrity clientele, but you won't find most of the people who come to see me on the cover of a magazine. That doesn't mean they're less important than the celebs—in fact, our whole shop philosophy is built on treating everyone equally.

And just as a bar staff loves their regular drinkers, tattoo artists can develop long-standing relationships with loyal customers. Why wouldn't we? We spend hours together, and if the client likes what we've done, they're going to want to come back for more.

I already mentioned Lucy and Richard in the first half of the book, so here are a couple of the other customers who've become my friends over the years.

ARA DYMOND

BANG BANG SAYS: Ara Dymond is a sculptor, a friend, and one of the coolest guys I know. He helped me build out the store, and he also has the weirdest collection of my tattoos out of anyone I've ever worked on. The funny thing about Ara's tattoos is that they're way outside my comfort zone. He wants me to do things upside down, in dumb spots that don't make sense . . . I never know what we're going to end up with. Normally I try to steer people into putting their tattoo where I think it'll look best, but not with Ara. That guy can argue! Eventually we got to the point where I give him the stencil and he goes to the mirror and works it out. Because otherwise we'll waste two hours arguing about it.

ARA SAYS: We started by tattooing bent coins on me and moved on to the Metropolitan Museum of Art logo pin and art deco mirror clips. They are odd shapes are based on sculptures I've done. Even though Bang Bang doesn't like doing traditional tattoos, when he did one on me, he did it better than anyone who does that regularly. At that point, I realized he can do anything. We've picked out art deco fonts, he tattooed the very first emoji on my arm . . . but my favorite one is for my dog. A couple of days after my dog died, I wrote her name in concrete near my apartment. I took a picture of that and Bang Bang did it from the picture. I feel like that one is as good as it gets.

THE VAUGHNS

BANG BANG SAYS: The Vaughns are the craziest set of brothers—I love them. There's the Blade (Anthony) and his slightly younger brother, Tornado (Chris). I've been working on them for years—they'd even come over to my apartment when I was between shops and we'd get filet mignon and Jameson and just tattoo all night.

I've come to really admire their late father, even though I never met him. They know about my issues with my own dad, and they had such a great one. When you meet them, you can see that their dad made two really great guys. It gives me something to aspire to in the relationship I have with my kids.

They're both enthusiastic gamblers, so doing the Seven Deadly Sins made a lot of sense. I need to remember that it's always a party with the Vaughns, so I make sure they're the last clients of the day.

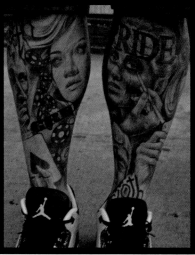

TORNADO SAYS: My dad passed away in August 2011. He was from the old school—he didn't want to hear about doctors or any of that. He owned a strip club for twenty years, sold that, opened up a trucking company in '93, and my brother and I run it to this day. The way my old man set things up, we never argue over business. I mean, we argue over dumb stuff, but we never stay mad at each other. Anthony was the first one to come to Bang Bang.

THE BLADE SAYS: The first piece Bang Bang did on me was a portait of my father, which is obviously great. But now we're in the middle of covering up this back piece that has taken twenty hours already, but we think it's going to take about a hundred. But even

more than the tattoos we end up with, it's about the experience—the interaction, and his personality. It's always a lot of fun. I'm not going to stop after my back is done, either—I've got two arms and two legs. This is a lifetime commitment.

ASHLEY HERNANDEZ

BANG BANG SAYS: Ashley was one of the teenagers who was always hanging around the tattoo shop when I worked over on Sixth Avenue and West Fourth Street. She was our little tattoo fan. That little stretch was rowdy ten years ago, but now that most of the tattoo shops have closed, maybe it's not so much anymore. Ashley used to get tattooed by everybody. I had tattooed her best friend, and later I tattooed Ashley a bunch of times. We just always got along—we even had our kids at the same time. As far as tattooing goes, she lets me do whatever I want. She had a bunch of typical flash-type tattoos, so we've been combining them into a nice sleeve. She's got neck and face tattoos, too.

She hasn't aged a day since I met her, so when we needed a cover model, I just called my friend Ashley. You'll see photos of her throughout the book.

ASHLEY SAYS: I used to go to an alternative high school on West Fourth, and after school was done for the day, I'd go over to Sixth Avenue and hang out with Bang Bang and the rest of the crew. That's where I got the fever and started getting tattooed (but not till I was nineteen). I have to say, my arm is my favorite. There were a bunch of smaller tattoos scattered around that he combined into a beautiful sleeve. I'm trying to fill in as much of my body above the waist as possible. Next is my stomach—I'm still thinking about what to get. Once I know, I'll talk it over with Bang because I always listen to anything he tells me.

I'M NOT GOING TO STOP... THIS IS A LIFETIME COMMITMENT.

—ANTHONY VAUGHN

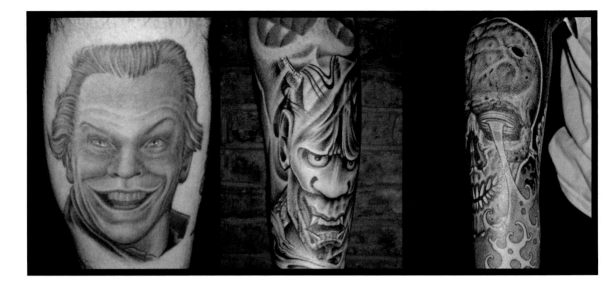

EDWARD BOREW

BANG BANG SAYS: I not only learned how to tattoo on my cousin Ed, I learned how *not* to tattoo on Ed. I struggled through Ed's tattoos and sometimes I excelled through them. Ed was that big step. Every time I was trying to learn something new, I tried it out on him. Sometimes it was great, and other times I'd miss and it would kill me. But Ed never complained.

The worst failure I had on Ed was his Chucky tattoo—I was trying to put some motion and flow on it and I couldn't pull it off. I really like the tattoos I did on his arms. Because they were more visible than his legs, I always made sure that the stuff I put on his arms wasn't too big of a test, so I would wait until I was fairly sure I knew what I was doing.

Most of them still look cool today, even though they're older. I still try things. In some cases, Ed's skin was kind of like a classroom. Tattooing right next to my teacher Little Dragon's tattoo was a learning experience. Tattooing alongside the one I did with Needles taught me a lot about how to apply blacks and use texture in contrast. Ed's tattoos also gave me confidence. Everywhere I worked, people would gawk at them, which is how he got the nickname "The Portfolio." He'd walk into a shop and everyone would be like, "Oh, The Portfolio's here." And my portfolio was stronger than anyone else's.

ED SAYS: The first tattoo I tried to do was a kanji on my thigh, but the first one Keith did was a big tribal flame in the middle of the inside of my arm. He did it with a liner—no shading needles. Not only is this way more painful, but it takes forever. Imagine painting your house with a tiny pointed paintbrush that you'd normally use for tiny details. Except it's metal and pointed. It took forever and I was heavily bruised.

It's a wonder that some of those first tattoos are still visible, since we used to pile gobs of A&D ointment on afterward. Only later did we find out that if you choose to use A&D, you should only use a thin layer. (Ideally you should use a non-petroleum-based product.) That first weekend we did the flame and a bracelet around my left wrist (which I still have), and he redid my kanji because it was so bad.

The first one he did in a shop was a gun with roses on the handle at Rage of the Needle. He had to do such a long straight line that he actually had to stop halfway through because he was in such a panic. But it still looks pretty great today.

When he did Tony Montana on my shoulder, I thought I was so cool—I'd go to the mall with my T-shirt sleeve rolled up so everyone could see. The last tattoo he did on me was to cover that up!

It's so hard to photograph tattoos well that it's best to get an idea of someone's work in person. So I've been used as Keith's portfolio many times. Among dozens of other pieces, I have about nine horror portraits and a total of about 250 hours of work spread over my body. You can really see the evolution of his style and how he's always learning just by looking at me. Like I have a hanya by Little Dragon, and on the other side of that same arm is an oni mask Keith did after working side by side with Little Dragon for a while. They're both amazing.

One of my favorites is a horror piece on my right arm—it's got new-school color and waves of Japanese-inspired blood pouring out of the eyes.

I had a front-row seat for how someone learns how to tattoo when Keith worked on my chest piece with Needles. It was like witnessing a master class. A very cool experience.

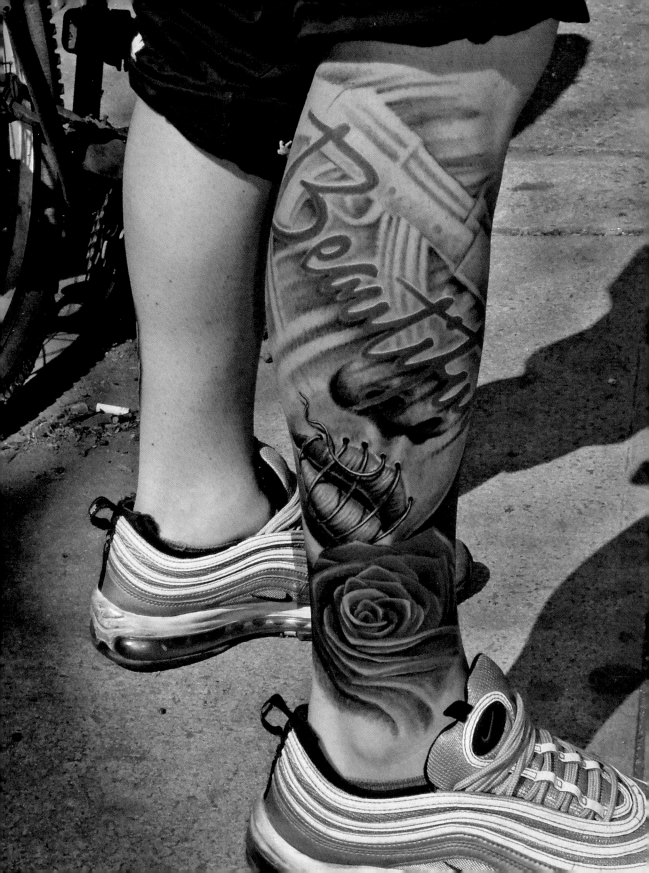

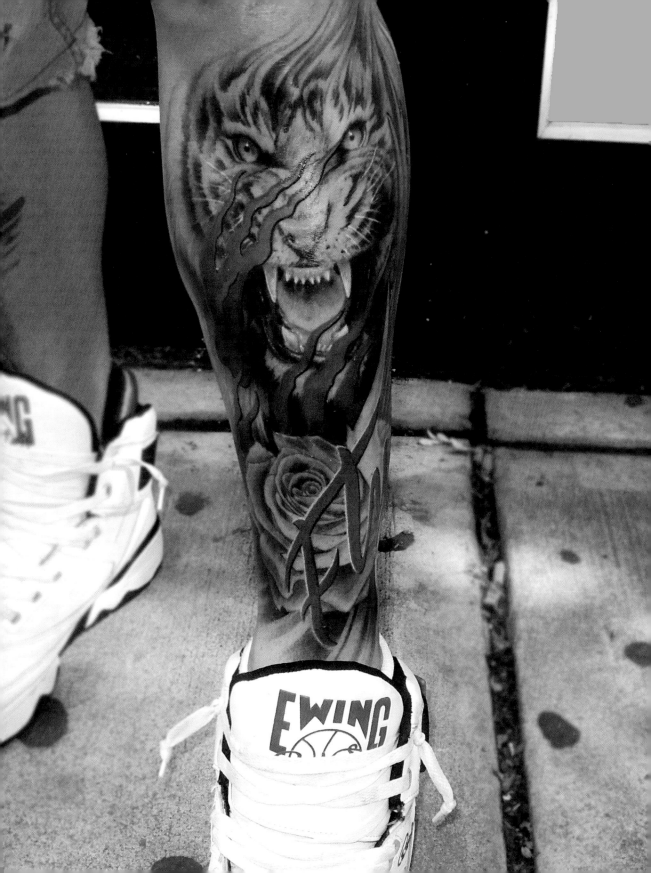

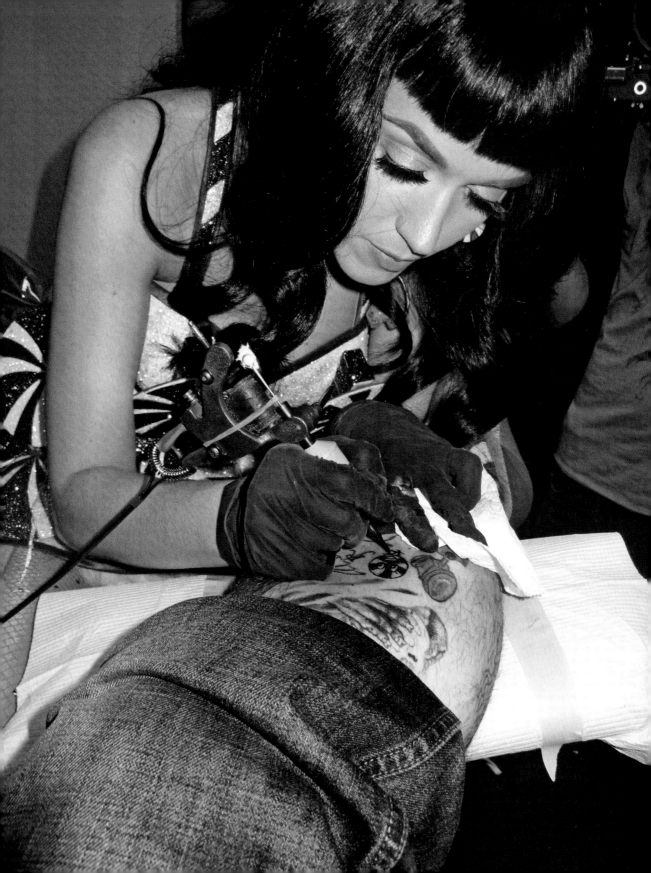

EIGHTEEN

+

CALF OF FAME

Some people want photos with their favorite celebs—I want them to tattoo me. I'm like a needy fan, but instead of a selfie, I need a thirty-minute autograph.

Let me make it clear that I don't care how famous they are, I'm not just setting these people loose on my leg with a tattoo machine. I'm a professional and I oversee every second of the process. I caught so much crap for letting celebs tattoo me—TMZ called the health department, the New York *Daily News* said Justin Bieber was going to be fined two thousand dollars for tattooing without a license (never happened, never would), and the *New York Post* said Rihanna had "left an indelible stain on [my shop's] record." Bitch, please. The reports of my staining have been greatly exaggerated.

Despite all the hysteria, nobody got fined, nobody got in trouble. What these news outlets don't understand is that people at the health department would text me and tell me they're on their way. Those guys want tattoos, too. And to fine anyone, they have to catch you in the act, which never happens. It's like a cop giving you a speeding ticket because he hears fourth-hand you were going eighty one day last week.

I love all of my tattoos, but looking at my calf makes me really happy because all of these were done while I was having a really good time. Let me break it down . . .

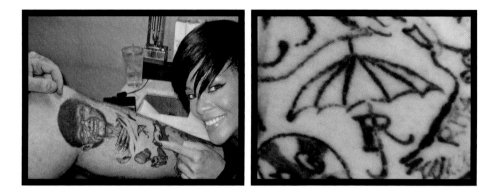

UMBRELLA This one's my favorite because it was my very first celeb tattoo and Rihanna did it. After all the tattoos I've done on her, I wanted her to tattoo me. Obviously, we picked the umbrella because "Umbrella" was one of her biggest hits, which also dropped right around the time we met. As cool as she is about getting tattooed, she was nervous tattooing me at first. But she got the hang of it pretty quickly. TMZ was outside the shop snapping pictures as the writer called the health department, hoping to turn it into a big story. I guess that would get them a lot of clicks. The health department did show up eventually and found one unlicensed artist in the place (*not* Rihanna), and he was fined. Other than that, nothing.

PEPPERMINT I traveled with Katy Perry for a whole week during her California Dreams tour. We went all around California—Sacramento, Oakland, San Francisco, and L.A. The tour ended at the Staples Center, and at the end of her last show, Katy walked offstage, still in costume and makeup, sat down, and tattooed this candy on my calf with her initials un-

derneath. I love that girl. She'd been on a *yearlong* tour and the last thing she did was sit down and give me a tattoo because she had said she would. I'll never forget that. That was so special.

HEART We did this the day I tattooed "CJD" on Cara Delevingne. She was so nervous to start—I have video of her looking at me in terror—though she eventually hit a point where she was super into it.

21 One of the perks of my job is the opportunity to meet people who I'm inspired by, and that happened when I got to tattoo Adele. This girl makes timeless music—how many people make timeless music? Getting to talk to her and see what kind of person she was was an amazing experience. I tattooed a few things on her—including her new son's name and the word "Paradise" on the side of her hand.

Adele and Chris Brown were the best amateur tattooists. She did a little "21" in green, and it's clean. It's money. She nailed it. If she quits singing, I'll hire her.

DOVE WITH ITS TITS OUT Tattooing Rita Ora is always a blast. The first time I tattooed her, it was a little too much fun, and she had repeated wardrobe malfunctions. In memory of her breasts, Rita gave me a dove tattoo with tits. Ha!

"SWASSY" Justin did this the first time I tattooed him. We had just done "Believe" on his arm and I didn't know him very well yet. It was a weird visit—just him and his manager. The store I was working in didn't even have furniture yet. It's supposed to say "swaggy," but it definitely says "swassy," whatever that means.

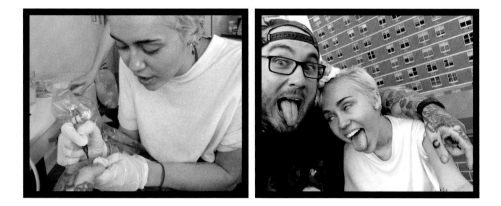

CRESENT MOON This is the only time I let an amateur move off my calf. Miley was a pretty good sport about this and didn't seem nervous, so when she grabbed me and was about to start, I jumped and yelped "OW!" That got an evil scowl off her and we both cracked up. It's closer to a "c" than the crescent moon it's supposed to be, but I'll take it.

BANG CHARACTER Chris Brown blazed right through this tattoo and did a great job. We did this in the basement at Whatever Tattoo. I had to sneak him in because my boss at the time was not about to let this happen. He was the most confident of the people who tattooed me. He drew it up, made the stencil, and tattooed me in less than ten minutes. Chris could be a tattoo artist. I'd hire him.

RITA ORA

BB: Which member of the British royal family needs a tattoo? Where would you put it and what would it be?

RO: Prince Harry. I would write "Rita" on his bicep!

BB: Any advice for people thinking about getting tattooed?

RO: Yes. Be sure to pick something meaningful, and have fun with it!

BB: What's your least favorite question people ask about your tattoos?

RO: Why have you got so many?

BB: What are you going to get next, and where?

RO: I would love a back tattoo—a really detailed picture of something across my back.

BB: How did getting tattooed in a tub compare to getting tattooed in a studio?

RO: It was so much fun! I have quite a few tattoos, so it was a new experience and made the tattoo even more meaningful.

BB: You and Cara came to get tattooed together—what's the best thing about getting tattooed with a friend?

RO: You trust them and it means you have shared something for life!

BB: You tattooed me like a pro—ever think about it as a second career?

RO: Yes, I love it! Any time, my friend!

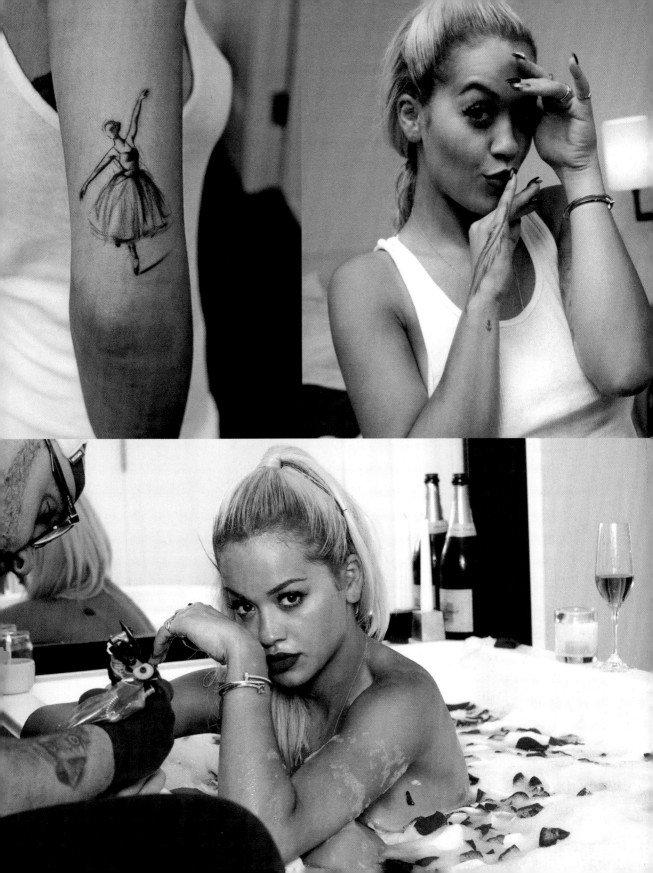

PART IV

NOW EVERY

WAS ONCE

NINETEEN

+

DREAM JOB

When I was in my early twenties, opening my own shop wasn't even on my radar. My goal was to become a partner at East Side Ink. I told the owners about my goal and they didn't seem to take me seriously. I proposed that I start at 10 percent ownership the first year, then my piece would increase by 2 percent each year, maxing out at 25 percent. I was the most popular artist in the store, but I was also the youngest. Maybe that's why they kept overlooking my offer.

I tried to make it work. I kept asking them and they kept putting me off, saying they were thinking about it. Meanwhile I was booked solid, making okay money, but still no sweat equity coming my way.

So when I got the opportunity, I bolted. I had been really patient with them for a year, and thank God they didn't take me up on it, because they would've gotten the deal of a lifetime and I would've been screwed for the rest of my career.

After years of working for other people—being a slave to their whims, trying in vain to get them to promote me, being boxed in by their aesthetics, and not having the freedom to be the best I could be—finally getting the opportunity to open my own shop . . . well, to call it a dream come true seems like an understatement.

IF YOU BUILD IT . . .

Finally I could do everything my way. I picked the Broome Street location because it's adjacent to the Bowery, which is where tattooing really took hold in the USA. The shop borders SoHo, Chinatown, and the Lower East Side, and is easily accessible to anyone in New York City.

My friend Ara Dymond helped me build out the space. We already had the design—logo, color, scheme, etc.—in place, and I knew I wanted it minimalist so it would be easy to keep clean.

I had hired a designer named Jesse McGowan to design a logo, and we collaborated on the vision of the studio. We wanted the interior to inspire artists and clients alike. When you walk in, you need to snake around to the right of the counter, then left of the stations, and right to the back—we wanted it sexy.

It was our first time designing a space, and I loved the process so much that I'll probably design more in the future. But luckily for most of this industry, for now I am just concentrating on one store for now.

OPENING A TATTOO SHOP: LET'S BE SERIOUS

When most people imagine a tattoo parlor, they think about a grim storefront staffed by unfriendly, aggressive assistants nodding along to death metal as grouchy artists scratch flames or devils onto people's bodies. And the fact is, a lot of places *do* look like that. Obviously standards across the industry have improved—for instance, we didn't *always* wear gloves. At least most shops make a show of sterilizing their equipment, but the industry standard is still not where I think it should be. I don't think the majority of people who do tattoos take it seriously enough. It's not a hobby; it's a career and a responsibility.

IMAGE ISN'T EVERYTHING, BUT IT'S A LOT

You know that cliché that you never get a second chance to make a first impression? It's true. So it's important that your logo, branding, and presentation accurately portray the kind of company you've built. That may sound business-y and boring coming from a tattoo artist, but if you want to be successful, you need more than talent. You need the full spectrum, and that goes for every kind of business.

EVERYONE'S WELCOME

Be inclusive. Many different people like many different kinds of tattoos. Let's be grateful to our clients and their interest in our work. Narrow focus not only limits artists, but filters out a lot of otherwise good (paying) customers.

SUPPORT STAFF CAN MAKE OR BREAK YOU

I don't hire wannabe tattoo artists to run the front of the shop; I hire New York City service professionals. Americans work hard, New Yorkers work harder. My guys bust their asses, but they're pleasant about it and extremely professional. They're not going to sneer at your request or ignore you to answer a text. Your front-desk staff is the face of your business, so you need to make certain that face is welcoming.

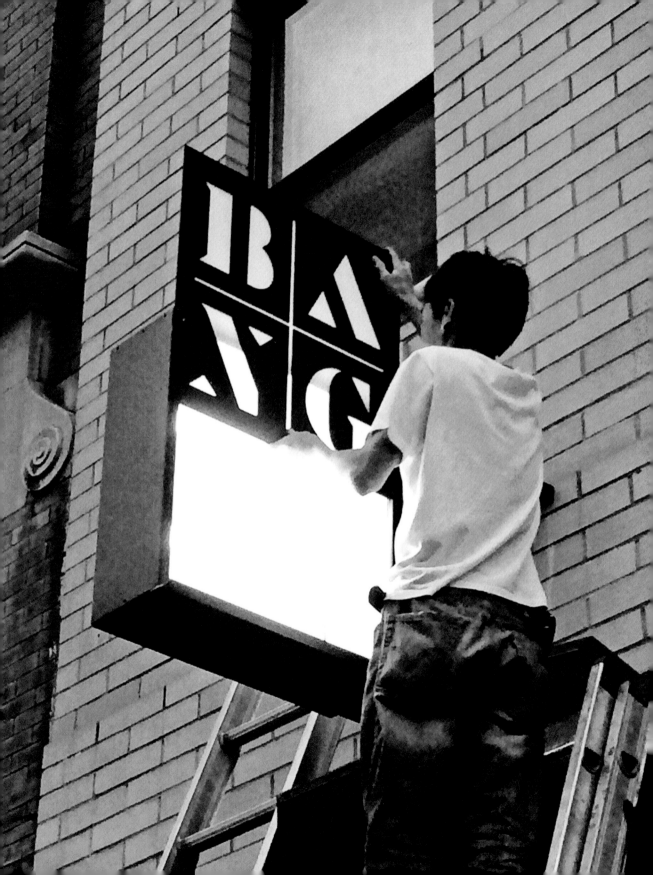

WELCOME!

I've never understood why so many tattoo shops play death metal. We don't. We'll play anything from Katy Perry to Led Zeppelin to Cypress Hill, not because we hate Cannibal Corpse, but because we want the suburban dad to be just as comfortable as a supermodel. (Okay, maybe the supermodel can be a little more comfortable.)

That's why the store is a big open space, too. We're trying to create an environment that gets people talking to each other. We don't want to seclude clients and artists away into tiny rooms where pain happens. When everyone's out in the open, you can see other people's tattoos happening, get inspired, meet new people . . . it's a group activity. Our soundtrack does its best to support that.

BE INCLUSIVE

Maybe it's because some of my most high-profile clients are women, but unlike most shops, our clientele is split about 70/30 in favor of women. We have female artists, too; we make sure our shop isn't the boys' club that so many can be. Also, our female staffers are paid the same as the men. The thought of anything different seems unbearably ignorant. Let's work on that, USA.

SPEAKING OF CLEAN . . .

In my experience, most tattoo shops are gross. Top to bottom, they're disgusting. I would challenge you to walk into any shop and ask them to wipe one of their stations with an alcohol-soaked paper towel or even worse, use one of those CSI lights. You would need a Silkwood shower if you knew how much disgusting shit lurked on your average tattoo station. I worked at one place where the stations were wood; another had stone countertops. Both are porous. It is *impossible* to sterilize either surface. Ugh. *Chills.*

Despite the fact that we deal in bodily fluids—people *bleed* here—the health department

hardly ever inspects tattoo parlors. As a result, most places are filthy. If you don't believe me, ask your tattooist to show you the shop's "dirty room." That's where they keep the used needles, the ultrasonic scrubber (which is not remotely sterile), the autoclave, as well as the sudsy soup of dirty tubes that will eventually get cleaned. The sink is usually full of brushes. Everything in there is dirty—you don't even want to breathe that air and trust me, most shops (not mine) have them—and they inevitably live up to the name. I challenge you to walk into any other shop and ask to see their spore test log—a required monthly test of a studio's autoclave. I've worked in NYC for eleven years and I haven't seen one yet. Ever!

I want my shop to be as clean as or cleaner than a hospital. I don't want stations to be cleaned once a week, not once a day; I want them to be cleaned *after every tattoo*. Clients coming in with HIV or hepatitis or any other blood-borne disease aren't required by law to tell me, but it's considerate when they do. The first time I (knowingly) tattooed someone who was HIV-positive, he gave me the heads-up, and I appreciated it, but our process here is the same for anybody. I can't be extra careful because someone has an infectious disease—I'm that careful for everybody who walks through that door.

Even when a shop claims to autoclave its equipment, there is a part of the needle mechanism called the tube that just never gets completely clean, so you're always only about three millimeters from scabbed-up blood from the last thirty or so people who got tattooed there. I believe the only 100% sterile way to give a tattoo is to make sure that everything used is *disposable*. Not every tattoo artist uses fully disposable setups, because it's a lot more expensive to do so. I'm happy to spend the extra money, but not every shop is. In some states it's even legal to sterilize and then reuse your needles! Yikes!

We clean and disinfect each station as meticulously as if it were an operating room, and we do not have a "dirty room." We are fully disposable.

DO GREAT WORK ALWAYS

Of course, it all comes down to the work. You not only have to be the best, you have to hire the best. Because no matter how clean the shop is or how accommodating the staff might be, the work is the thing that matters most.

LET ARTISTS BE ARTISTS

I think one of the best aspects of working at my shop is that we're so accommodating to our artists. We have staff to take care of all their setups, their breakdowns, their cleaning, booking, managing, scheduling, orders, supply runs—we anticipate everything they might need and take care of it.

All my artists need to do is show up, tattoo, and leave. We lay out all the tools they need to create art and eliminate the need for them to do anything they're not good at or don't like to do. Artists don't want to scrub the floor—they want to work on their drawing. Our assistants are happy to do the dirty work, and we're grateful for that.

I would welcome stricter tattoo laws in New York. And I think that anybody who's truly an artist would welcome the same. I don't know why they haven't done it. We work with blood and needles! I think it's more important that my store be clean than that the corner bodega be clean. Yet those are the guys getting fined.

We also help our artists present themselves in the best possible light. If I hire someone and their photography isn't up to our shop standards, we won't use it on our Instagram account or anywhere else. We'll start them off with walk-ins, doing small tattoos, and photograph their work. We'll help them build their following and get them where they need to be. Liz had 600 Instagram followers when she started—as of the writing of this book she has 120,000!

We make some of the best tattoos in the world, and it's not just me making them.

BUILDING THE DREAM TEAM

Even more than designing a sleek, clean, beautiful workspace, I knew I needed to make my hires carefully. I wanted artists who knew what they were doing, were happy to be there, and were always looking for ways to improve their work and their surroundings. I didn't want the jealousy that I experienced firsthand in so many shops, nor did I want support staff who looked down their noses at the clientele. I can't tell you how many

shops hire someone's girlfriend to sit at the front desk and check Facebook all day.

I wanted my shop to be run like a *real business*. Crazy, I know. But I'm happy to say I did it, with the help of these amazing people:

COMPETITION

I heard once that if you brand yourself properly, competition becomes irrelevant. I'm not entirely sure if that's true, but I will say we have branded ourselves properly, and our competition is only with our own expectations. The name "Bang Bang" used to be mine—simple, easy to remember, Google-able—and like any good moniker, it came unexpectedly. But a year ago, I decided to give this name to my store, and "Bang Bang" became a brand. Bang Bang is not just me anymore. It's a diverse, globally recognized company devoted to raising the bar with relentless group effort and unparalleled self-expectations. Here's Team Bang Bang.

IF YOU WANT TO GO FAST, GO ALONE. IF YOU WANT TO GO FAR, GO TOGETHER

—AFRICAN PROVERB

MATTHEW GANSER
ASSISTANT MANAGER/PERSONAL ASSISTANT

I met Matt because he was a server at my favorite restaurant—the late WD-50, owned by Wylie Dufresne. One of my skills is that I can read people really well and can tell a lot about them from interacting with them. Because I ate at WD-50 so often, I got to know Matt, along with his work ethic and his habits. I was able to see a lot of parallels in the job that I needed filled with the one Matt was doing. Because the tattoo industry is generally run so unprofessionally, I didn't want someone with tattoo shop experience, because I'd just have to unteach them everything they knew. Matt is great with clients and an amazing multitasker. He's made the shop a thousand times more efficient and has been a huge part of our success. Oddly enough, Matt didn't even have one tattoo when he started, but that wasn't part of the job requirement. We think a bit differently here.

EDWARD BOREW

CHIEF OPERATING OFFICER

There was never any question that Ed would work with me. He's my cousin; we grew up together; he's my best friend and my big brother. Now he's also cool enough to let me *play* big brother while he keeps everything together. He lets me be the star and, at the same time, makes sure I stay in my lane.

Ed's been with me for my whole career—from my first tattoo through to today. He and his brother Chris were the first people (besides myself) that I practiced on. Ed has always been there—lending me his skin when I needed to practice a style or do a certain piece for my portfolio. I may be a great artist today, but a lot of Ed's tattoos are bad! I remember him limping around tattoo conventions for me, because we decided to tattoo both his ankles in one day. (Pro tip: Don't do that.) He never bitched when I didn't tattoo him for years; he just works. He's never missed a day—works twelve- to fifteen-hour days, five days a week, and

when he's home, he answers emails. I can't emphasize enough how lucky I am to have Ed.

He's never called in sick. Not once. NEVER!

Ed had a real job for years, until I could afford to pay him to be my manager full time. He has just as much experience as I do in tattooing, except that he doesn't do the tattooing part. Strategy, sales, business, and organization are his strong points. I couldn't run my shop without him. I wouldn't want to. As a salesman, he's unstoppable, because he is fully confident that we are best tattoo shop in the world. You have no idea how much that means to me.

He's the glue here. He keeps us all together. We're all individually talented, but without that anchor, we'd all be lost. Edward is my number one.

+

THE BUSINESS END OF THE BUSINESS

Keith's (Bang Bang's) father is my mom's brother, and he introduced my parents to each other, so we've kind of known each other since before we were even born. My brother and I are a couple of years older than Keith, so growing up we did our best to keep him out of trouble. Although when I first smoked a joint, he smoked his first joint within that first year. I got my first tattoo when I was sixteen years old and he was thirteen. He immediately wanted to get tattooed, too, so he was already starting to think that way by thirteen.

A few years later, we both ordered tattoo kits at the same time. The kits were very basic and we had no idea what we were doing, but that didn't stop us. We both have crappy Chinese letters—kanji—on our upper thighs. That's the first place we started, just because it was easy to navigate. He tattooed his wrist the same day he got the machine and just never stopped.

Though I am artistic on some level, I'm more of a brainstormer. I never had the passion for tattooing that Keith did. That's why I went on to do my own thing and he went on to be the best

tattoo artist he could be. But by no means were either of us any good back then.

I learned how to run this business from working for Jean-Georges Vongerichten at a four-star restaurant in a celebrity hotel. Having met everyone from Jay-Z to Brad Pitt helps me navigate our business, because we have a lot of high-profile clients and I'm not fazed by that kind of thing. I don't want an autograph. I don't want a photograph. I will ask you to sign this credit card slip, though.

Keith and I had always talked about opening a shop, and a decade ago this is where we saw ourselves in ten years. Opening it was a matter of putting in the work.

Aside from the tattooing part, this business was invented from the ground up. I saw how other shops were run and I'd also had all this hospitality industry experience, and we *knew* they could be combined into something super successful.

Unlike most other shops, we have procedures, protocols, and policies. When you get tattooed here, you get what you're paying for. I see us as a luxury brand, and we treat our

clientele accordingly. For any other business this would be standard practice, but just the fact that we greet everyone who comes in our door makes us stand out from most other tattoo shops, where you're greeted with a grunt if at all.

Compared to what I found while working at other shops and getting tattooed in them, too, another difference here is the amount of care and attention to detail that goes into every aspect of the business.

We recognize that we're dealing with people who are getting permanent pieces of artwork on their bodies, so we talk to our clients and, more important, we *listen* to them.

If you walk into most other shops and you don't already have tattoos, you're going to get attitude. I would say eight out of ten people who come in here have no tattoos or fewer than they can count on one hand.

As a result, we regularly get clients who've been to five other shops where they've been treated like garbage. After talking to us for a few minutes, they can't believe the difference. We're proud of that, but seriously, that part is

just so simple—treat people the way you'd like to be treated. So many people in this industry think they're too good to answer a question or talk someone through a process. And that translates into the way they run their business.

I'm so serious about this, I wrote an employee handbook! I have no doubt we're the only tattoo shop with one.

If you're not an enthusiast or, even better, a tattoo artist, please don't open a tattoo studio. If you're in it for the money, go do something else. It's not about the money here—it's about the artwork and the clientele, first and foremost.

However, it is a business, and we run it as such. We need to be confident in what we're selling or else nobody's going to buy. Being friendly and informative is another big thing that I stress. There are no divas here. I also feel like it's fine for the artists to wear whatever they're comfortable in, but at the front of the shop, you don't want to be too casual or people won't take you seriously—that's why wear a suit. It just bespeaks professionalism. And professional is what we do here.

ANATOLE
LEAD ARTIST

Tole had some amazing black-and-gray in his portfolio, though he was so quiet during our interview, I almost didn't hire him because tattoo artists really need to sell their work. He was the first person I hired who I didn't already know, and I'm so glad I decided to give him a chance, because now he's the busiest person here. There was never any question in my mind about his talent—his work is inspiring. It's incredible. He's also smart enough to boost my ego; whenever I compliment him he shrugs and says, "I just steal everything you do."

When he walks in I smile like a proud big brother. I've seen him grow so much over the past few years we've worked together.

GEORGIA

ARTIST

When I met Georgia, she was mainly known for doing traditional tattoos, which she did extremely well, but that's not what we were looking for. Though she was super talented, I hired her thinking we'd teach her realism and black-and-gray work. I saw her as someone searching for a style, but instead, she found her niche immediately, developing a style completely unique in the simplicity and abstract style of her line work and amazing color blending. Her work is unlike anyone else's in the shop—unlike anyone else's I've ever seen. She's a superstar.

HECTOR

ARTIST

Hector also worked at Whatever Tattoo (sensing a theme?). We always got along, though while he worked there, Hector was confined to a style that was very flash-heavy—that was the Whatever way. His art and his real passion for tattooing didn't really emerge until he opened his own store in Connecticut and then came here. Hector has the best energy, and that just spills over into the room when he walks in. On Hector's second or third day here, one of the other artists asked him, "Hector, why are you so happy?"

Hector said, "I've got two legs, two arms . . . I'm just happy to be healthy and alive."

This guy is just the best. He can do very delicate tattoos with incredible precision. People seek him out for that style. I hired him to be the walk-in guy, but he's fully booked because his talent and understanding of design is incredible and people recognize that.

NICO

ARTIST

Nico is the youngest one here and is incredibly talented. A mutual friend recommended him because his work is very similar to mine, in that it's uniquely designed, high-contrast black-and-gray realism. I'm impressed by him because he's so much better than I was when I was twenty-five. I can't wait to see how much he improves—I'm watching this young man, and I'm in awe. Just in the short time he's been here, his work has grown by leaps and bounds. It's an awesome thing to witness. He reminds me so much of myself, but better.

TYE

ARTIST

Tye says the best tattoo he ever did is the portrait of my daughter on my arm, although everything he does is perfect, so that's hard to believe.

Tye's work is very style specific—he does portraiture, but he does it better than anyone. His personality is just the best—everyone wants to be around Tye, because he's a party. Tye and I have become really close because we have similar backgrounds and styles.

We started working together because we would comment on each other's work back in the Myspace era. Tye's work kept getting better and better, and when I was opening a store, I wanted to have him as a permanent guest. He lives in Austin, Texas, but comes up here for about a week every month.

ROB

ARTIST

Rob has a wide range of styles he works in, from incredibly rendered illustrative color pieces to delicate line work. He also does graphic new-school designs and realism—a bit of everything. Rob and I were the guys who worked in the window at Whatever Tattoo. I worked the day shift, he worked the night shift, and we were the stars of the Avenue. Rob doesn't age—when I met him he was this thirty-year-old skateboard kid, now he's this forty-year-old tattoo artist with a seventeen-year-old soul. Definitely the hardest-working dude I've ever worked with. Like me, he never says no.

ELIZABETH

ARTIST

Liz and I both worked at Whatever Tattoo at the same time, but we always had different schedules. When I hired her, she was a little limited stylewise, but everything she did, she did perfectly. She accepted the challenge of becoming a strong tattoo artist and has really excelled in her new environment. Her tattoos are iconic and she has a great grasp of feminine style and design, along with a completely unique take on tattooing. As a result, Liz has built herself one of the largest Instagram followings in the shop. Her work is incredible and just keeps getting better all the time.

TURAN

ARTIST

My most recent hire, Turan, does amazing realistic object work and illustrative, fine-line detailing. What's cool about him is that he's super diverse—he's happy to do small, delicate designs, but also thrilled to do the most intricate Buddha statue or the kind of Brooklyn Bridge where you can see every single wire. He excels—even above me—at isolated pieces of realism. I'm great at covering an entire arm (or leg, or whatever), but I can't make something timeless and small in the middle of someone's arm. That's a tough skill to master. Turan's also a dad, like me, so our work ethic is similar. Everybody who works here is under a lot of pressure to do great work. Some people crack under that pressure, but he puts all his energy into his work, and it shows.

KRISTI WALLS

ARTIST

Remember the little girl named Kristi I was best friends with back when I was four? Well, about seven years ago, while visiting Delaware, I met a girl named Kristi. Every time I'd go to her house, Kristi would be huddled over a sketch pad or canvas, drawing away. She was so dedicated to her art and turned out to be a really nice person, too. Kristi was also a tattoo artist, and she and I became friends. I thought she could do way better than Delaware, so I convinced her to move to New York.

About a year or so after she moved here, we were on vacation with friends. Someone ordered hummus with mushrooms and offered me some. I told her that I don't eat mushrooms because when I was four, I'd had to drink liquid charcoal after eating mushrooms I found in a field. Kristi then said that the same thing had happened to her when she was four.

Something clicked.

I asked her where it had happened, and she said, "This neighborhood in Delaware that isn't there anymore."

All of a sudden, it hit me. "Kristi, it's ME! I'm Keith!"

Kristi couldn't believe it. "I was shocked at first—I had a physical reaction because my mind was trying to process it and figure out how it was possible. It was amazing," she says.

Besides being one of my oldest friends (albeit with a twenty-year gap), Kristi is unique because she's the only traditional artist here. Well, *was* the only traditional artist here. As her style developed and our store became more known as a place for realism, unique designs, and a newer sort of tattooing style, our clientele tended to be less interested in traditional American tattoos. So Kristi adapted beautifully. She's always loved geometric line work and sacred mandalas. Her work blows me away. She's passionate about doing this intricate, repetitive line work, and she's just so good at it.

Everyone who meets Kristi loves her. It's been awesome to watch her grow from my first best friend, to the girl painting alone in her attic in Delaware, to the woman who creates amazing tattoos that nobody else in the world can do.

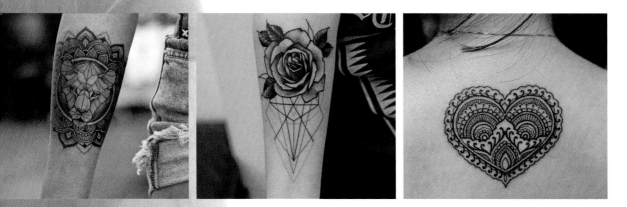

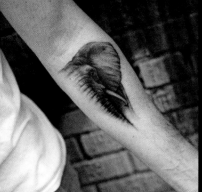
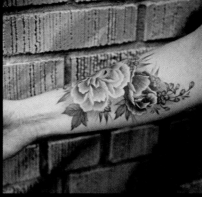
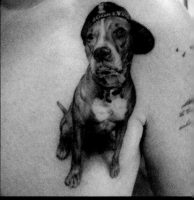
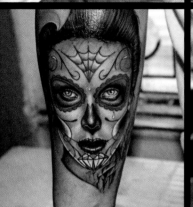
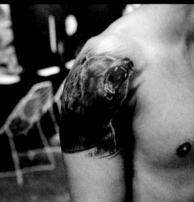
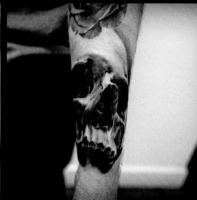
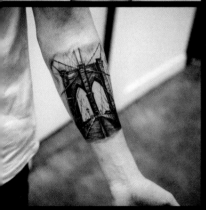
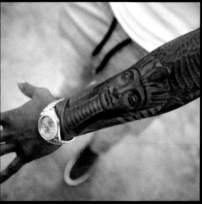
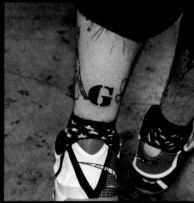
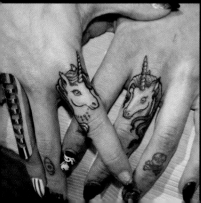
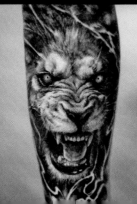
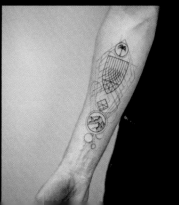

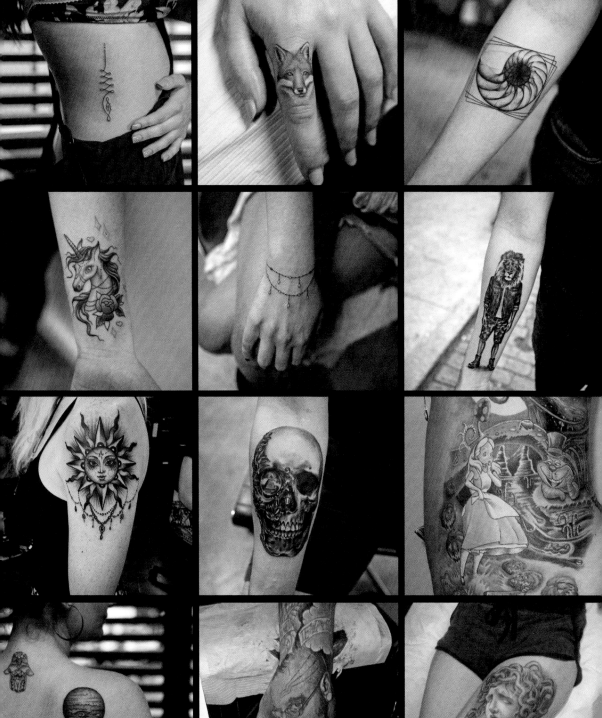

They say that people don't have *one* tattoo; they have their *first* tattoo. Why is there almost inevitably a second? Or a third? Or a thirtieth?

For one thing, the simple act of getting tattooed is a huge adrenaline rush. Even if you have a dozen already, that lead-in to the process is pretty exciting: What kind of art are you getting? Who's going to do it? How will you afford it? What will your mother think? What if the artist makes a mistake and you hate it? Should it be bigger? Smaller? Color? Black-and-gray? Your body's response to all this anxiety is to blast your system with adrenaline to cope. So just like people who get "addicted" to bungee jumping or dating crazy people, that thrill—even though it's scary—can be pretty compelling.

You're also putting your body through a traumatic experience, but it's up there as one of the most exciting experiences your body will ever have. And when you're done, you're high because your brain has flooded your body with endorphins. Everyone loves endorphins, so naturally you'll be thinking about how you can get your next fix.

If you go to the right person and get the right piece, you're going to look and feel *amazing*. There was even a study conducted by the department of psychology at the University of Westminster in London that concluded both men and women had higher self-esteem right after getting tattooed. If that means addiction, it's certainly a lot healthier than a lot of other things people get addicted to.

Tattoos, to me, can either be spur of the moment or deeply meaningful. I have both; some I regret and some I couldn't live without. Here are a few of my favorites:

GUNS ON NECK These are symbolic of my commitment to become a great tattoo artist—two of the boldest decisions I've ever made in my life.

STATUE OF LIBERTY FINGER I got this to mark ten years of tattooing in New York City. My good friend Stefano did it at one of the few tattoo conventions I've attended. It's special because I feel like I earned it. I made it here, so I can make it anywhere.

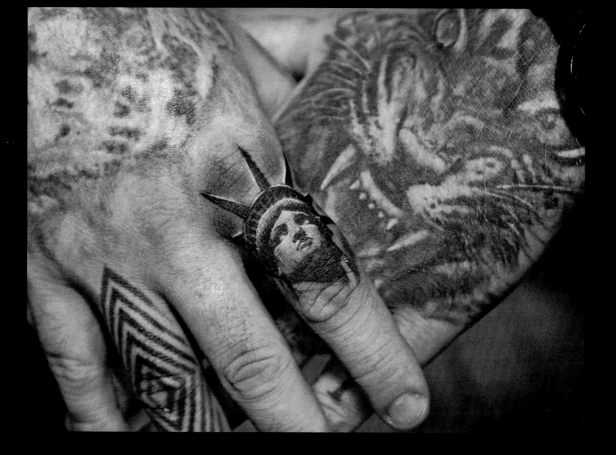

TIGER HAND TATTOO I just learned so much from watching Little Dragon make this. Being able to see this tattoo all the time is a reminder of why I got it. It's about aggression and being fierce about the pursuit, about how hard I had to work to get to where I am now. It feels like my spirit animal.

KUMIKO Kumiko's tattoo will soon be accompanied by a picture of Yukari. You have to wait till kids get a little older and their features have developed. Yukari, you aren't old enough for this book, but next book—your picture will be on my arm.

NUMBERS ON PINKIES These very important to me. One of them is some*thing,* the other is some*one.* But it's private and I don't want to tell.

LITTLE KID PLAYING ON BLANKET This was from the cover of a book my mom used to read me: "I love you forever."

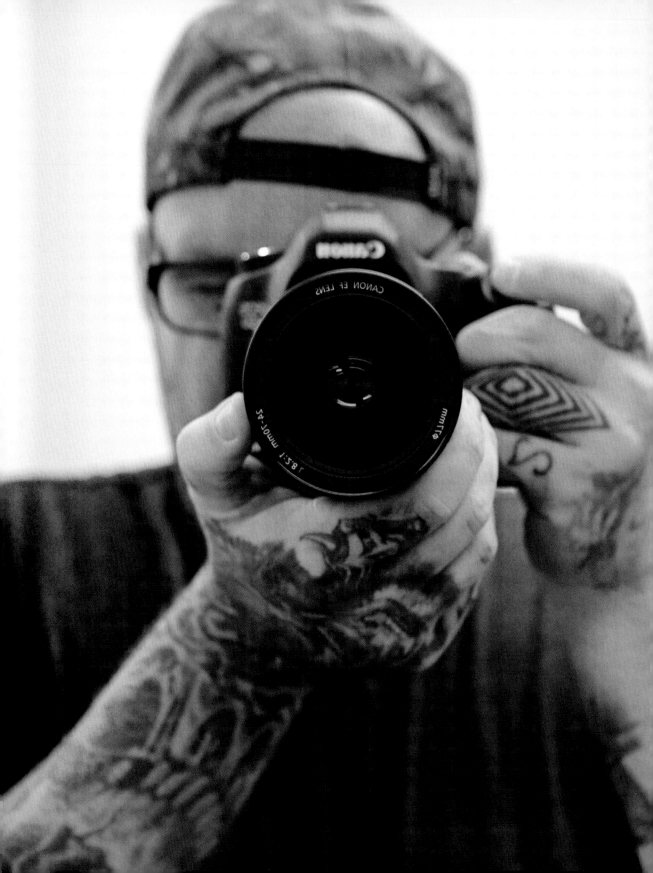

+

THE CAREER ARTIST'S TRAJECTORY

Everyone who works for me takes their work seriously. We pride ourselves in the tattoos we make. It's what we love, and all the artists who work here have extremely high expectations of themselves and each other.

When I interview potential hires, I have them tattoo in front of me. Can they do good work with me standing over them, watching? Because someone's *always* watching. We're not like writers—we don't work in a vacuum. There are always other artists around, other people's clients, your own clients . . . all eyes on you, can you handle it?

I learned for myself that the lessons come fast and furious when you're first learning— you will look back on things you did a week ago and think they're horrible. Then you gradu- ate to months before you look back and see work you wouldn't put in your portfolio. Then it's a year, then two years, then three. You hit a wall after five to seven years, and you can either stand there and draw on it or you can climb it.

I've seen this in so many people I've worked with. They either plateau and then the

quality of their work drops off, or they realize that they actually still suck (we all do) and they don't get complacent.

I hit that wall early in my career. I realized that it's not good enough to be good. You have to be great at everything you do. If I don't try to be great, I'm just wasting my time.

INFLUENCES ON MY ART

There are tons of amazing tattoo artists who've taught me by example, but I also look outside that insular world for inspiration. Hip-hop has always had a huge impact on whatever I'm doing, as have sports and other artists in many mediums. I love beautiful design, whether it's on somebody's skin or they're driving around in it. I didn't have much of an arts education, so influence taught me. Here are a few of the men and women who inspire me to be better every day, in no particular order.

MICHAEL JORDAN

The most successful people don't just walk through life, and that's especially true of someone like Michael Jordan. I'm such a fan, I still watch old Bulls games. What I loved about him was that no matter what, he was unstoppable. At the most pivotal moment—when everyone was counting on him—he was the guy. He'd pull you through. In Mike we trust.

There's a lot of pressure being a tattoo artist—maybe not the kind that Jordan would feel, but there is a lot of it. And I like being the one people know they can count on. It's an incredible feeling.

BOB TYRRELL
TATTOO ARTIST

He was one of those guys, along with Shane, who did the kind of realistic work that really influenced my style. He is the master of black-and-gray realism. I only met him a couple times, and he seemed really nice, too.

WYLIE DUFRESNE

RESTAURATEUR/CHEF

I haven't tattooed Wylie, but I have Wylie tattooed *on* me . . . as a messiah. He won a James Beard award as the owner/chef of my favorite restaurant, WD-50. I ate there more than two hundred times—more than any other customer (though one guy came close). This is a guy who rethinks food and reinvented cooking.

SHANE O'NEILL

TATTOO ARTIST

Shane was the best tattooist in Delaware when I was starting out, and he remains one of the best tattoo artists in the world. I have one O'Neill; my cousin Ed has a few. Since I was a kid, I've held Shane in high regard—he's the reason I started tattooing, and I think he knows that. When I was a teenager, I'd go in his shop and rap for them.

He was a little apprehensive when I told him I was a tattoo artist, because great, here's another kid doing shitty tattoos. Shane never sat down and taught me anything, but I learned a ton from him. Later, he showed me the respect that takes years to earn, and I'm humbled to have it.

SHIGE

TATTOO ARTIST

He's one of the few traditional Japanese tattoo artists who regularly breaks the rules, and does so beautifully. If I had to pick a perfect designer, artist, and orchestrator of tattoos, it would be Shige. I would love to spend a month learning from him. Someday I will ask him.

BALAZS
TATTOO ARTIST

Balazs Bercsenyi is a self-taught artist from Hungary who's also a celebrity favorite with a huge following in his country. You can tell just by looking at his work that he doesn't have a tattoo background because his work is so unique in its approach.

He stopped by the shop while he was here on vacation, and since he's never worked in a shop before he wanted to apply for a job here. I would love to have him work for me.

During his visit, we took a wireless tattoo machine to the top of the Empire State Building and tattooed the iconic building on him. Balazs wanted to do it to symbolize how much he wanted to come here and bring his work to the world. Every time I see that building in the skyline now, I think of that day.

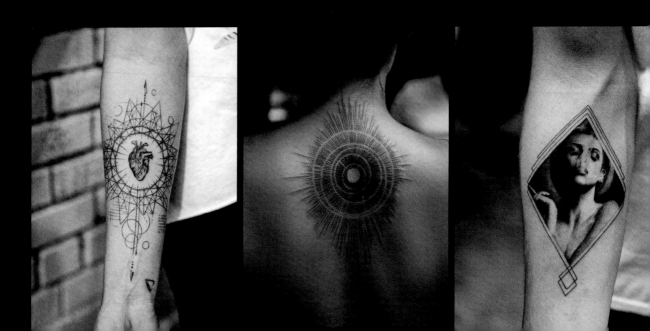

LITTLE DRAGON
TATTOO ARTIST, BEIJING, CHINA

Little Dragon is just such a natural tattoo artist that he's able to make even the most intricate, complicated work look completely effortless. He's taught me so much, face-to-face, one-on-one. His English is bad and my Mandarin is nonexistent, but he managed to give me a lot of confidence when we worked together.

I like to think I broadened his world a little, too—I took him to my grandmom's house and he had peanut butter and jelly and French toast for the first time. He loved it. I consider Little Dragon the best teacher I ever had.

TOM RENSHAW
TATTOO ARTIST

When I was beginning to tattoo, I only had two tattoo magazines, and Tom Renshaw was all over both of them. His specialty is animal portraiture, and few do it better than he does.

MIKE TYSON

I love Tyson's attitude toward being the best. He was just *so* aggressive early in his career, with that unstoppable attitude. I just loved watching him work, speak, train—whatever. As with Michael Jordan, old films of Tyson in action motivate me with the sheer amount of effort he puts forth. I try to put that much effort into my own work—I'll even sleep at the studio when I have to. I like to say I'm relentless and unstoppable—that's my inner Mike Tyson.

RIHANNA AND THIERRY HENRY

These two are so different from each other in every way, yet they've taught me so much, from how to handle whatever notoriety comes my way to knowing who you can trust. I am so lucky that they both started out as clients but ended up tremendous friends and mentors.

NEEDLES, PATRICK, AND ANDREA ELSTON
TATTOO ARTISTS/FORMER COWORKERS

I was lucky enough to have worked with all three of these amazing artists at East Side. These three were extremely encouraging to me at a time (and in a shop) when I was really in need of mentorship. Needles and Pat would sketch with me, while Andrea always gave me great career advice. Andrea worked harder than anyone in there and is a legend on the Lower East Side.

I would watch sit and watch Patrick's hand motions and techniques and learned so much just watching. It was like getting a one-on-one class with a master illustrator.

Needles and I did a huge piece on my cousin Ed's chest. It was the first time I ever tattooed alongside another artist. The experience was fun (probably less so for Ed), and I learned a ton from it. Needles also taught me not to be afraid of black, which sounds crazy, but is super important.

✝

OSCAR
TATTOO ARTIST, SWEDEN

Oscar Akermo is so young and so talented. I met Oscar when he was vacationing in New York. He started tattooing when he was fourteen in his home country. In his six-year career, he's gained international acclaim, and won numerous awards from invitational tattoo conventions. Oscar is widely considered one of the best tattoo artists in the world. His attention to detail, wide range of styles, and design ability are unparalleled. He's showing me up; I'll admit it. He tattoos circles around me. He can create beautiful work, and is the nicest, humblest kid you'll ever meet. Oscar is the youngest great tattoo artist in the world. I'd give my left thumb to hire this kid.

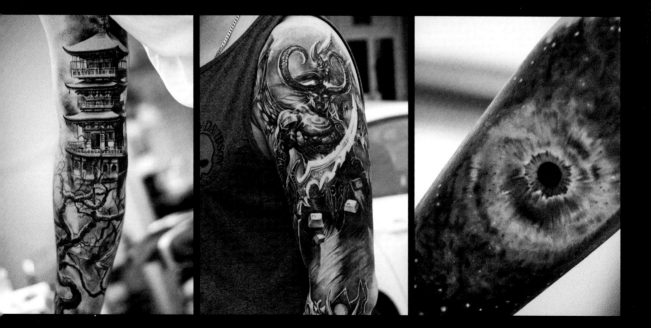

TWENTY-ONE

+

THINKING ABOUT GETTING A TATTOO?

The decision to get your first tattoo is one you shouldn't take lightly, but you shouldn't let it freak you out, either. This chapter should help guide you.

THINGS TO BRING

Getting tattooed—especially your first one—can be a nerve-wracking experience. Here are a few things to bring along that will make the experience seamless.

AN OPEN MIND

Hopefully you've been researching and found an artist whose style you like and whose talent you trust. When you find the right person to do the job, you should let them do it, and trust that they want what's best for you. That means that sometimes you'll get a little pushback on your idea. If I think a tattoo is going to look crappy, I'm going to try to steer you toward either a different design or maybe a different location on your body. A good tattooist won't do a job he *knows* he's not going to be happy showing off. Expect your tattoo to be better than you imagine.

EASY-ACCESS CLOTHING

Think about where you're getting tattooed—if it's your shoulder, wear a tank top or strapless shirt; if it's your ankle or foot, wear shorts or loose pants. A button-up-the-front shirt worn backward is a great idea for back tattoos. Don't be modest—we make bodies beautiful.

A RELAXED ATTITUDE

If you're super stressed, it's okay to have *a* glass of wine or *a* beer, or smoke, but don't overdo it. Alcohol can thin your blood, and that gets messy. And if you're wasted, you've just wasted my time and yours, because I'm not going to tattoo you. I don't want to do anything you're going to regret.

A FULL STOMACH

Eat within a couple of hours of your appointment, and make sure that meal contains protein so your blood sugar doesn't come crashing down mid-tattoo. Hydration is important, too, so drink water. People sometimes feel faint or woozy during their tattoo, and a good meal can keep you from feeling crummy. If you start to feel faint, let us know and we can help you through it.

REFERENCE

Some people come in with a firm idea and photo of exactly what they want tattooed on them, and though we may do that for you, we may both have a lot more fun if you let us interpret your idea and work *with* you to come up with the best possible original design. For example, if I know you like art nouveau, but also want a memorial tattoo of your dearly departed kin, I can combine the two into something incredible that would've probably never even occurred to you. We book consults with clients before we work on them so we have time to give them the best tattoo. We design great tattoos for a living—you've never designed one, so we got you. :)

ENOUGH MONEY

I have no doubt you'll be able to find *someone* to tattoo your mom on your neck for sixty dollars, but you're going to get what you pay for and it ain't gonna be pretty. Cheaping out on a pair of socks is one thing, but you will be wearing your tattoo *for life.* If you can't afford to have a good artist work on you, you're much better off waiting and saving up to get a quality piece of work. I have worked in shit holes. I know what goes on there. You don't want to know.

✝

IN CLOSING

Most people don't know it, but I was born a poet. The direction that I'm going in, I don't really show it. So I'm guessin' that I hold it in, trying not to blow it.

Trying not to let go, it seems I might be too controlling. But if I lose control on my words you get to know me, I might be to embarrassed to show me—I'm still the old me.

All you ever knew me is how I present the new me—I just wonder would you feel me if you got to know the real me?

And that I've always wondered as I've kept my feelings covered, so when you see me standing, I'm surrounded by my branding.

Can't let you see me fall as I stand so tall, not afraid at all, and that's a lie of course.

But it depends on who you ask, my present or my past, my life's moved so fast—I can't forget who I am.

I'll never forget who I was—and the way I grew up is not indicative of who I am or the man I've become.

But if you listen closely, that's the way that shit's supposed to be.

I'm supposedly the older me that's grown into who I chose to be.

So hearing those opposing me, saying how I'm supposed to be, I laugh uncontrollably 'cause I'm the one that's molding me.

It's easy to join the crowd, so I chose to stand alone.

From the concrete I rose, like a rose made of gold—never to fold, they either try to pick me or they kick me, so few know the legit me, especially those who rip me.

Even those who try to pick me often don't know my hist'ry, so I'm always a little cautious of people who say they miss me.

Friends'll pretend and family can do the same, people will let you down—and let you drown in the pain.

And they're sayin' I'm insane 'cause I'm the only one that sees it.

It's not a secret or facetious or even about gettin' even.

I'm speakin' about believin' in, reachin' at all you dreamin'.

Stop this tetrahedron, the demons can never reach me.

+

ACKNOWLEDGMENTS

This book could not have happened without the following people—thank you all:

Mom, you were the first person to believe in me and the last person that would ever give up on me. We haven't always had it easy, but I love you and appreciate you.

Ets, you have been such an amazing mother to our kids. You are there for them, even when I can't be. I will love you forever for your support.

Ed, no matter what I've done, you've been there right by my side supporting me. You have everything I don't, so we complement each other like yin and yang. I couldn't do this without you.

Chris, you and Ed knew I could do it, even before I did. And anytime I needed a blank canvas, you were there. You have a number of my worst tattoos, which helped me become the best I could be. Thank you.

Rihanna, you've always been so generous and never stopped spreading my name to the world. I'm proud to call you my friend. You've influenced my life more than words can explain. You are my spirit animal and my favorite person to tattoo.

Joe Snake, thank you for lying to Rihanna and telling her I was the best tattoo artist in town at a time when I wasn't even close. I'll never forget you moving in to help care care for me after my overdose.

Cara, you're as sweet as you are beautiful. You've brought my work to the world and I'm so grateful. Thank you for believing in me.

Thierry, there aren't words that adequately describe how grateful I am to have you in my

life. You are the best mentor I've ever had and you've changed my life as much as anyone, my man.

Judy McGuire, thanks for helping translate my vision from brain to book and putting up with my nonsense.

Jesse McGowan, it's amazing to have a designer who sees things through the same eyes.

Karen Bridbord, thank you for directing my crazy.

Lisa Sharkey, thank you for believing in a guy who cold-called you asking for a book deal.

Matt Harper and Daniella Valladares, you made this book better every time you touched it.

Christian Carino, thank you for your support—it's meant the world to me.

Needles, you helped me look at things differently and changed the way I tattooed. Thanks for the lessons that helped shape me.

Little Dragon, you influenced how I tattoo more than anyone. You are a master! I learned more from you than you could know.

Shane O'Neill, you're the one who inspired me to become a tattoo artist. If I hadn't met you when I did, I don't know what I'd be doing. I'm so grateful to be influenced by you.

Pat McCutcheon, you taught me so much, more than you'll ever know. Thank you.

Dad, thank you for being who you are. It helped me become who I am.

Katy Perry, traveling with you and your crew has been one of the best experiences of my life.

Demi Lovato, you inspire me—you know why.

Rita Ora, you're amazing, and being around you is always amazing.

Vanessa Hudgens, you are a superstar whose first tatoo was a neck tattoo—amazing. Thank you for helping with my book.

+

CREDITS

Jason Banker: 1, 2, 22, 28, 46–47, 54, 78, 110–111, 164, 168

Pages xii–1: All photos courtesy of Susan McCurdy, Ed Borew, and Mum-Mum and Pop Dusa

Pop Dusa: 6

Susan McCurdy: 4, 5, 7

Edward Borew: 8–9, 12, 73, 114, 132, 136 (middle), 147, 148, 180, 184, 200 (bottom left, bottom middle, bottom right), 201 (bottom left, bottom middle, bottom right), 202 (bottom left, bottom middle, bottom right), 203 (bottom left, bottom middle, bottom right), 204 (bottom left, bottom middle, bottom right), 205 (bottom left, bottom middle, bottom right), 206,(bottom left, bottom middle, bottom right), 207 (bottom left, bottom middle, bottom right), 208 (bottom left, bottom middle, bottom right), 209 (bottom left, bottom middle, bottom right), 210 (row 1: left, middle; row 2: right; row 3: left, middle right; row 4: left), 211 (row 1: left, middle, right; row 2: left, middle, right; row 3: left, middle, right; row 4: left, right), 213

Gurber Mathews Photography New York: 8 (top left, top right), 44, 45, 150, 158, 159 (top), 163, 177 (top left)

Lauren Colchamiro: 8 (bottom),

Etsuko Tsujimoto-McCurdy: 11 (bottom),

Bang Bang: 11 (top left, top right), 14, 19, 20, 25, 31 (bottom), 32, 35, 36, 38, 40, 42, 50, 51, 56, 57, 58, 59, 61, 62, 63, 65, 66, 67, 68, 69, 70, 71, 72, 74, 75, 76, 77, 81, 82, 83, 85, 86, 89, 90, 91 (right), 92, 94, 95, 97, 98–99, 100–101, 102, 103, 104, 106, 107, 108, 116 (bottom), 117, 119, 121, 124, 125, 126, 128, 129, 130, 131, 134, 135, 136 (top, bottom), 137, 139, 140, 143, 145, 146 (bottom), 153, 155, 156, 160, 161, 166, 167, 170, 172, 173, 174, 176, 177 (top left, bottom right), 178 (top right, bottom right), 179, 182–183, 210 (row 1: right; row 2: left, middle), 211 (row 4: middle), 214

Leah Misbach Day on behalf of South Kent School: 15

Jonathan Mannion for *Inked Magazine*: 31 (top)

Norval Ramirez: 48, 52, 112–113, 178 (top left, bottom left), 181

Giovanni Grassi: 91 (left)

Matthew Ganser: 116 (top)

Leah Adler, Katy's dancer: 122

Robert Green: 146 (top)

Jesse McGowan: 1, 2, 22, 28, 46–47, 54, 78, 110–111, 159 (bottom), 164, 168, 188, 189, 195, 196–197, 200, 201, 202, 203, 204, 205, 206, 207, 208–209

Oscar Akermo: 210 (row 4: middle), 221

Balaz Bercsenyi: 210 (row 4: right), 218

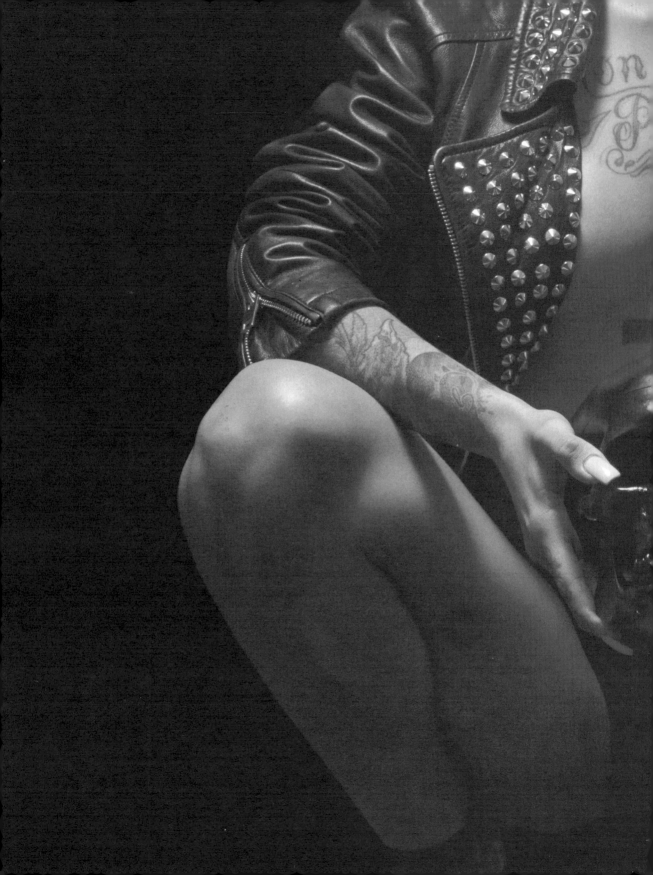